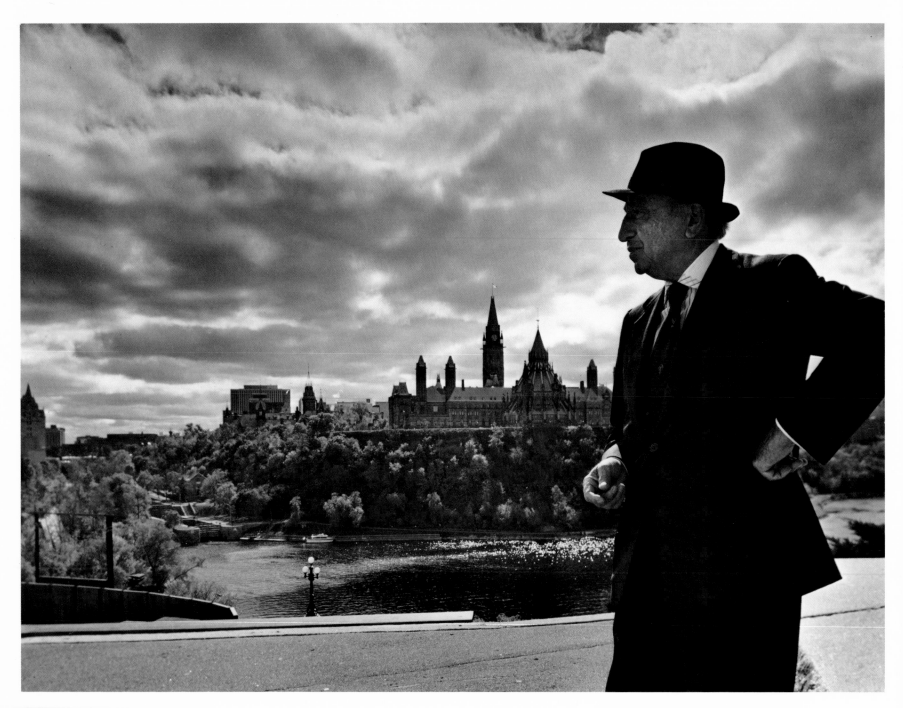

Overlooking the majestic
Houses of Parliament from
Major's Hill Park, Ottawa,
1982

KARSH

A Fifty-Year Retrospective Yousuf Karsh

A New York Graphic Society Book Little, Brown and Company

Boston

New York Graphic Society books are published by
Little, Brown and Company (Inc.)

Fourth printing
First paperback edition published 1986

Printed in Switzerland

Material has been excerpted from the following books by Yousuf Karsh:

Portraits of Greatness, Copyright 1959 University of Toronto Press and
Thomas Nelson
In Search of Greatness, Copyright © 1962 University of Toronto Press
and Alfred A. Knopf
Karsh Portfolio, Copyright © 1967 University of Toronto Press
Karsh Portraits, Copyright © 1976 University of Toronto Press and
New York Graphic Society
Karsh Canadians, Copyright © 1978 University of Toronto Press

Photograph on page 2 by Lorfing.

Library of Congress Cataloging in Publication data

Karsh, Yousuf, 1908-
 Karsh: a fifty-year retrospective.
 "A New York Graphic Society Book."
 Includes index.
 1. Photography – Portraits. 2. Karsh, Yousuf,
1908- .I. Title
TR681.F3K374 1983 779'.2'0924 83-9405
ISBN 0-8212-2549-3 (cloth)
ISBN 0-8212-1626-0 (pbk.)

To my wife, Estrellita, and to the memory of my Father and Mother

1 Introduction

On the stormy New Year's Eve of 1924, the liner *Versailles* reached Halifax from Beirut. After a voyage of twenty-nine days, her most excited passenger in the steerage class must have been a sixteen-year-old Armenian boy who spoke little French, and less English. I was that boy.

My first glimpse of the New World on a steely cold, sunny winter day was the Halifax wharf, covered with snow. I could not yet begin to imagine the infinite promise of this new land. For the moment, it was enough to find myself safe, the massacres, torture, and heartbreak of Armenia behind me. I had no money and little schooling, but I had an uncle, my mother's brother, who was waiting for me and recognized me from a crude family snapshot as I stepped from the gangplank. George Nakash, whom I had not seen before, sponsored me as an immigrant, guaranteed that I would not be a "public charge," and traveled all the way from his home in Sherbrooke, Quebec, for our meeting – the first of his many great kindnesses.

We went up from the dock to the station in a taxi, the like of which I had never seen – a sleigh-taxi drawn by horses; bells on their harnesses never stopped jingling; the bells of the city rang out joyously to mark a New Year. The sparkling decorations on the windows of shops and houses, the laughing crowds, for me it was an unbelievable fantasy come true. On the two-day journey to my uncle's home I marveled at the vast distances. The train stalled in a deep snowdrift; we ran out of food; this situation, at least, was no novelty for me.

I was born in Mardin, Armenia, on December 23, 1908, of Armenian parents. My father could neither read nor write, but had exquisite taste. He traveled to distant lands to buy and sell rare and beautiful things – furniture, rugs, spices. My mother was an educated woman, a rarity in those days, and was extremely well read, particularly in her beloved Bible. Of their three living children, I was the eldest. My brothers Malak and Jamil, today in Canada and the United States, were born in Armenia. My youngest brother, Salim, born later in Aleppo, Syria, alone escaped the persecution soon to reach its climax in our birthplace.

It was the bitterest of ironies that Mardin, whose tiers of rising buildings were said to resemble the Hanging Gardens of Babylon, and whose succulent fruits convinced its inhabitants it was the original Garden of Eden, should have been the scene of the Turkish atrocities against the Armenians in 1915. Cruelty and torture were everywhere; nevertheless, life had to go on – albeit fearfully – all the while. Ruthless and hideous persecution and illness form part of my earliest memories: taking food parcels to two beloved uncles, torn from their homes, cast into prison, for no reason, and later thrown alive into a well to perish; the severe typhus epidemic in which my sister died, in spite of my mother's gentle nursing. My recollections of those days comprise a strange mixture of blood and beauty, of persecution and peace.

I remember finding brief solace in my young cousin's relating her *Thousand and One Nights* tales of fantastic ships and voyages and faraway people, and, always, solace in the example of my mother, who taught me not to hate, even as the oppression continued.

One day, I returned from school, my forehead bleeding. I had been stoned by Turkish boys who tried to take away my only playthings, a few marbles. "Wait," I told my mother defiantly, "from now on *I* am the one who will carry stones." My mother took me in her arms and said, "My son, they do not know what they are doing. However, if you must retaliate – be sure you miss!"

My mother's generosity, strength, and hope sustained our family. She took into our home a young Armenian girl, shared our few morsels of food with her, and encouraged her to use her hands instead of her eyes, which had been cruelly mutilated. My mother herself seemed tireless. She had to go every day to the distant mountain spring which was the one source of water for the whole community. Allowed only one small pail, she would wait patiently in line for hours to get enough water for her children. Running water, to me, is still a great blessing.

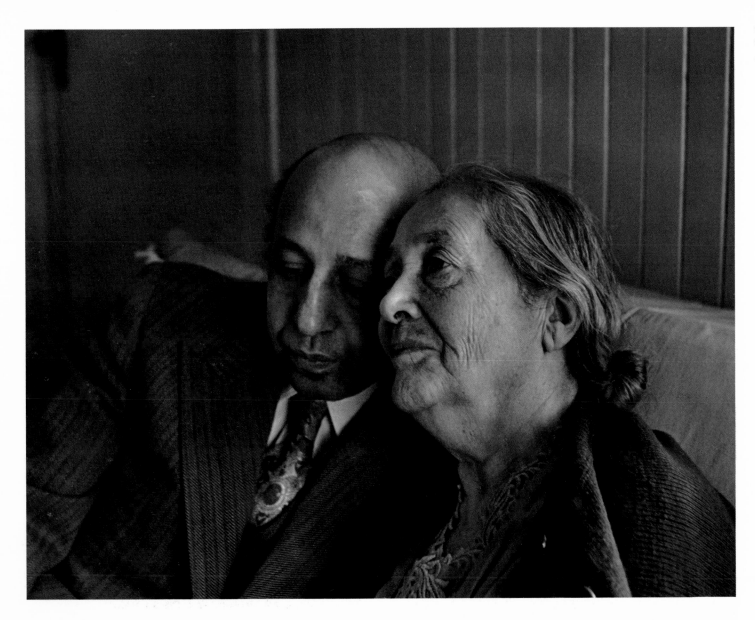

With my mother at Little
Wings, 1945.
(Photograph by my brother Malak)

In 1922, our family was allowed to flee. We had to leave our doors open – with us we took no baggage, only our lives. And we had to flee on foot. During our month-long journey with a Bedouin and Khurdish caravan, which would have taken only two days by the forbidden train, my parents lost every valuable they had managed to save. My father's last silver coin went to rescue me, after I was caught foolishly making a sketch of piled-up human bones and skulls, the last bitter landmark of my country.

In the safety of Aleppo, Syria, my father painstakingly tried to rebuild our lives. Only those who have seen their savings and possessions of a lifetime destroyed can understand how great were the spiritual resources upon which my father must have drawn. Despite the continual struggle, day after day, he somehow found the means to send me to my Uncle Nakash, and to a conti-

nent then to me no more than a vague space on a schoolboy's map.

Uncle Nakash was a photographer of established reputation, still a bachelor when I went to live with him, and a man of generous heart. If my first day at Sherbrooke High School proved a dilemma for the teachers – in what grade did one place a sixteen-year-old Armenian boy who spoke no English, who wanted to be a doctor, and who came armed only with good manners? – the school was for me a haven where I found my first friends. They not only played with me, instead of stoning me, but allowed me to keep the marbles I had won. My formal education was over almost before it began, but the warmth of my reception made me love my adopted land.

In the summer of 1925, I went to work for Uncle Nakash at his studio, burying my original desire to study

medicine. While at first I did not realize it, everything connected with the art of photography captivated my interest and energy—it was to be not only my livelihood, but my continuing passion. I roamed the fields and woods around Sherbrooke every weekend with a small camera, one of my uncle's many gifts. I developed the pictures myself and showed them to him for criticism. I am sure they had no merit, but I was learning, and Uncle Nakash was a valuable and patient critic.

It was with this camera that I scored my first photographic success. I photographed a landscape with children playing and gave it to a classmate as a Christmas gift. Secretly, he entered it in a contest. To my amazement, it won first prize, the then munificent sum of fifty dollars. I gave ten dollars to my friend and happily sent the rest to my parents in Aleppo, the first money I could send to them.

Shortly afterward my uncle arranged my apprenticeship with his friend John H. Garo of Boston, a fellow Armenian, who was recognized as the outstanding portraitist in the eastern states. Garo was a wise counsellor; he encouraged me to attend evening classes in art

and to study the work of the great masters, especially Rembrandt and Velásquez. Although I never learned to paint, or to make even a fair drawing, I learned about lighting, design, and composition. At the Public Library, which was my other home in Boston, I became a voracious reader in the humanities and began to appreciate the greater dimensions of photography.

It was Garo himself, who bore a physical resemblance to Mark Twain, but without the humorist's flamboyance, who made a lifelong impression on me. Originally I had been sent to Boston for six months, but Garo took so kindly to me and was so encouraging that, in the end, I spent a total of three years with him. In Garo's studio, I learned many of the technical processes used by photographic artists at that time, among them platinum printing, and pigment or gum arabic, carbon oil and bromoil. The complicated procedures demanded great skill, intuitive judgment, discipline—and patience. My first gum arabic print took me eighteen days; it had to be sensitized, coated, and resensitized many times. Learning these processes made me strive for perfection; time meant nothing, and only the final result counted.

But Garo taught me something more important than technique alone—Garo taught me to see, and to remember what I saw. He also prepared me to think for myself and evolve my own distinctive interpretations. "Understand clearly what you are seeking to achieve," he would say, "and when it is there, record it. Art is never fortuitous." When he had made six glass plates of a person, there had been much sharing of truth between the photographer and his subject.

An air of cultured informality surrounded Garo. Since sittings in the studio were by available light, we stopped long before dusk. That hour was the beginning of many a happy and often spontaneous gathering of his artist friends—men and women of great talent—who would come to be with Garo and each other. During those days of Prohibition, my extracurricular activities included acting as bartender for the hospitality that flowed, delivered to the studio in innocent-looking paint cans. As mixer of concoctions of "nitric acid" for Arthur Fiedler, or "hypo" for Serge Koussevitzky, I shared in wonderful encounters with some of the great personalities in the world of music, letters, the theater, and the opera of the 1920s. Even as a young man, I was aware that these glorious afternoons and evenings in Garo's salon were my university. There I set my heart on photographing those men and women who leave their mark on the world.

Early landscape, 1927. Later finished in bromoil

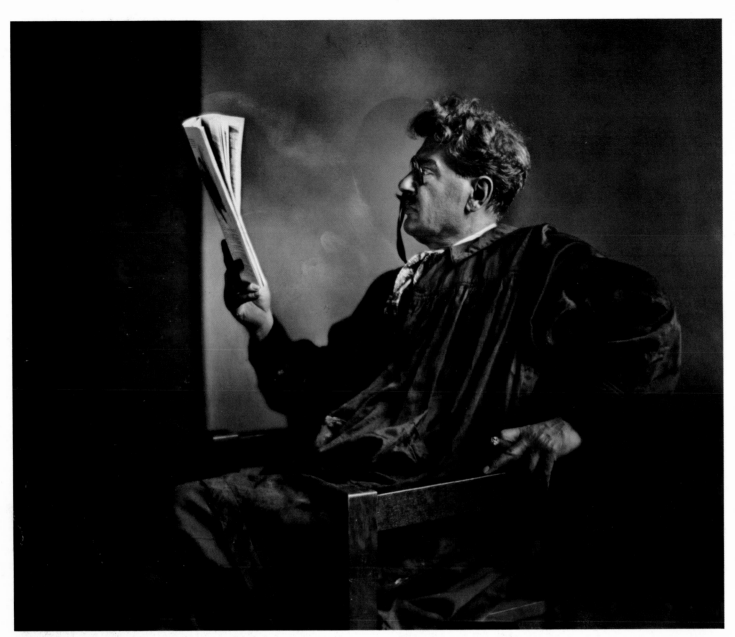

My master, John H. Garo, 1931

Garo's health broke and he died in 1939, when I was still struggling with my own first independent studio in Ottawa, and I grieved and felt remorse that I could not be with him at the end. Those last months impressed me with what I have come to hold as a general truth: It is rarely possible to repay directly those who have rendered us great personal kindnesses. But it is also futile to rationalize and say that the time for sacrifice, to repay just moral debts, is past – for I do not believe that time ever passes. Nature does not often collaborate with men to permit simple repayment, whether the debt is from son to father, from soldier to comrade, or from pupil to master. We may never be able to pay directly for the gifts of true friendship – but pay we must – even though we make our payment to someone who owes us nothing, in some other place and at some other time.

I left Boston in 1931, my interest in the personalities that influenced all our lives, rather than merely in portraiture. Fostered by Garo's teachings, I was yearning for adventure, to express myself, to experiment in photography. With all my possessions packed in two suitcases, I moved to Ottawa. In the capital of Canada, a crossroads of world travel, I hoped I would have the opportunity to photograph its leading figures and many foreign international visitors. I had a modest studio; the furniture was mostly orange crates covered – tastefully, I thought – with monk's cloth, and if I occasionally found myself borrowing back my secretary's salary of $17.00 a week to pay the rent, I was still convinced, with the resilience of youth, that I had made the right choice.

Within a short time I was fortunate to meet B. K. Sandwell, the learned editor of the prestigious and

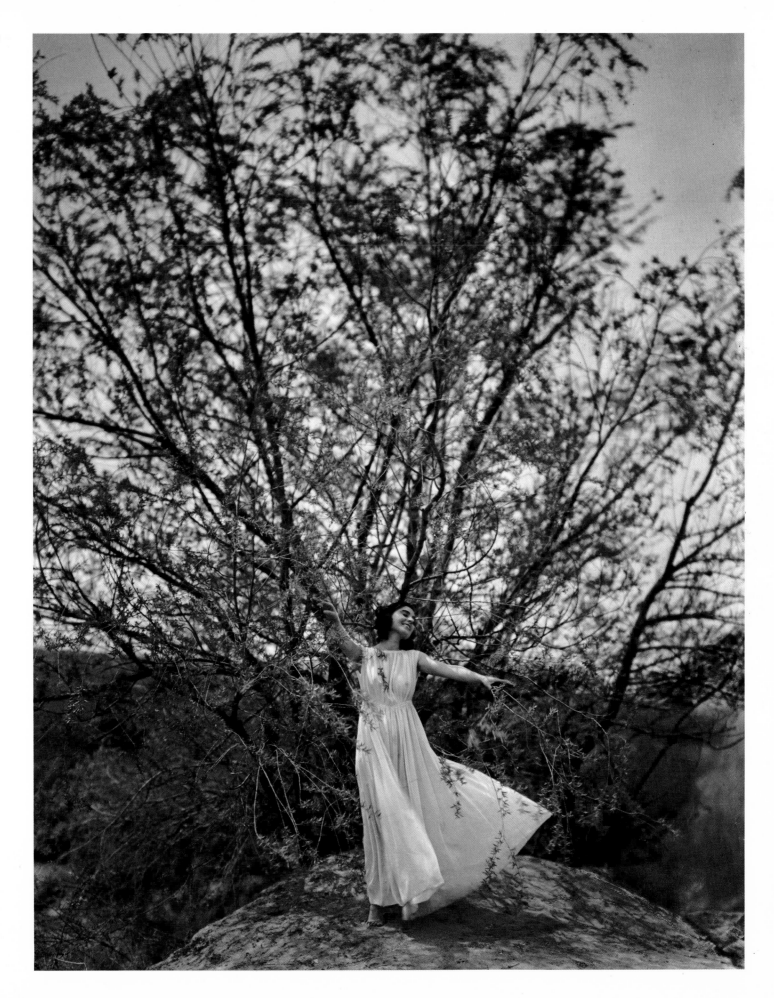

elegantly illustrated periodical *Saturday Night*; a civilized, warm attachment grew up between us. Accompanying Sandwell's political and social comments, my photographs were reproduced for the first time in his magazine.

While my career seemed to be well launched, I had few friends in Ottawa during those early months, and I welcomed an invitation to join the Ottawa Little Theatre, an enthusiastic group of amateur players. The casual invitation was to have lasting effects on my life and career. The experience of photographing actors on the stage with stage lighting was exhilarating. The unlimited possibilities of artificial light overwhelmed me. Working with daylight in Garo's studio one had to wait – often for hours – for the light to be right. In this new situation, instructions about lighting effects were given by the director; he could command the lighting to do what he wished. Moods could be created, selected, modified, intensified. I was thrilled by this means of expression, this method of interpreting life; a new world was opened to me.

One of the leading actors at the Little Theatre was Lord Duncannon, the handsome twenty-one-year-old son of the then Governor General, Lord Bessborough, and Lady Bessborough, who were themselves avidly interested in stage production, and had a miniature theater in their own castle in Scotland. Lord Duncannon prevailed upon his parents to sit for me, and soon the Governor General, in full regalia with sword and decorations, accompanied by his elegantly gowned, statuesque French wife, was climbing the steps to my studio. In my eagerness and delight I became too excited. My mistakes in English frustrated me; I did not even focus the camera correctly; not surprisingly, this first photographic attempt was disastrous. But the Bessboroughs proved most understanding of a nervous young photographer's feelings and consented to sit for me again; this time my portraits were a great success and appeared in *The Illustrated London News,* and *The Tatler, The Sketch,* and many newspapers across Canada.

Something more important than my introduction to incandescent lighting came out of the Little Theatre. My first night there I was ushered into the dressing room of the leading lady, the spirited and independent Solange Gauthier, from Tours, France. From our marriage some years later, to her death in 1960, she was a source of encouragement, understanding, and inspiration. In those early days, convinced that I had some talent, she was interested in helping me, and often did, after her own day's work as a technical translator in the field of metallurgy. Because of the grim circumstances of my childhood, I had missed experiencing the arts; Solange was acquainted with music, literature, drama, and the dance, which she shared with me. After the searing grief of her death, I felt the most fitting tribute to her would be a living memorial at the Ottawa Little Theatre, and I established the yearly Solange Karsh Award for the Best One-Act Play in Canada, the cash stipend accompanied by a medal based on a photograph I had taken of her one carefree day, dancing under the willow trees.

But all this was still in the future. When Lord Bessborough's tenure was over, his successor as Governor General was Lord Tweedsmuir, better known to readers of adventure thrillers as John Buchan, the author of *The Thirty-Nine Steps.* He was the most informal of men, impatient with the strict protocol his position sometimes demanded. In 1936, when Franklin Delano Roosevelt, the first American President to pay an official visit to Canada, came to Quebec City to confer with Lord Tweedsmuir and Prime Minister Mackenzie King, I was invited to photograph this eminent guest. The resultant photograph was not only my first foray into photojournalism, but also the occasion when I first met Prime Minister Mackenzie King. From then on, we were not strangers in the world of Ottawa, and he would in time become my patron and friend. It was Mackenzie King who made it possible for me to photograph Winston Churchill in Ottawa in December 1941. The world's reception of that photograph – which captured public imagination as the epitome of the indomitable spirit of the British people – changed my life.

A year after the Churchill photograph, early in 1943, I was on my way to England on a slow and frightening voyage on a Norwegian freighter, part of a ninety-three-ship convoy. Only when I had climbed on board did her captain confide to me that the ship's cargo hold was loaded with explosives!

In wartime London, as I photographed one exhilarating personality after another – among them George Bernard Shaw, the Archbishop of Canterbury, and the British royal family – I felt once again the excitement of my apprenticeship days in Boston, drinking in the conversation of Garo and his colleagues. It was in London that I started the practice, which I continue to this day, of "doing my homework," of finding out as much as I can about each person I am to photograph. I returned to Ottawa fatigued, but with a feeling of accomplishment

Governor General Lord
Tweedsmuir (John Buchan),
Prime Minister Mackenzie
King, President Franklin
Roosevelt and his son
James, Quebec City. My first
foray into photojournalism,
1936

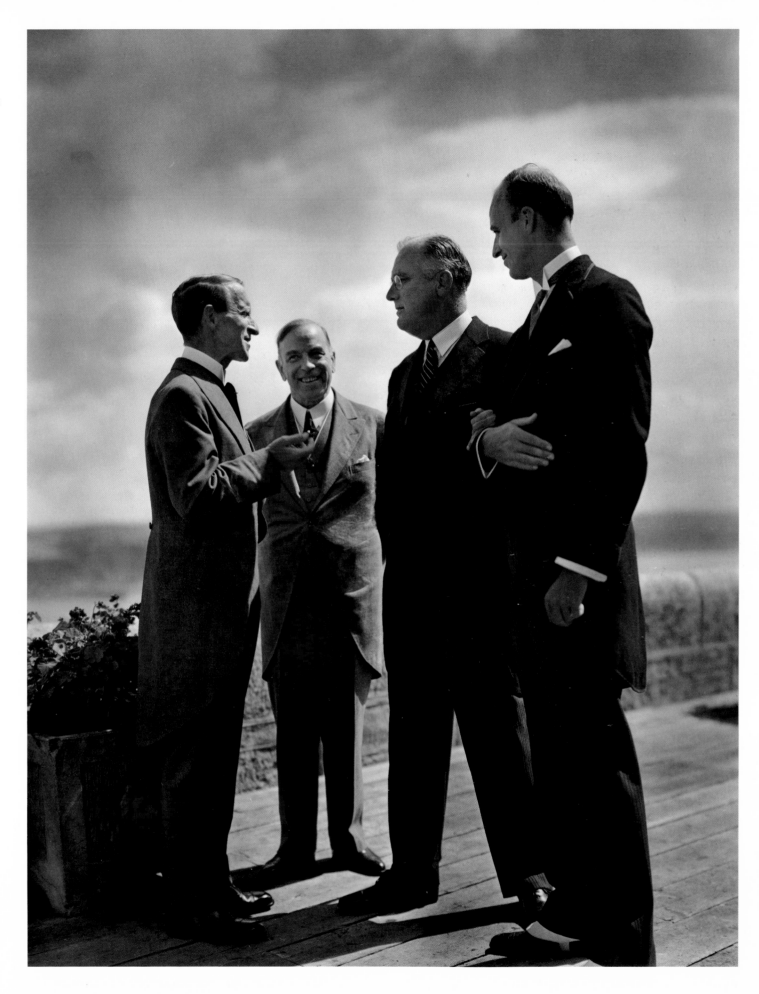

Early photographic
experiments...

City of Straws, 1940

Elixir, 1938

Texture on Wood, 1953

at having completed my first "international portfolio." My life had been enriched by meeting many remarkable personalities on this photographic odyssey, the first of many, to record those men and women who leave their mark on our era. It would set a pattern of working away from my studio. Any room in the world where I could set up my portable lights and camera – from Buckingham Palace to a Zulu kraal, from miniature Zen Buddhist temples in Japan to the splendid Renaissance chambers of the Vatican – would become my studio.

Through my photography I have not only become acquainted with some of the most celebrated personalities of our era, but have had the opportunity to visit fascinating parts of the world I might not otherwise have known. On an off-the-beaten-track movie assignment in the Moroccan desert between Casablanca and Marrakesh, I put to use the Arabic I had learned as a small boy, and photographed some of the principal actors in the film *Sodom and Gomorrah*. The royal family of Morocco was intrigued by the presence of the film company, and invited ten members of the crew on a most unorthodox deer-hunt. At the foot of the mountain our party was provided with mules, guns (I used my camera), and individual soldiers as honor guards. We awaited the arrival of our host, the Crown Prince. As we reached the top of the mountain, imagine our surprise when he finally appeared – in a helicopter roaring overhead, and proceeded to shoot his prey from above!

But wherever I traveled, it was to Little Wings, our haven and anchorage, that I always returned, with its grove of white birches and rows of Lombardy poplars on the bend of the Rideau River. It took its name from the fact that the gently rolling property was on a bird migratory route and we logged many birds each year. The trees we planted were named not after their species but for dear friends. A row of global maples flanked by beds of roses is "Avenue Marsh Jeanneret" in honor of the former Director of the University of Toronto Press, who encouraged the publication of my early books and supported me in my insistence on high aesthetic standards of reproduction. A weeping mulberry tree and an umbrella crabapple are the central focus of two kidney-shaped gardens of spring tulips and seasonal flowers I designed in honor of our friend Dr. John P. Merrill of Boston, the eminent physician and pioneer in kidney transplantation.

After World War II, my ties to the New World were drawn even closer when, some twenty years after my arrival, I was able to bring my parents and two of my brothers to my adopted land. (My other brother, Malak, had come in 1937.) I had hesitated at tearing my parents away from lifelong friends in Aleppo in the twilight of their lives, and bringing them to a country completely different in language and customs. But I reckoned without their adaptability. Uncle Nakash and I secured permission to go aboard their ship before it docked in New York, to the surprise of my family and to our mutual joy. My mother and father, who had traveled little in their lives except to flee from persecution, chose to make the last lap of their journey to Canada by air, instead of by train or automobile. When the plane drew up to the ramp, after landing in Montreal, and everyone shouted "Welcome, welcome!" my parents dissolved in tears of joy, and I knew I had made the right decision.

Years later, another newcomer to Canada I brought to Little Wings when he was six weeks old. One of three brothers and sisters, he boasted a distinguished lineage, having been born in the house of an American Secretary of State. For the trip to Ottawa, I had taken the precaution of reserving two airplane seats, providing the unsuspecting reservation clerk only with the enigmatic identification "Y. Karsh and C. Karsh, young personality." That the "young personality" made the journey in my warm coat pocket, rather than in the cold baggage car, was due to my insistence, but with the benign approval of the gentlemen in Customs and Immigration. They were also beguiled by two pounds of black, energetic poodle fluff punctuated by a cold nose. His name, Clicquot, was short for the champagne, "Veuve Clicquot." (The proud male bore no resemblance to a *veuve* [widow], but he was as effervescent as champagne.) Just as I had had no real childhood, I had had no real pets. Clicquot was my first pet, my philosophical companion on long walks. He was actor enough when coming in out of what he considered misty weather to shake nonexistent drops from his dry coat with an air of reproach. He innocently chased squirrels in the wrong direction, sent holiday greetings, and freely dispensed advice to his friends on how to commandeer that extra cookie and how to look pitiful so your mistress will feed you by hand. We hoped that because he gobbled up, in one ecstatic, disobedient moment, the chocolate *ankh* (key of life) we had brought safely from Egypt, half a world away, he, too, might partake of its magical powers – but we hoped in vain. We still miss him.

With Clicquot, 1968
(Photograph by Michael Kerr)

It was a congenial medical office – one that always made me think of my original desire to be a physician – which provided the setting for Estrellita Nachbar, the gifted medical writer and historian who was to become my wife. I was in Chicago photographing her employer and mentor, one of America's most distinguished physicians, Dr. Walter C. Alvarez. He was then bringing to millions of readers, through his syndicated column, the reassuring clinical wisdom and compassion that had made him a beloved and world-famous diagnostician at the Mayo Clinic. Estrellita had been Dr. Alvarez's editor for some years, using her extensive literary and medical background to make difficult scientific concepts exciting and readable to the layman, and collaborating with the doctor on his current best-sellers. As *Newsweek* whimsically put it when reporting our marriage in 1962, "Something else clicked beside the shutter." With our marriage, at which Dr. Alvarez gave away the bride, we blended our worlds, each adding a new dimension to the other. With her editorial ability Estrellita helped me to formulate my thoughts. She also brought her organizational skills to planning trips and schedules so that work was always complemented by new discoveries. On all our travels over the years – whether to Zululand, to Japan, to Russia, to Finland, to Scandinavia, to Egypt –

we have pursued our joint interests in archaeology, in art, in medicine. She has continued to write articles on medical history. I have often sat in the audience at her lectures, when her carefully concealed scholarship transforms research in old tomes into engaging and modern social history.

Early in our marriage I began to photograph, as my contribution, the National Poster Children of the Muscular Dystrophy Association. Over the years our relationship with these remarkable young people has been close and meaningful. We have watched many grow up, graduate from high school and college, and marry. But not all. The premature deaths of many of these young people serve as a spur to medical researchers to try to eradicate all forms of crippling diseases.

Throughout my career, I have welcomed young people to my studio. I always think back to Garo and all he taught me, and to Edward Steichen, who took the time to discuss photography seriously with me at a crucial moment in my young career. I welcomed the intervals when I was Visiting Professor of Photography at both Ohio University at Athens and Emerson College in Boston, and was buoyed by the contact with fresh viewpoints and youthful experimentation, in a humanistic

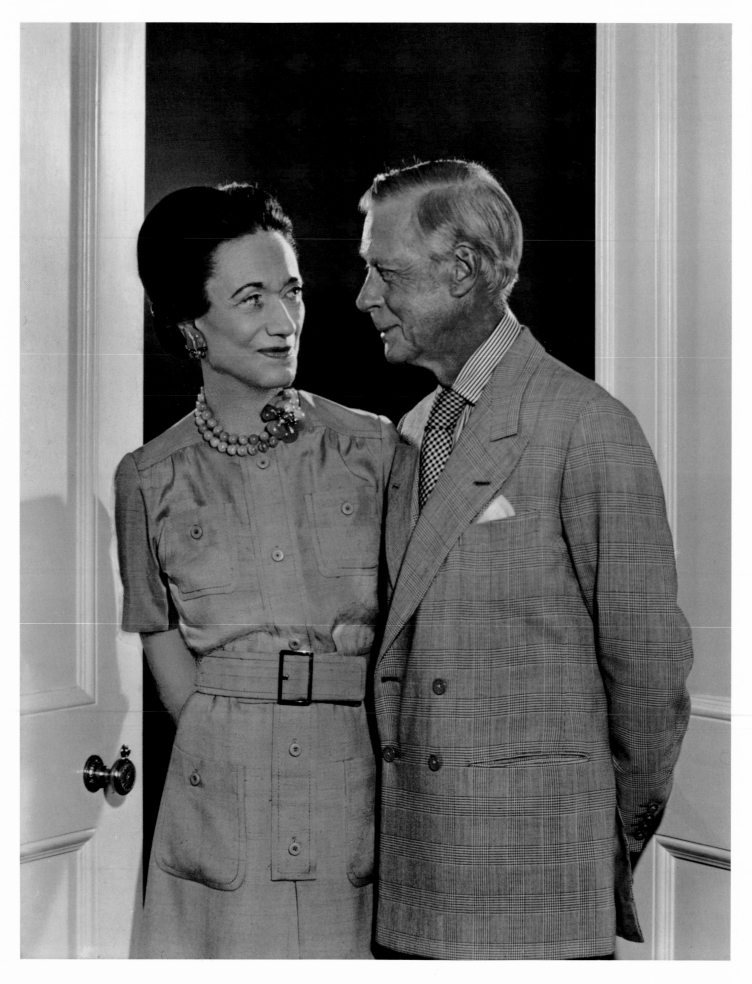

It has been a privilege to share intimate moments with many remarkable personalities…

Duke and Duchess of Windsor, 1971
After viewing this photograph, the Duke and Duchess graciously wrote to me that I had captured their deep feelings for each other after thirty-four years of marriage.

A meeting of minds with
Ernest Hemingway at his
home in Havana
(Photograph by Monty Everett)

A light moment with
French President François
Mitterrand, 1981
(Photograph by Manuel Litran,
Paris-Match)

On the way to a photographic
session at the White House
(Photograph by Jo C. Tartt, Jr.)

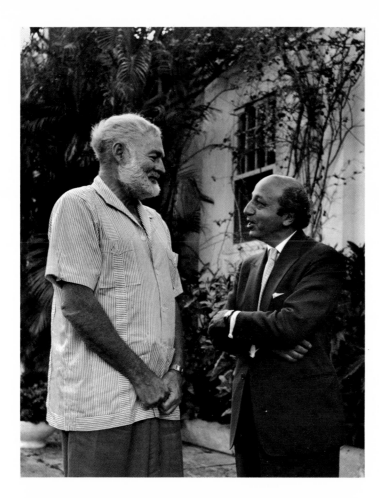

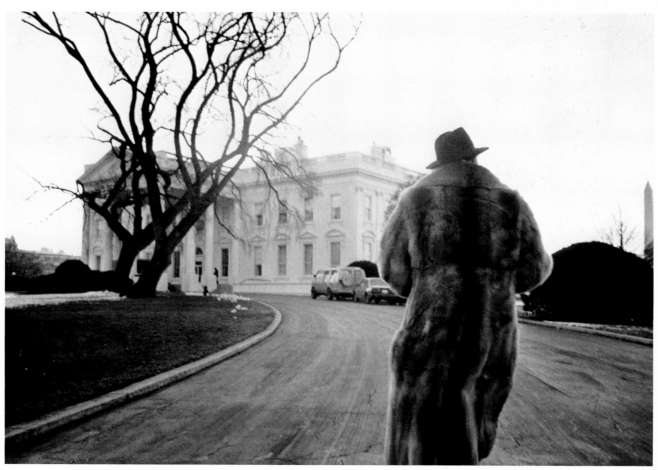

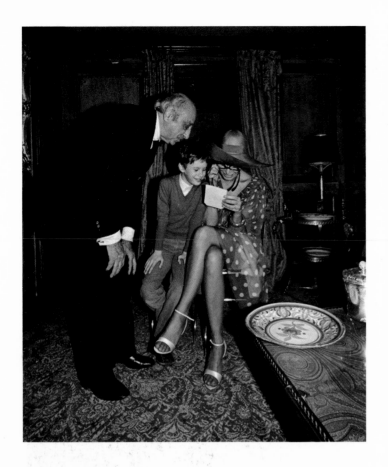

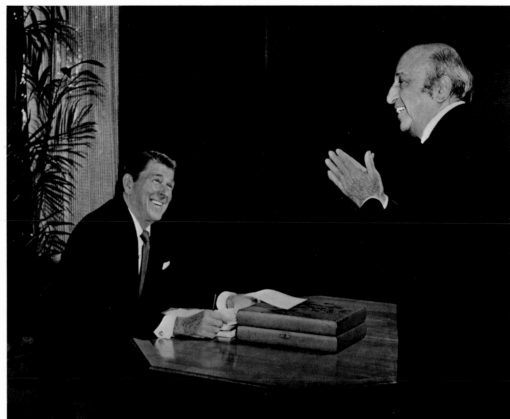

Sophia Loren and her son
Eduardo share the first
results of our photographic
session, 1981
(Photograph by Manuel Litran,
Paris-Match)

Enjoying the punch line to
President Reagan's anec-
dote, 1981
(Photograph by Jim Macari)

Pope John Paul II, 1979
His Holiness talked with me
about the rescued Polish art
treasures I had photo-
graphed in Canada after the
Second World War – now
safely returned to Krakow.

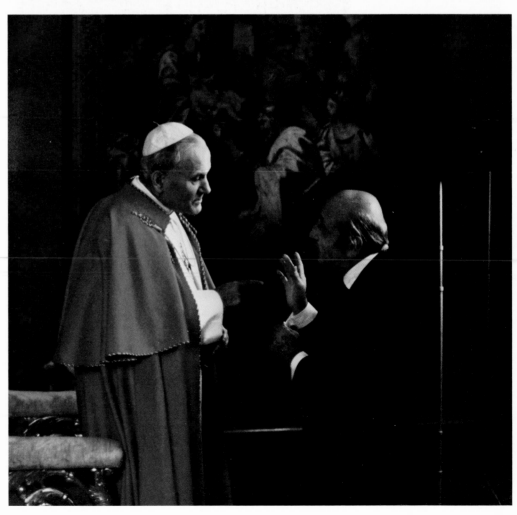

Jacqueline Kennedy, 1960
Widowhood and adversity
had not yet touched the
glamorous young wife of
the handsome Senator
and President-elect from
Massachusetts.

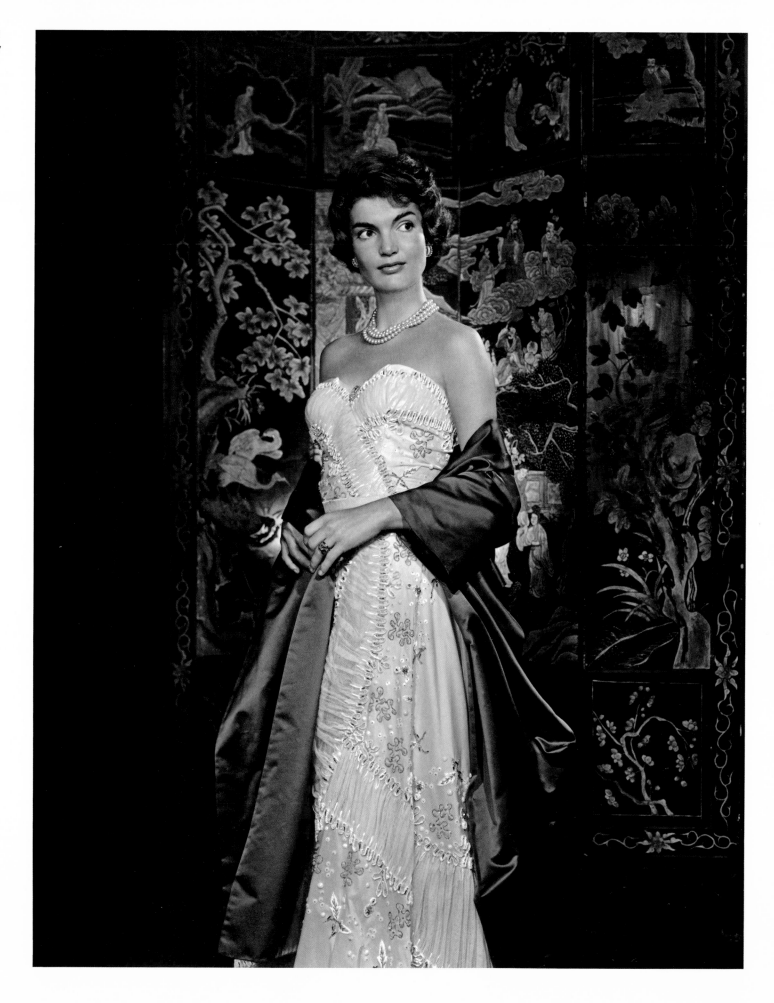

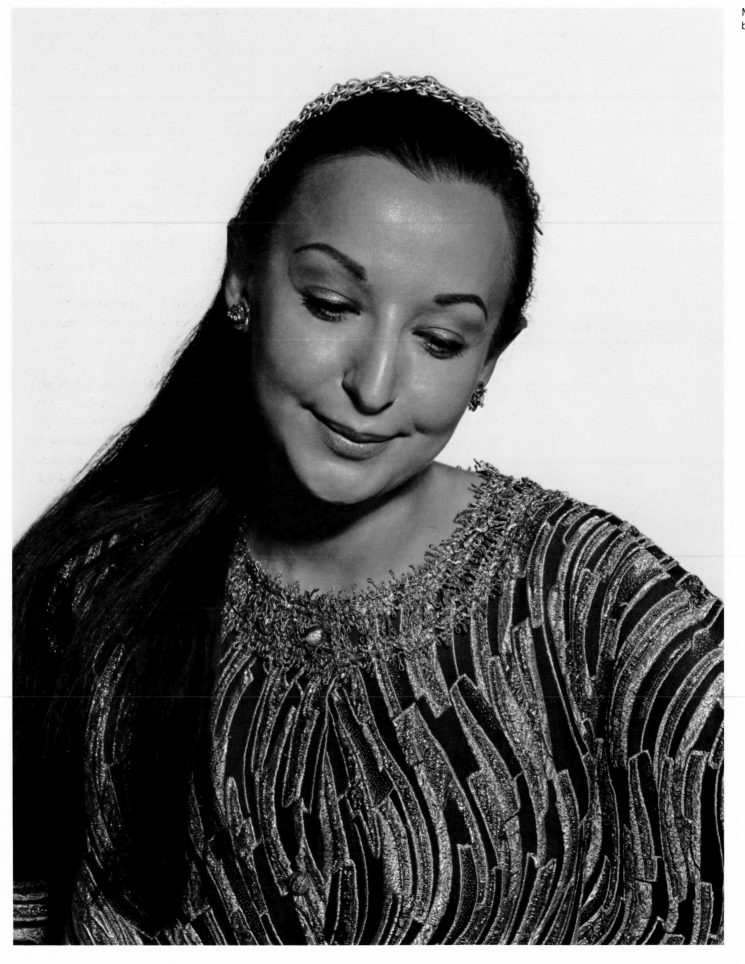

My wife, Estrellita Karsh, a
birthday portrait, 1970

setting. Today, when it seems every young person flirts with photography, the decision to pursue it as a lifetime career is an especially important choice.

My "studio family" in Ottawa has remained constant over the years – a tribute more to their loyalty, expertise, and devotion than to my patience. A frequent source of studio amusement is when I proclaim, of a potentially lengthy and arduous task, "I can do it in five minutes."

Mr. Ignas Gabalis, my printer, in 1983 marks his thirtieth year with me. We are old friends who have seen much together. He is a superb printer with high aesthetic standards and enormous technical skill, an artist in his own right. I still marvel at his consistency of excellence.

Miss Mary Alderman, my secretary, with the seeming effortlessness that is the hallmark of a professional, handles the day-to-day studio operation. She has an inexhaustible archival knowledge of where everything is, including my tiny scraps of paper full of important notes I constantly manage to misplace. Quietly, and with subtle, low-key persuasion, she makes me keep up-to-date, and remains cool and unflappable at last-minute schedule changes.

Estrellita and I travel extensively, but my mind is always at ease because I am confident that Mr. Gabalis and Mary are running things well in Ottawa.

Before leaving my studio to pursue her own artistic career, Mrs. Hella Graber was my librarian and technician for over twenty years.

Two men who have been important figures in my life are Tom Blau and Harry Lunn. I first met Tom Blau during my wartime trip to London, and for over forty years he remained my staunch friend and European photographic representative. During recent years I have enjoyed the friendship and artistic expertise of Harry Lunn, Jr., who has done much to create interest in fine photography.

More and more often now, I am asked whether I think that there are as many great men and women to photograph today as in the past – whether the strengths of a Churchill or an Einstein can be found today in this era of antiheroes. When my portrait of Winston Churchill in 1941 opened the door to the world for me and started me on my search for greatness, I had a legacy of half a century to draw upon. During the war, in one brief period in England alone, I photographed forty-two leaders of international stature, and, later, in Washington, a similar number. After the war, there were still many personalities whose reputations extended back for decades. A Sibelius, a Helen Keller, a Schweitzer, a Casals are of enduring stature. But I believe the past has no claim on greatness, for such arresting personalities are always among us. Nor can we yet judge what lessons remain to be learned from the young. I know only that my quest continues.

The endless fascination of these people for me lies in what I call their inward power. It is part of the elusive secret that hides in everyone, and it has been my life's work to try to capture it on film. The mask we present to others and, too often, to ourselves, may lift for only a second – to reveal that power in an unconscious gesture, a raised brow, a surprised response, a moment of repose. *This* is the moment to record.

To my deep satisfaction, through my photographs many people have been introduced to some of the outstanding personalities of our time, and, I hope, have been given a more intimate glimpse of, and greater insight into, them.

My own quest now has stretched for over half a lifetime. The search for greatness of spirit has compelled me to work harder – to strive for perfection, knowing it to be unattainable. My quest has brought me great joy when something close to my ideal has been attained. It has kept me young in heart, adventurous, forever seeking, and always aware that the heart and the mind are the true lens of the camera.

Karsh in Color

I have been photographing in color as well as black and white throughout my career. During my sittings, I have made it a practice to alternate taking black and white and color. Today, the technology of color has begun to catch up with its aesthetic possibilities. One can now print muted and subtle tones which, especially in portraiture, are important to capture the expressive nuances of the human face.

Karen Magnussen
1973

Upon meeting the unpretentious young woman who had just dazzled me with her performance on ice, I would not have guessed that the champion figure skater was once told she could never skate again. She refused to give up, and after completing an arduous rehabilitation program, she regained her world titles.

The day we met she was understandably fatigued after her performance but her spirits revived when she put on the glorious chiffon dress designed by George Stavropoulos. Captivated with her image, she twirled round and round as the gown fell in graceful folds. She reminded me of a joyful butterfly on a spring day.

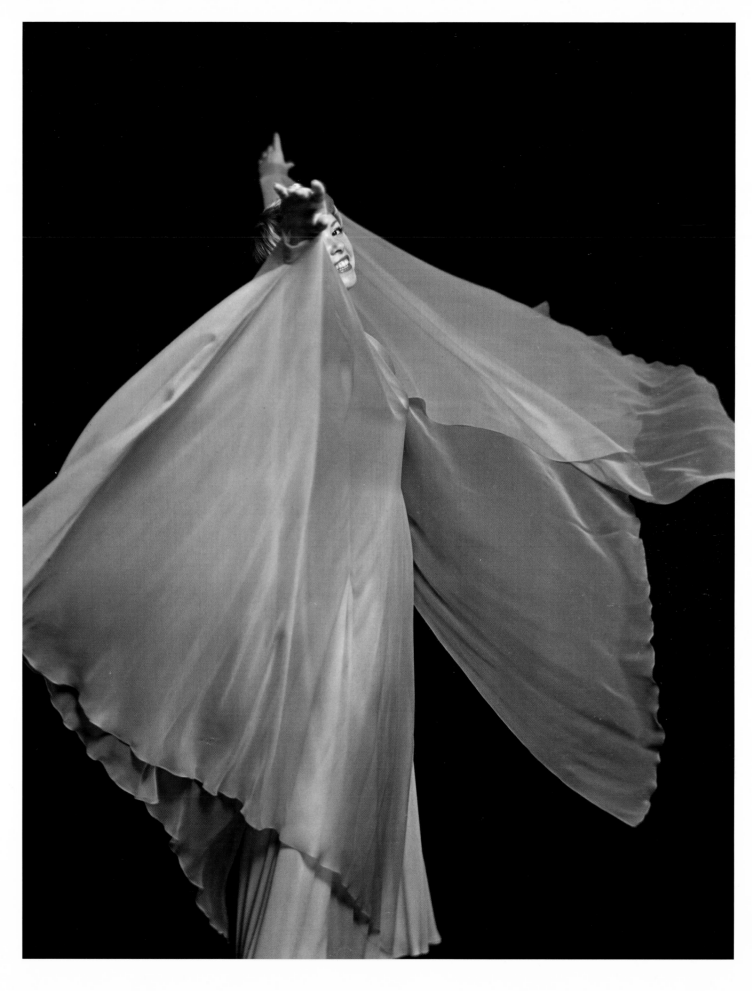

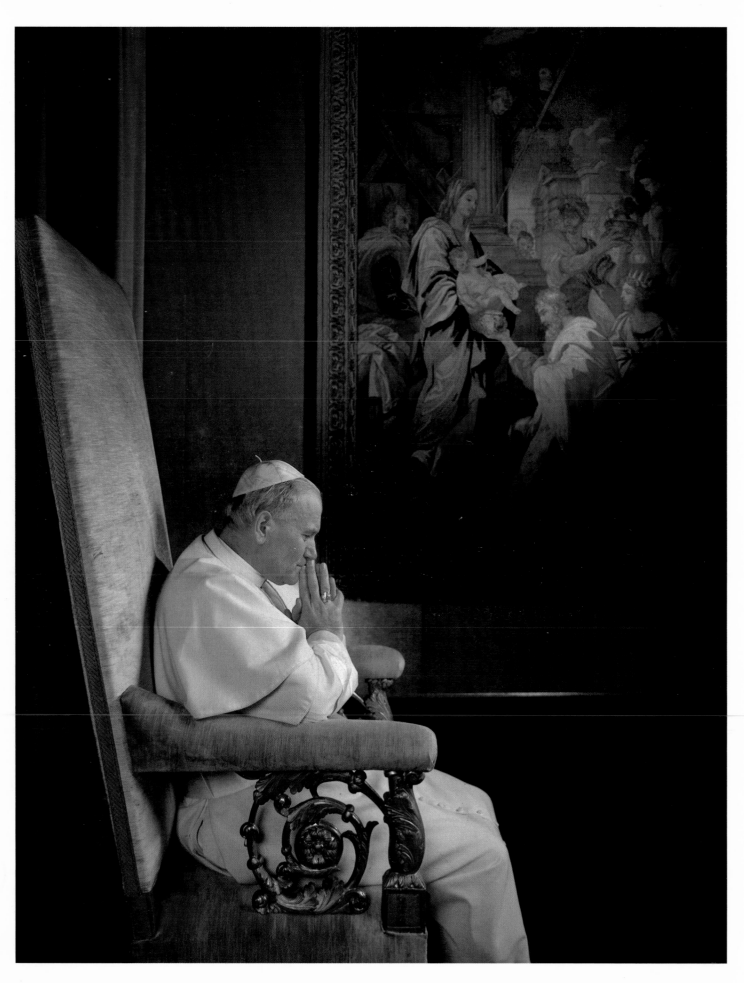

Pope John Paul II
1979

The warmth of his greeting and his personal dynamism humanized the Renaissance grandeur of the Vatican's Hall of Tapestries.

This photograph was taken
in the Music Room of
Buckingham Palace to mark
Canada's Centennial in 1967.

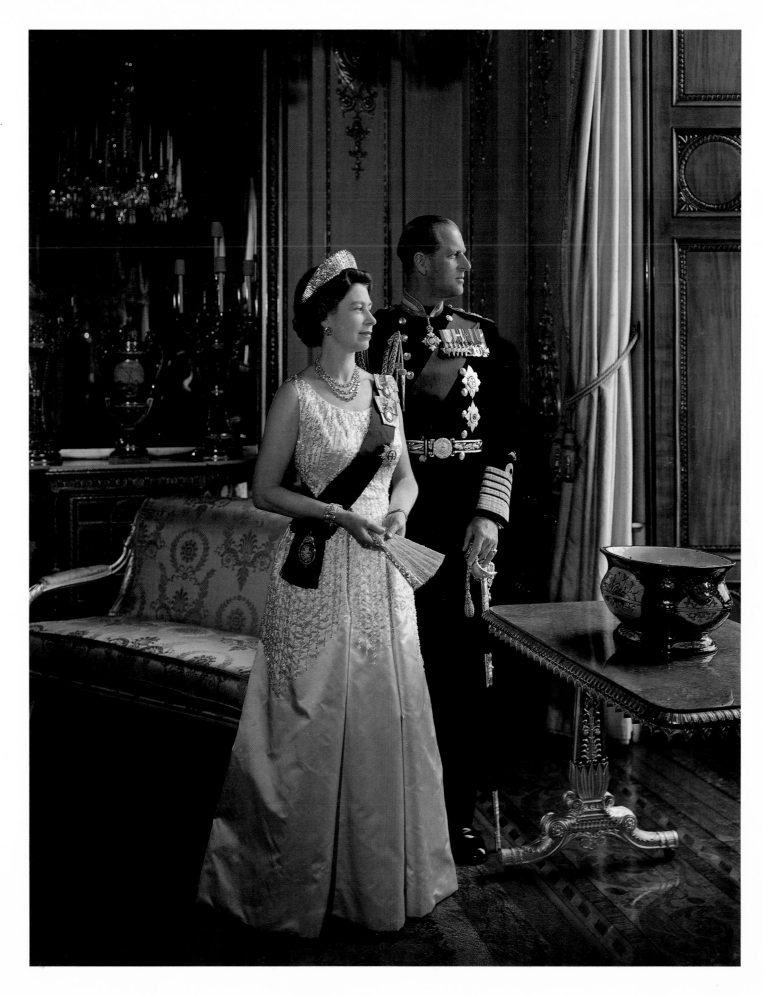

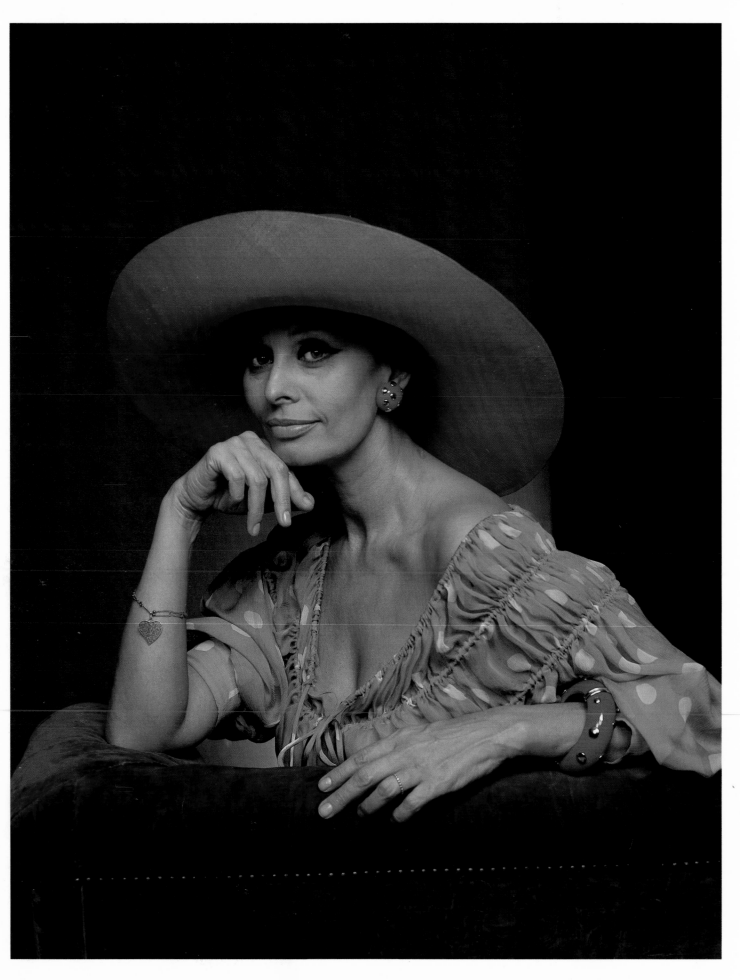

Sophia Loren
1981

When an actress has the intelligence and professionalism, as well as the beauty, of Sophia Loren, photographing her becomes a highly enjoyable collaboration.

Alain Delon
1981

The French actor was surprised that I did not come alone, but accompanied by my photographic assistant, a writer, and two photographers from *Paris-Match* who were to record the session. Even though Delon is at home on the sound stage surrounded by technicians, he is essentially a private person, and relaxed only when we were alone.

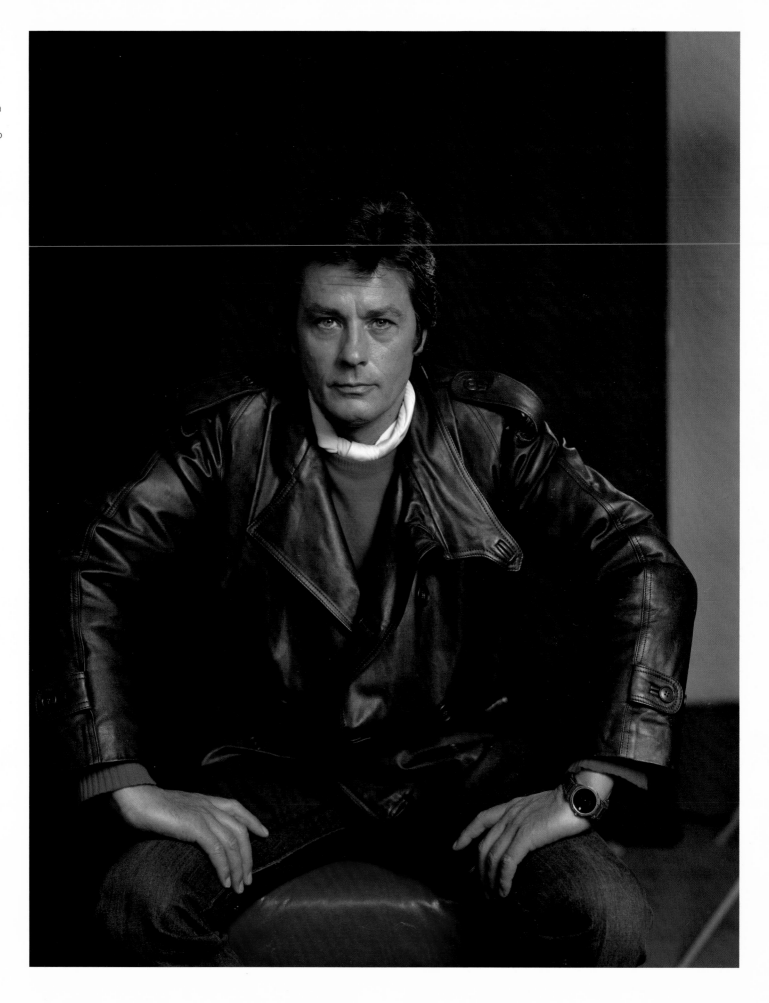

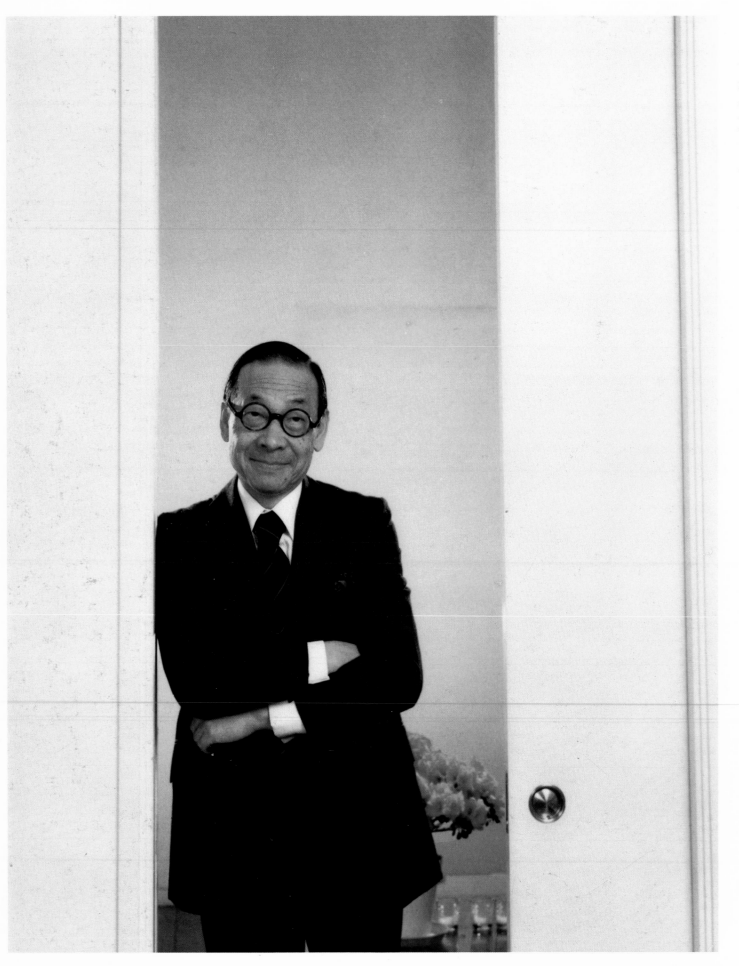

I.M. Pei
1979

"Buildings are for people to enjoy," the Chinese-American architect told me. The appreciative millions who throng through his creative public buildings, the East Wing of the National Gallery in Washington, the Kennedy Library and the addition to the Museum of Fine Arts in Boston, or the Fragrant Hill Hotel outside Peking, respond instinctively to I.M.'s "dedication to humanity through architecture."

Ben Shahn
1966

The work of this versatile American painter reflected his acute awareness of social injustice. "It is the mission of art," he told me, "to remind man that he is human."

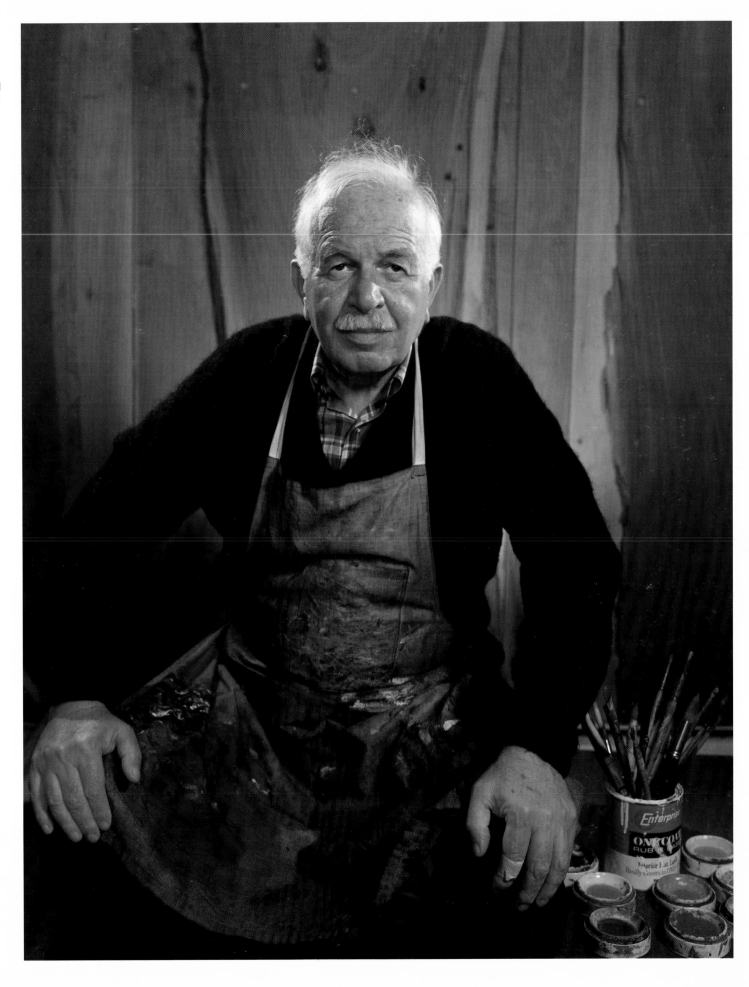

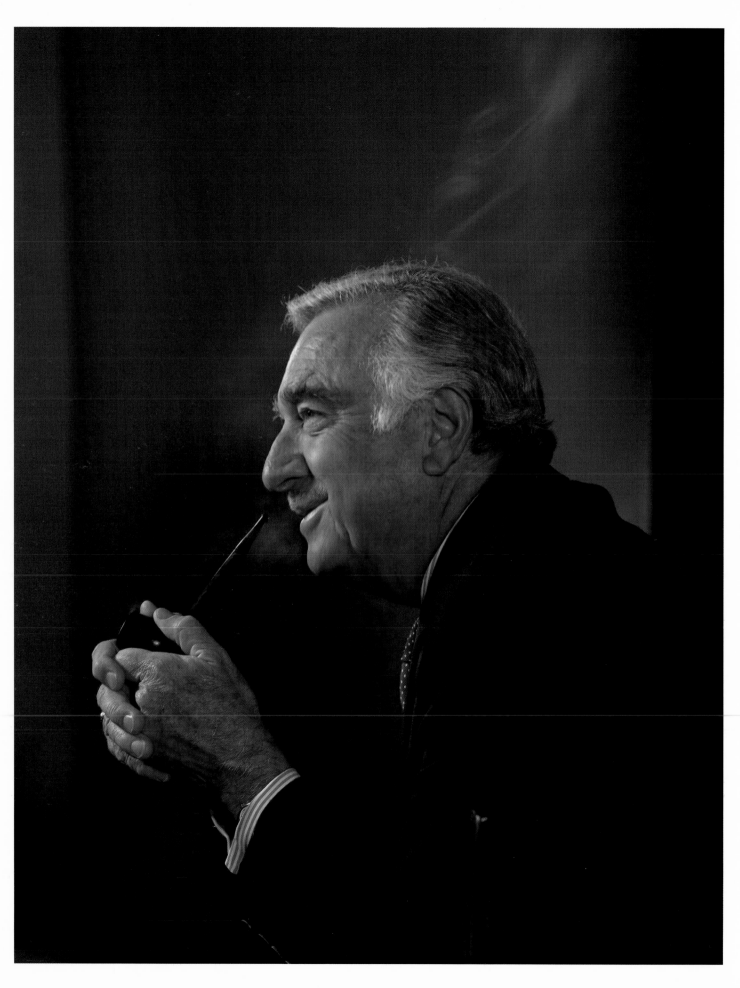

Walter Cronkite
1979

His journalistic integrity and reassuring manner made him television's "Uncle Walter," a trusted interpreter of world events, and a welcome family member in millions of homes.

Norman Mailer
1974

I had been warned that the eminent American author of *The Naked and the Dead* and Pulitzer Prize winner was an ''enfant terrible.'' When we met at his home in Stockbridge, Massachusetts, Mailer looked at me with his piercing blue eyes; I was enveloped by his warmth, and his grave, almost formal consideration; we immediately became understanding friends. Estrellita and I joined him in his kitchen as he cooked dinner for us. We did not want to miss one moment of this restless and fascinating man's conversation. When we left, he showed his protective concern by driving ahead of us in his car for miles to make sure we were safely on the right road back to New York City.

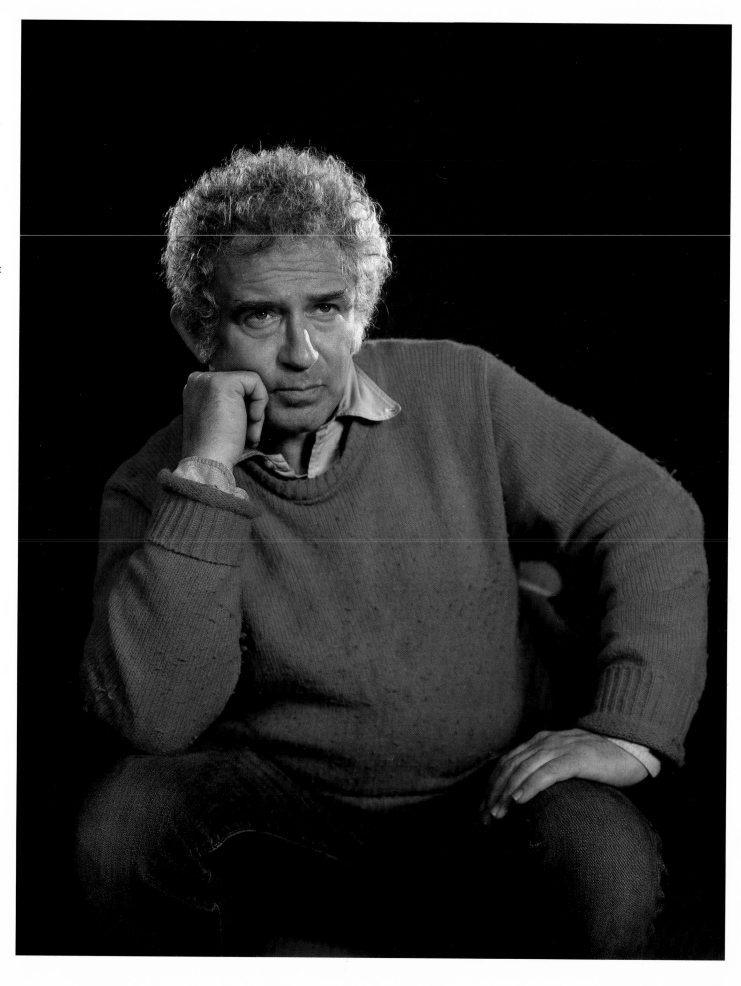

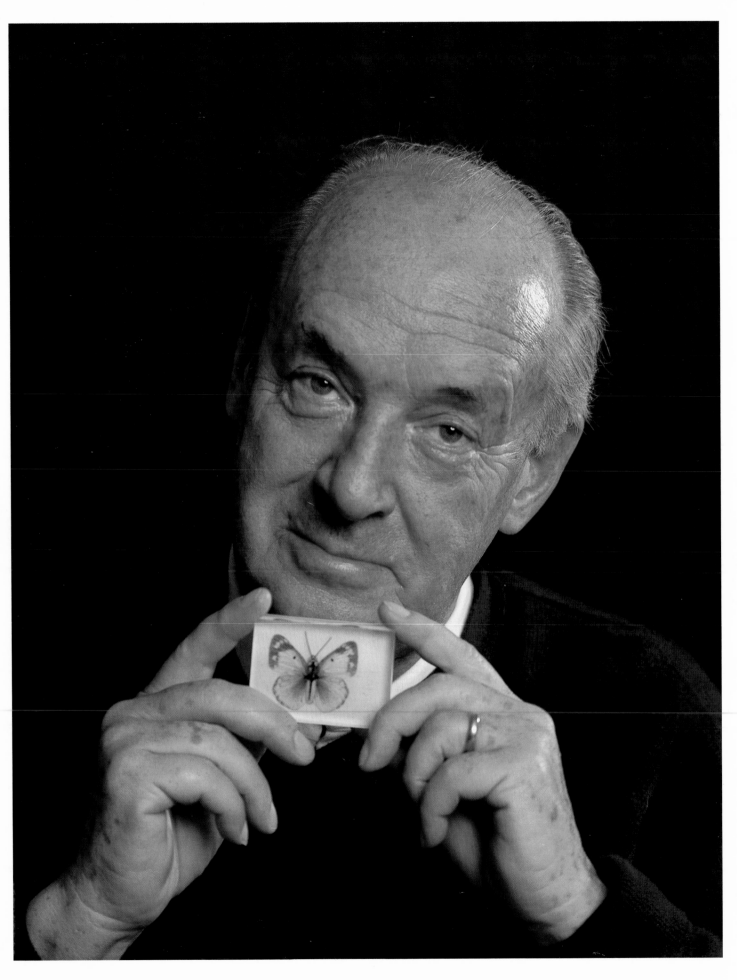

Vladimir Nabokov
1972

The Old World atmosphere of the Montreux Palace Hotel in Switzerland, where Nabokov made his home in later years, suited the Russian émigré. Of his satire on American values, *Lolita,* he drolly commented, ''I know the American woman very well. When I was a butterfly scientist I taught them during their crucial years at college.''

François Mitterrand
1981

In the French President's Paris home, his favorite attic corner, three flights up, was crowded with manuscripts, books, and photographic memorabilia. As I surveyed the small space, which could barely contain my lights and camera, I remarked, "Monsieur Mitterrand, I hope when I ultimately meet my Creator, I will be given a little more space than you have allowed me." He more than made up for the inconvenience by his total cooperation. When I left, he trudged down the three flights of stairs to present to me one of his archaeological prizes. "I want you to have this; when we next meet, I will explain how much it means to me."

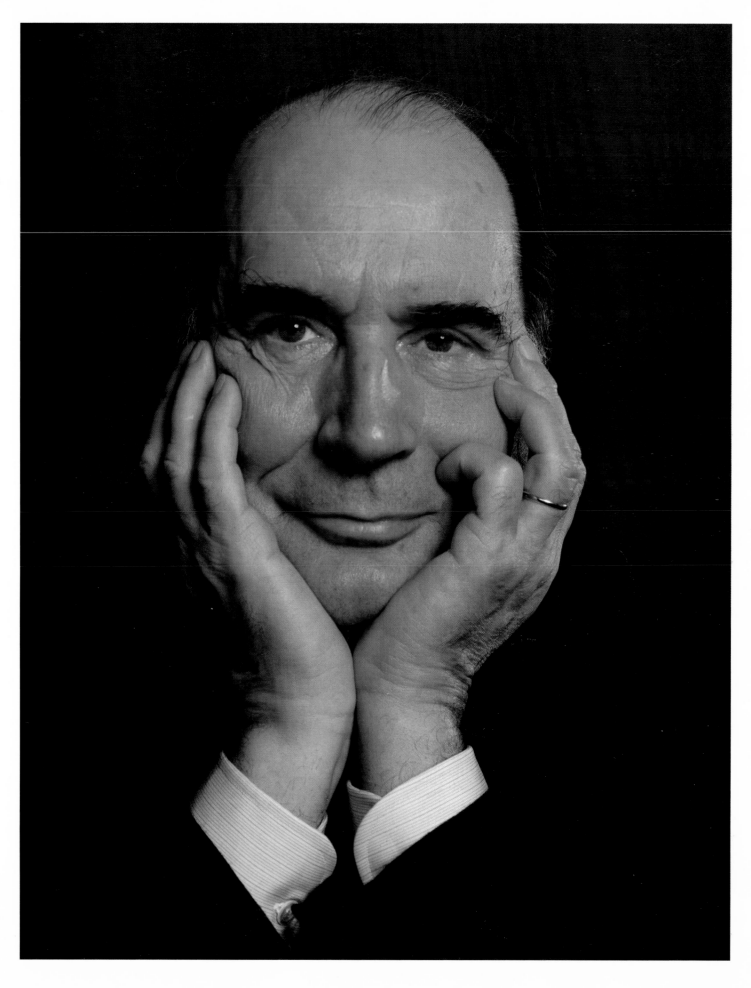

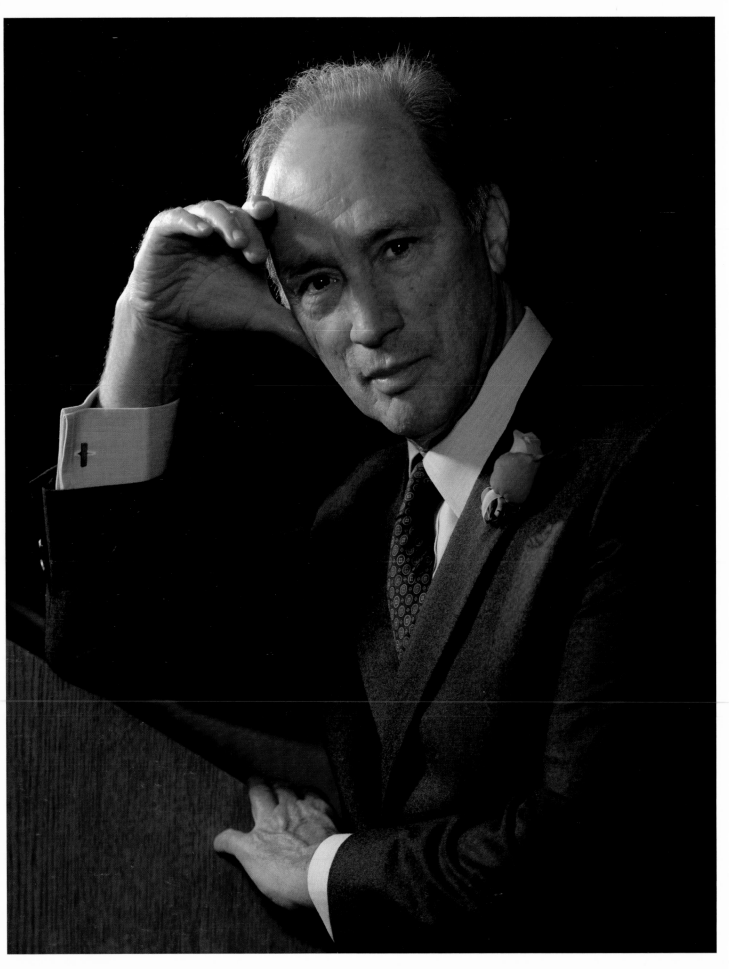

Pierre Elliott Trudeau
1982

I photographed the Canadian Prime Minister on his sixty-third birthday. When he speaks directly to you, you feel the force of his ironic wit, as well as the charm of his personality. After occupying so great a part in the nation's public life, he still remains an essentially private person.

The word "statesman" used to bring to mind an image of a formal gentleman in sumptuous, but subdued, surroundings, a serene governor of affairs of state, his demeanor suggesting Olympian detachment. The word today has come to mean, more often than not, an elected leader, a globe-trotting diplomat shuttling from crisis to crisis, or sometimes the mastermind of a recent revolution. Even looks are deceiving. The man who came closest in recent years to resembling the stereotypical statesman was Lord Louis Mountbatten. His aristocratic bearing and royal lineage was faithful to the traditional image, but to me he seemed more a modern-day soldier of fortune, a man who would have been at home as a swashbuckling captain of an eighteenth-century frigate. Statesmanship today, as everything else, is more informal. The rules of protocol are stretched as far as the leader wishes, to reveal, perhaps, his sense of humor – Prime Minister Trudeau pirouetting in Buckingham Palace; his vanity – Brezhnev wanting to look "as beautiful as Audrey Hepburn"; his unself-consciousness – Khrushchev donning a fur coat that he knew would make him look more like a roly-poly Russian bear than the Chairman of the Supreme Soviet, and Castro peeling off his green army tunic for the photographer.

Even the necessary formality and heavy security of the Oval Office is often relieved by the informality of the man occupying it. President Kennedy did not hesitate to exchange neckties with me when he realized his own was not suitable for a color portrait. After I helped her select her gown, Betty Ford then made me her dancing partner in a carefree impromptu waltz around their private presidential quarters. Jimmy and Rosalynn Carter graciously invited me to tea at the White House the afternoon before our photography session so that we could get to know each other better. And even after a strenuous schedule, Ronald Reagan could not resist telling me a choice anecdote or two. I remember these moments as warm, reassuring glimpses into the playful and humane side of our leaders.

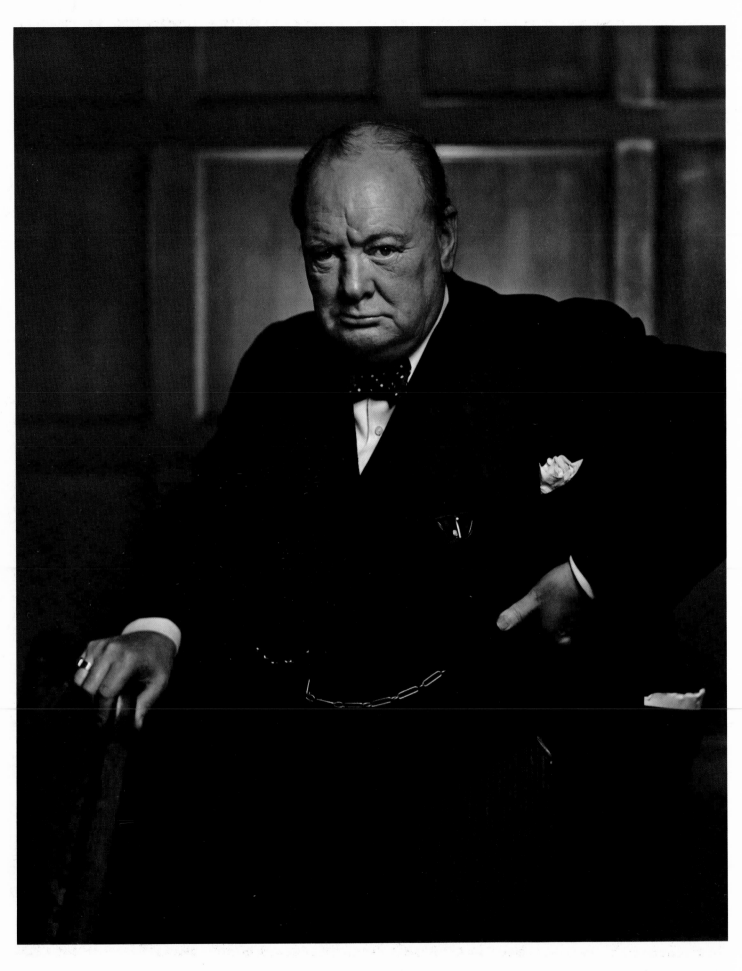

Winston Churchill
1941

My portrait of Winston Churchill changed my life. I knew after I had taken it that it was an important picture, but I could hardly have dreamed in 1941 that it would become one of the most widely reproduced photographs in the history of photography. Soon after the Japanese attacked Pearl Harbor, Churchill visited first Washington, where he delivered a memorable speech in which he referred eloquently to his American heritage, and then Ottawa, where he addressed the Canadian Parliament. The Prime Minister, Mackenzie King, invited me to be present, and to observe Churchill's expressions, moods, and attitudes. The moment of inspiration came when Churchill referred to the French generals who, after the fall of Paris, commented on what they considered England's futile decision to fight on alone, prophesying, "In three weeks' time, England will have her neck wrung like a chicken." Churchill's emphatic rejoinder, "Some chicken, some neck!" was accompanied by a defiant and confident stance.

After the electrifying speech I waited in the Speaker's Chamber where, the evening before, I had set up my lights and camera. The Prime Minister, arm-in-arm with Churchill and followed by his entourage, started to lead him into the room. I switched on my floodlights; a surprised Churchill growled, "What's this, what's this!" No one had the courage to explain. I timorously stepped forward and said, "Sir, I hope I will be fortunate enough to make a portrait worthy of this historic occasion." He glanced at me and demanded, "Why was I not told?" When his entourage began to laugh, this hardly helped matters for me. Churchill lit a fresh cigar, puffed at it with a mischievous air, and then magnanimously relented: "You may take one." But to get

the giant to walk grudgingly from his corner to where my lights and camera were set up some little distance away was a feat! To this day I consider it my greatest diplomatic triumph. Churchill's cigar was ever present. I held out an ashtray, but he would not dispose of it. I went back to my camera and made sure that everything was all right technically. I waited; he continued to chomp vigorously at his cigar. I waited. Then I stepped toward him and, without premeditation, but ever so respectfully, I said, "Forgive me, sir," and plucked the cigar out of his mouth. By the time I got back to my camera, he looked so belligerent he could have devoured me. It was at that instant that I took the photograph. The silence was deafening. Then, Mr. Churchill, smiling benignly, said, "You may take another one." He walked toward me, shook my hand, and said, "You can even make a roaring lion stand still to be photographed." In my archives, the photograph of Churchill is filed under "The Roaring Lion."

Edward R. Murrow, upon seeing the Roaring Lion, remarked, "Here was the man who marshalled the English language and sent it into battle when we had little else."

Winston Churchill
1941

For my second photograph Churchill was smiling and benign. This one was a favorite of his family, but I did not publish it for some years.

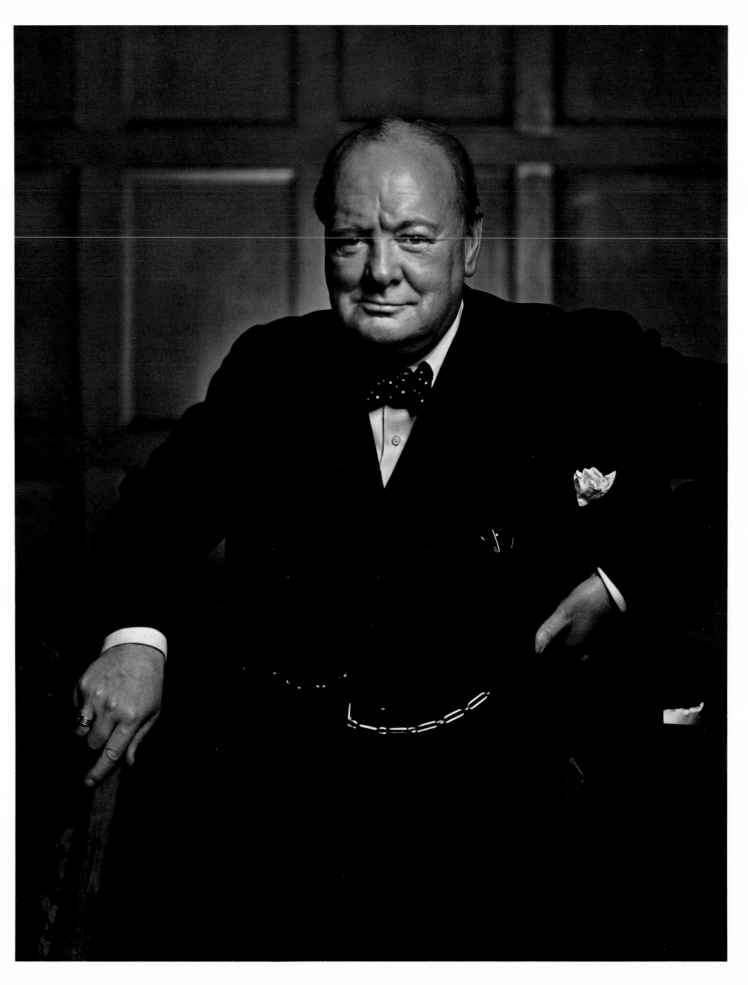

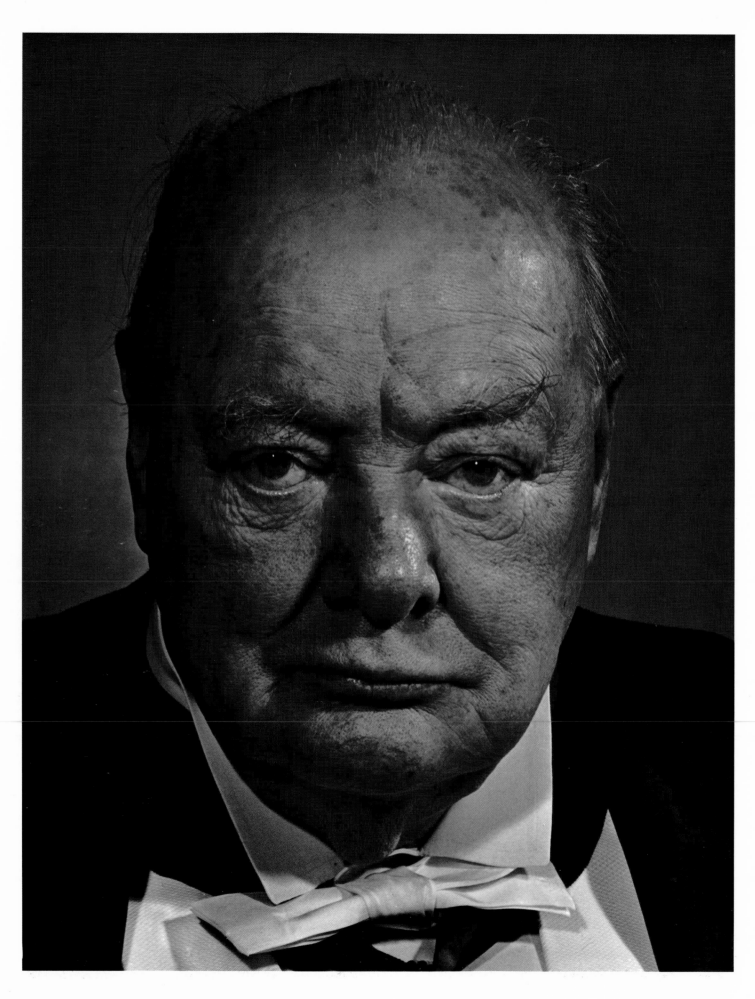

Winston Churchill
1956

Fifteen years later, Churchill was still England incarnate. Older now and tired, but wise, experienced – and immortal.

Dwight D. Eisenhower
1946

As the Supreme Commander of the Allied Expeditionary Forces, Eisenhower appeared confident and imperturbable – his calm face and clear eyes reflecting a man certain of his course. Although he had witnessed intimately the tragedy of war, he had strong faith and trust in mankind. When I sent him a print of this photograph, he wrote me at some length of his "belief that through universal understanding and knowledge there is some hope that order and logic can gradually replace chaos and hysteria in the world."

I photographed Eisenhower as President, and later in retirement at Gettysburg, where he was pursuing his new hobby of oil painting. President Eisenhower had a twinkle in his eye as he watched my reaction to the painting on his easel – a portrait of Sir Winston Churchill, unmistakably inspired by my portrait of the great man that was propped up beside it.

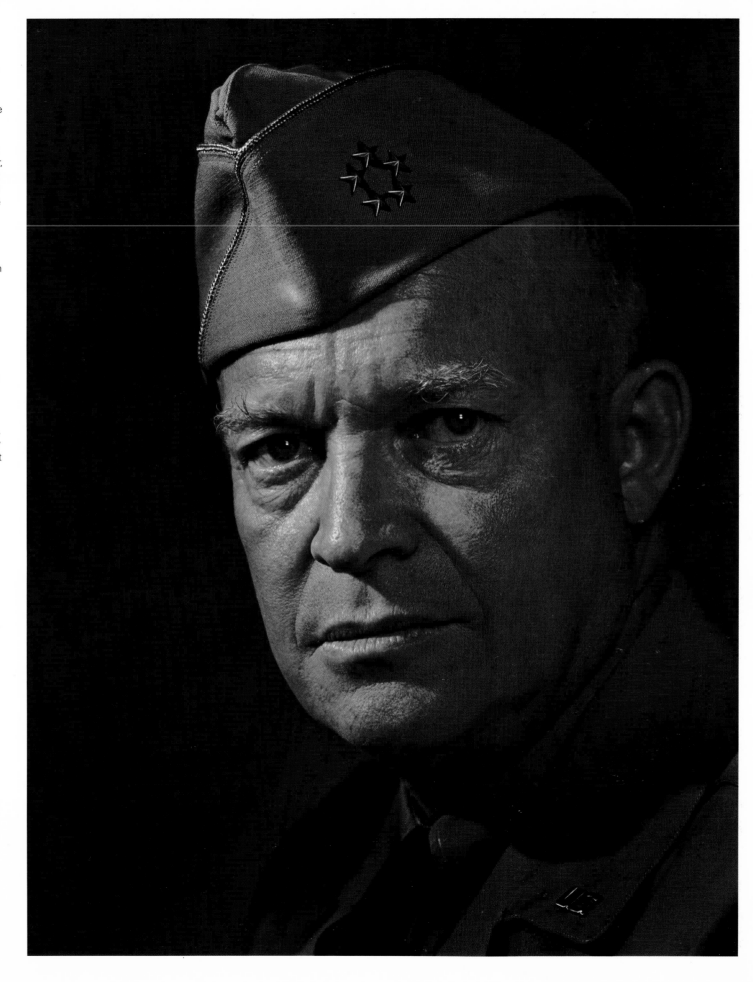

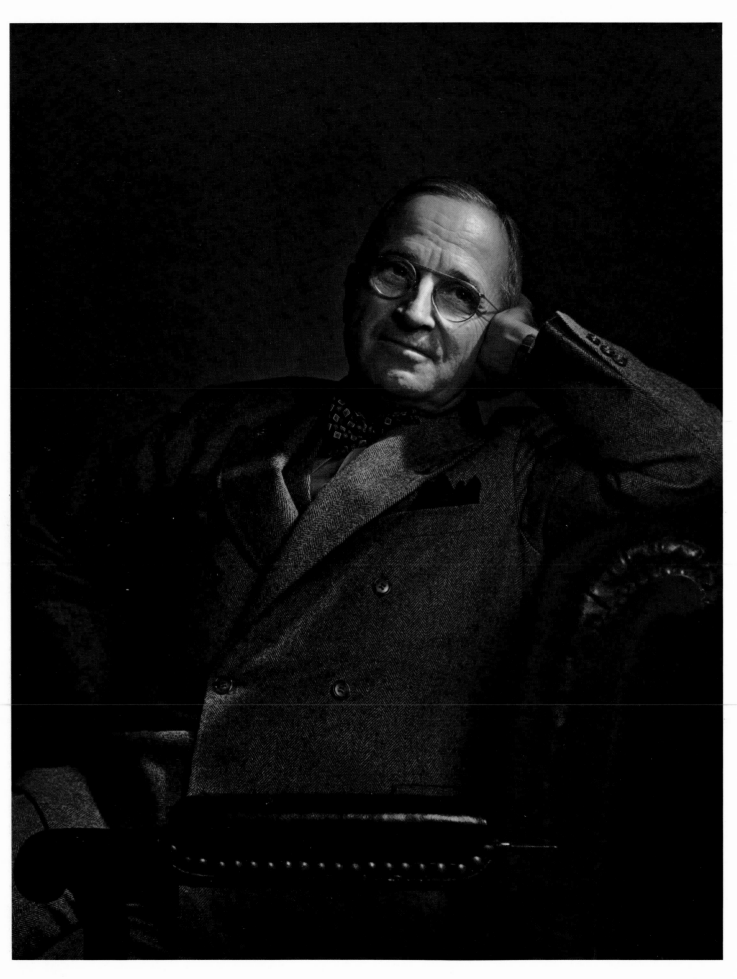

Harry S. Truman
1948

He made one of the most momentous decisions in the history of man – to drop the atomic bomb. He recalled MacArthur, the implacable general, hitherto seemingly invulnerable to authority. He was short of temper, long on common sense, and his outward image of the haberdasher from Independence, Missouri was belied by his political sophistication and acute human judgments.

King Faisal
1945

Faisal was Saudi Arabian foreign minister, not yet king, when he came to San Francisco as his country's principal delegate at the inception of the United Nations. When I asked him why, of all the delegates, he was the only one who had not yet delivered a speech, he replied, "Public speaking is like the winds of the desert: it blows constantly without doing any good."

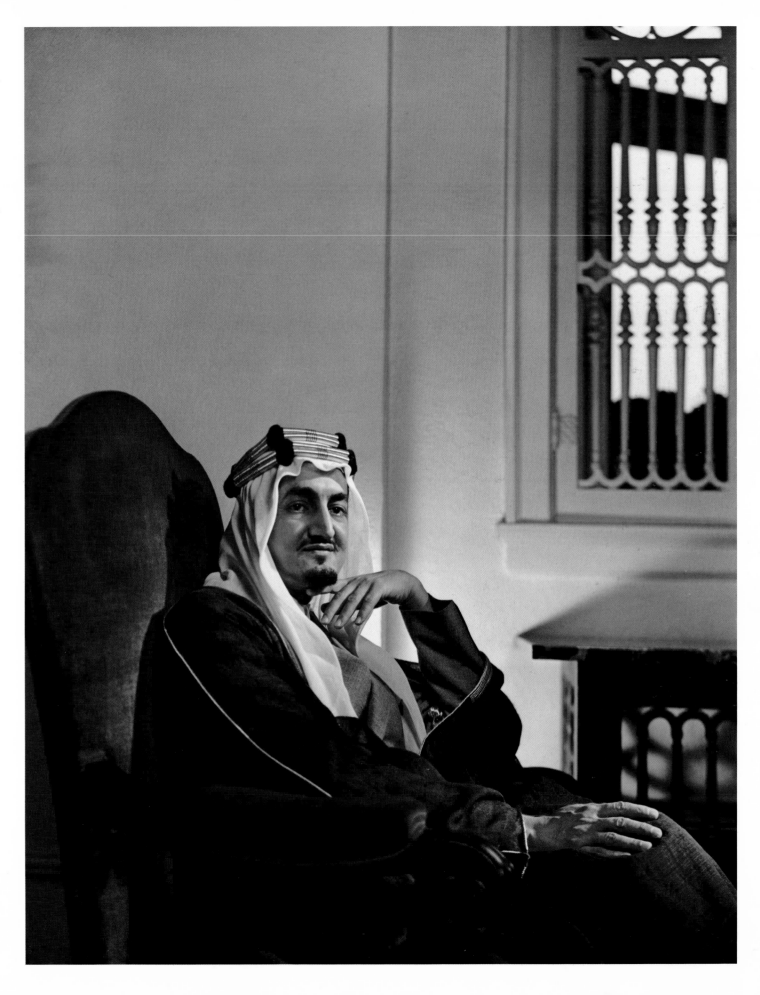

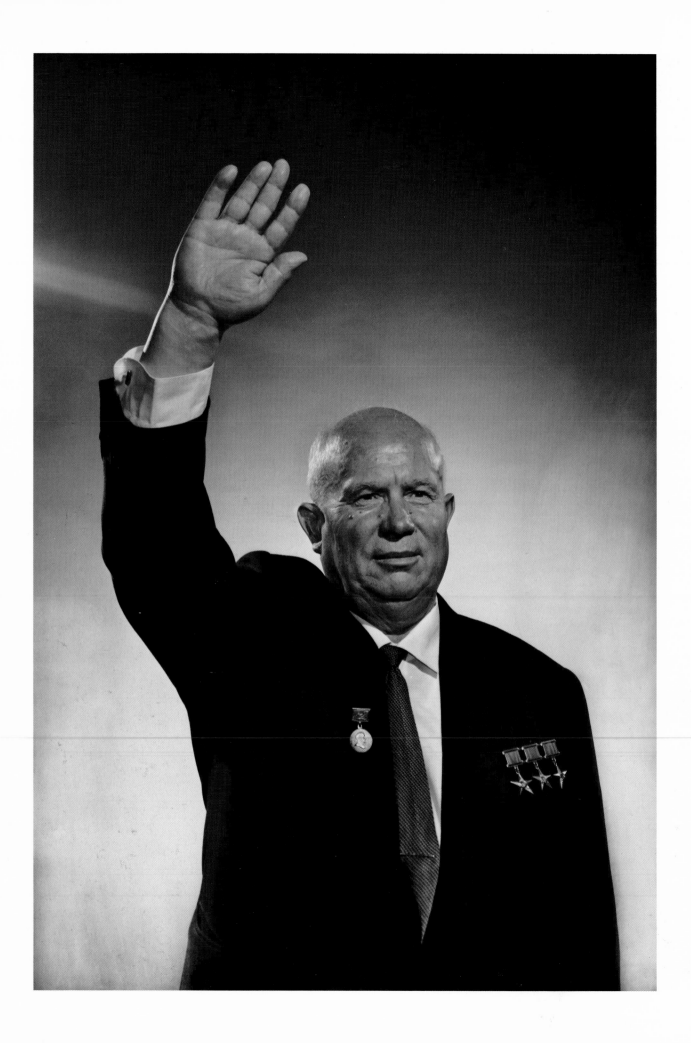

Nikita Khrushchev
1963

In 1963 I had already spent three weeks in the U.S.S.R., photographing their men of letters, scientists, Cosmonauts, artists, and dancers, when the invitation arrived for which I had been waiting – to photograph Chairman Khrushchev, who had just returned from vacation near the Black Sea. On April 21, Moscow's first real spring day, two closed Zim limousines transported us to Khrushchev's official *dacha* (country home) outside Moscow. There, to my surprise and delight, not only the Chairman, but his entire family, came to greet us. Access to Khrushchev was accomplished after many preliminary interviews by the foreign office: Precisely how much time did I require with the Chairman? I answered, ''I had half a minute with de Gaulle, an hour with President Kennedy, and two days each with Sibelius, Casals, and Schweitzer. If you will take an average of these times, that will suffice for the Chairman.'' But time limitations seemed to be the last thing on Khrushchev's mind during our session. The moment I saw Khrushchev walking with his three-year-old grandchild skipping ahead of him, I felt that his portly figure demanded a large fur coat. But Mrs. Khrushchev, who was entertaining my wife, demurred: It was springtime, she said, the fur coat was in mothballs in Moscow. His aides were too abashed to do anything to help. I bided my time, and after making formal photographs, ended with one showing the jovial wave of greeting.

I then switched off the lights and, to the shock of his official translator, I said, "I am now addressing myself to the Chairman of the U.S.S.R. I would like the biggest fur coat possible." "Why not? Why not?" agreed the Chairman. Within twenty minutes the largest fur coat I have ever seen appeared as if by magic. Khrushchev also sent for a stocking cap. The Chairman smiled and said, "You must take the picture quickly or this snow leopard will devour me." Mrs. Khrushchev refreshed her memory. As the mountain of fur passed by, she remarked, "Ah, *that* fur coat! Prime Minister Macmillan of England wore it when he and my husband went tobogganing. And"—political acumen laced with concern—"Mr. Macmillan fell off and my husband did not!"

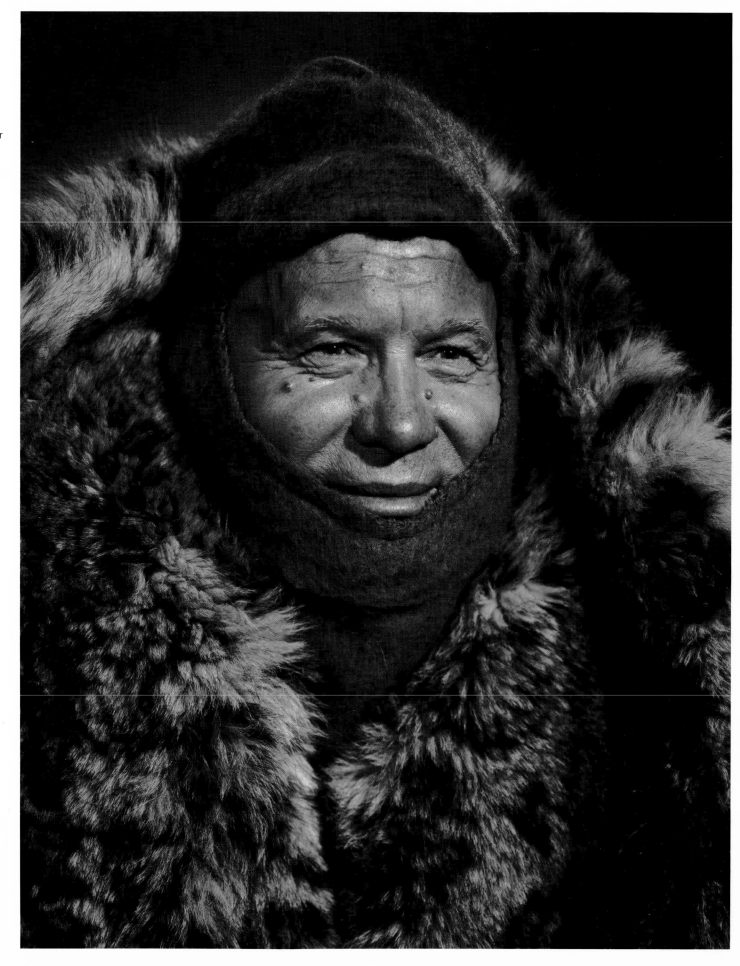

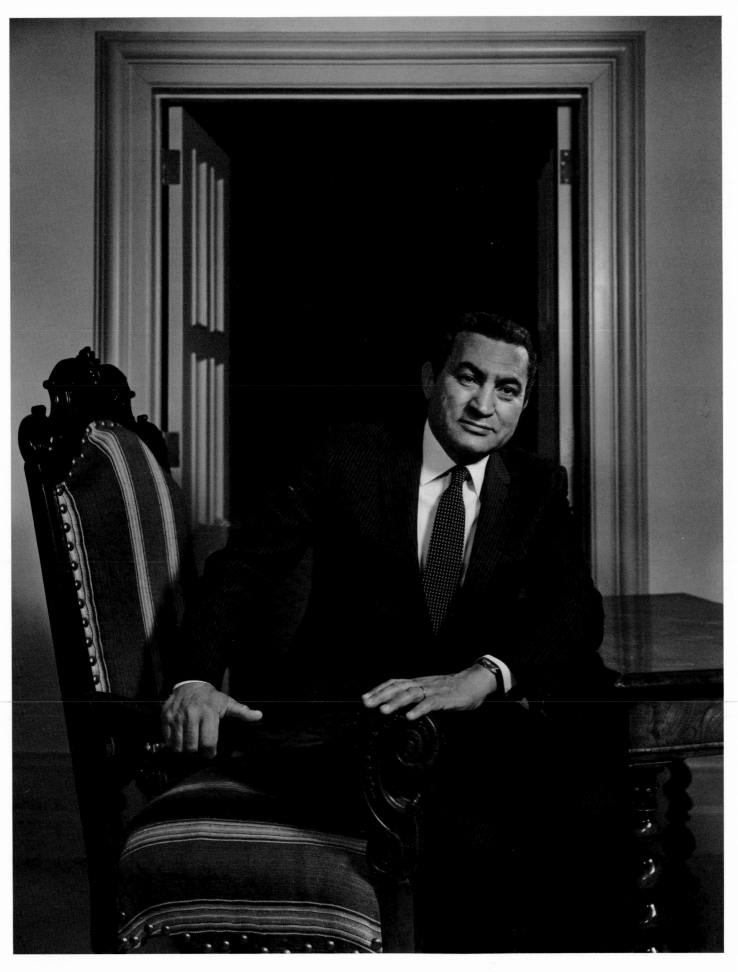

**Muhammad
Hosni Mubarak
1983**

I photographed the President
of Egypt on his first official
visit to Canada. My impres-
sion was of a man of determi-
nation, strength, and dignity,
posed and reflective.

John F. Kennedy
1960

During our photographic session, President-elect Kennedy seemed completely able to throw off political concerns and constant interruptions, and concentrate completely on the job of the moment. That day, ironically, I photographed both President-elect Kennedy and Vice President-elect Lyndon Johnson. Johnson came into the room and Kennedy turned his gaze on his Vice President as the photograph was taken – a poignantly prophetic note.

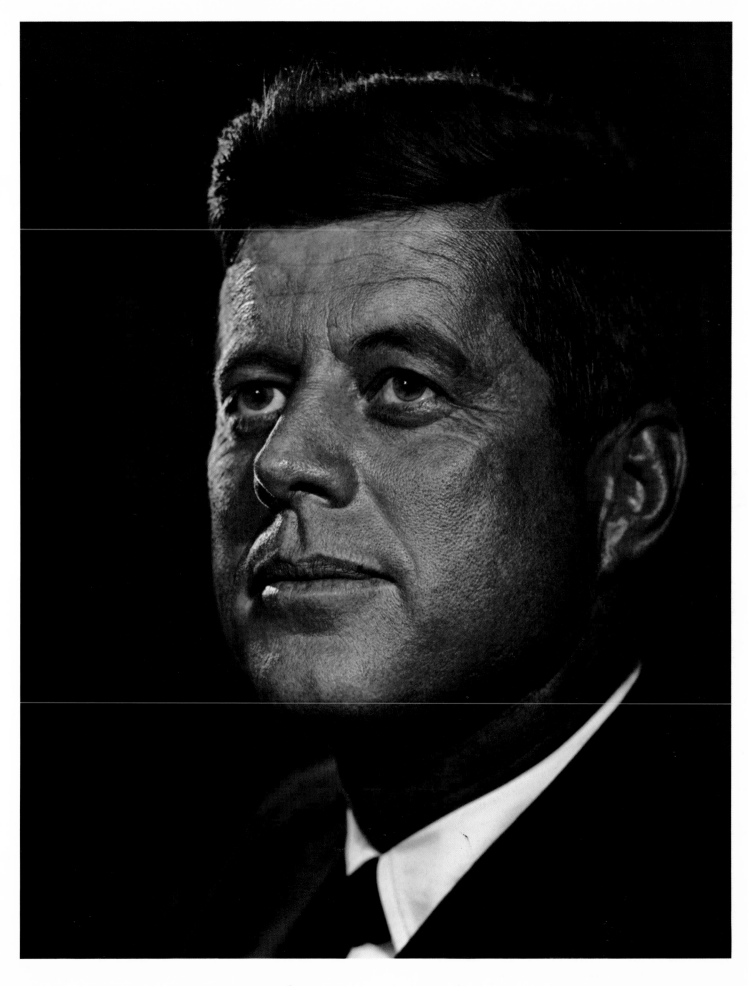

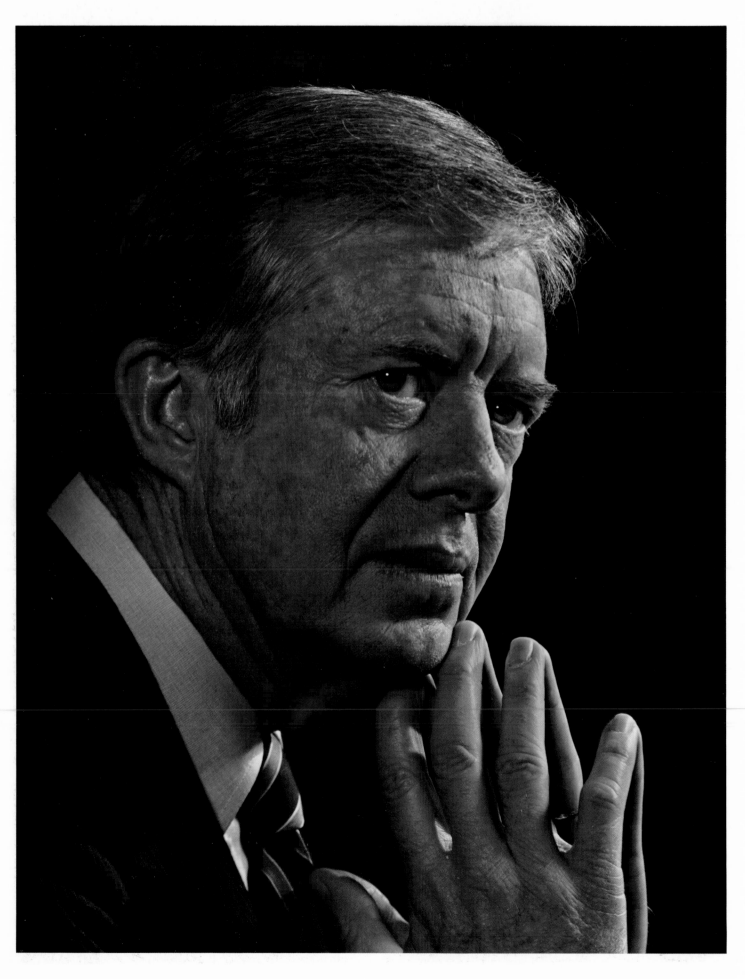

Jimmy Carter
1981

He seemed to exemplify the American Horatio Alger dream when, as a relative political unknown, he became the thirty-ninth President of the United States.

Anna Eleanor Roosevelt
1955

During the war in Vietnam, I received a request from a sergeant for my photograph of Mrs. Roosevelt. It intrigued me that a young man would be interested in a First Lady who was in the White House before he was born, and I wrote asking the sergeant about it. He replied that he was not a "young man," but rather a career soldier. He told of being a patient in a Korean military hospital ward, where the broken and wounded soldiers viewed the impending visit of the globe-trotting President's widow with a mixture of ridicule, guffaws, and defensive cynicism. In the end, of her sincerity, compassion, and tender concern, which had an intense impact on each war-hardened man, he wrote, "When she came in, I thought she was the home-liest woman I had ever seen – and when she left, the most beautiful!"

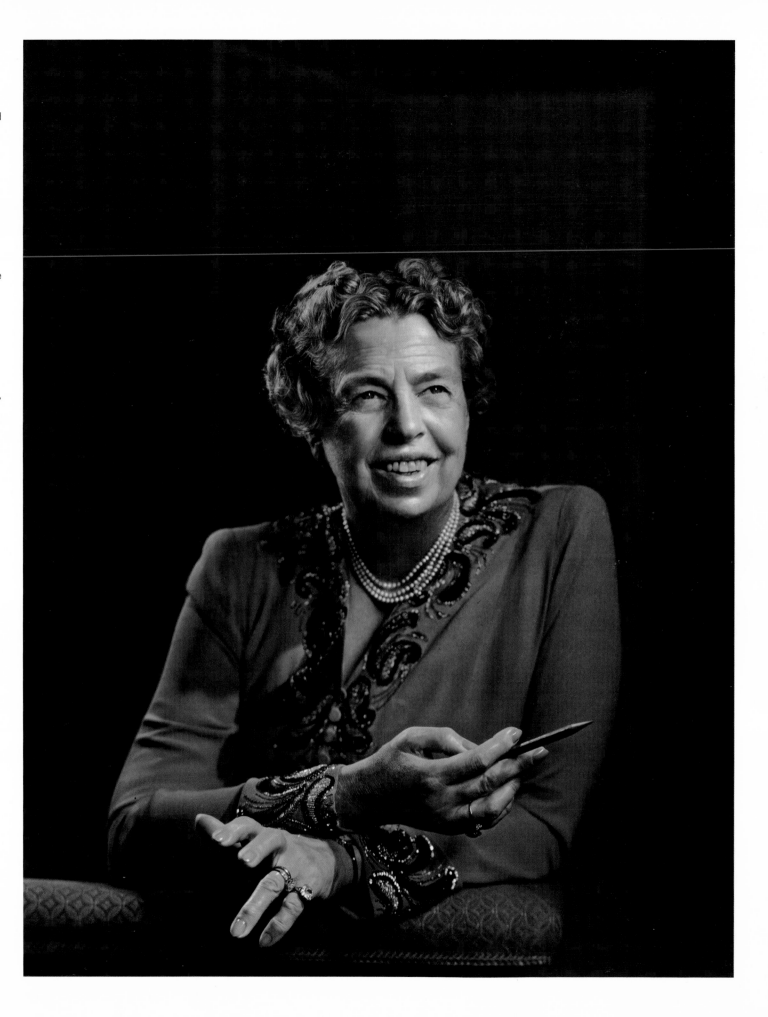

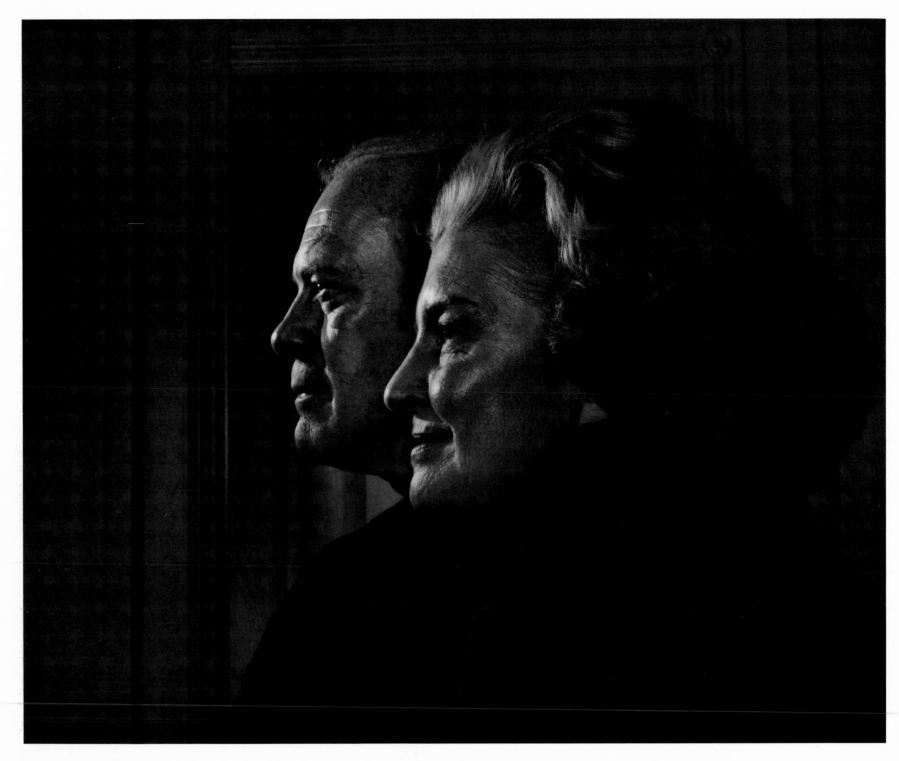

Gerald Ford and Betty Ford
1977

A straightforward, principled man of honor, Gerald Ford reassured the nation and restored its faith after the trauma of Watergate. Betty Ford's personal courage and refreshing candor – and her gift of sharing herself – opened the doors of self-help and understanding to millions. This portrait was chosen by the Fords for the Gerald R. Ford Museum in Grand Rapids, Michigan.

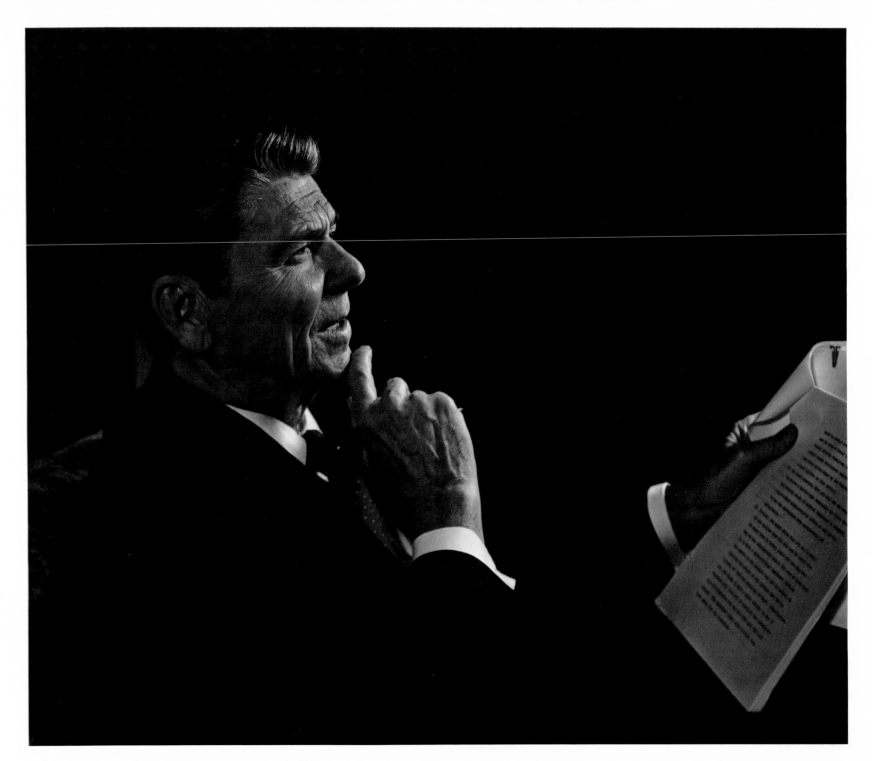

Ronald Reagan
1982

The day I photographed the President he had accepted the resignation of Richard Allen as national security adviser, sworn in William Clark as his successor, and spent a two-hour working lunch with German Chancellor Helmut Schmidt – and still had enough resiliency to tell me two humorous anecdotes before our lengthy portrait-session.

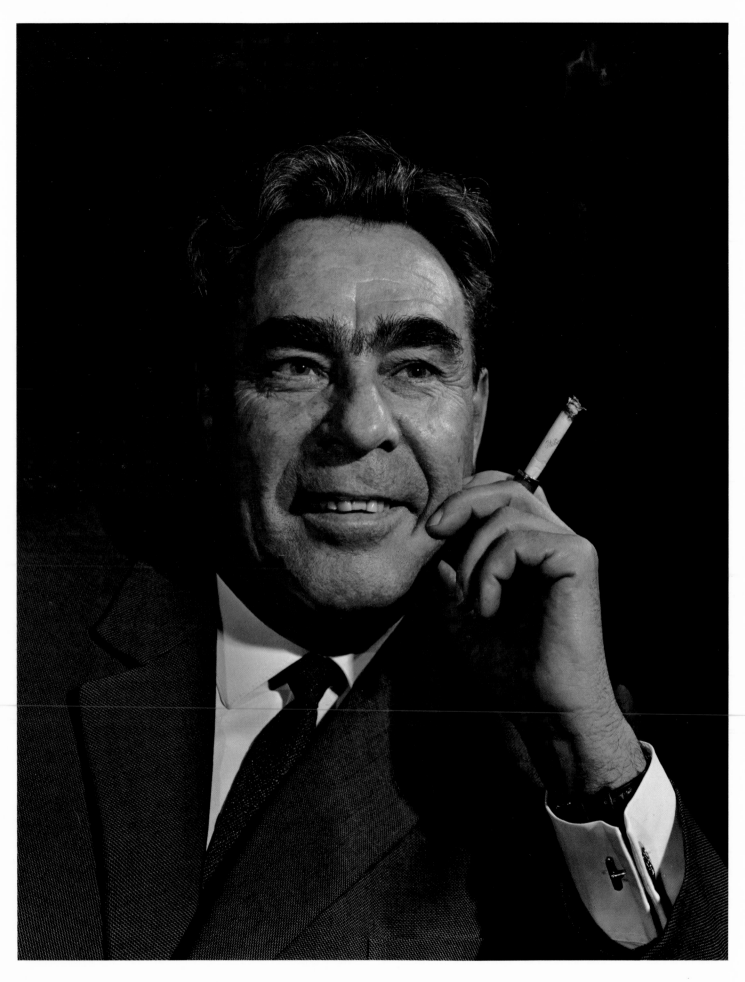

Leonid Brezhnev
1963

Khrushchev introduced me to the man who was to succeed him as Chairman of the Supreme Soviet. Brezhnev's commanding presence and immense self-confidence were lightened by his humor, his interest in fashionable clothes, and his knowledge of Hollywood movie stars.

Fidel Castro
1971

I arrived in Havana on the twenty-sixth of July, Cuba's national holiday since the revolution, in time to hear this magnetic speaker address thousands of people. It was a short speech—only two and a half hours, instead of Castro's customary six. The crowd screamed its support as he lauded Cuban solidarity, punctuating every new thought with his finger. He was dressed in army fatigues, with the ever-present cap on his thick black hair. Señora Celia Sanchez, his wiry, energetic Secretary of State, was my companion and tour guide for the next three days through Havana and the Cuban countryside. From the two or three places she offered for photography, I chose a simple ceremonial room with a few bookshelves, its stark walls suggesting a barracks. It turned out to be Castro's favorite office. I was anxious up until the moment of photography; not until the eleventh hour before my scheduled departure did the eagerly awaited telephone call come from the foreign office that Castro was ready.

Castro arrived looking grave and tired, taller and more imposing than he appears in photographs. He shook my hand warmly, apologized for the delay and, with a gesture of weariness, removed his belt and pistol and placed them beside him. When I suggested that he might try to recapture the spontaneity of those first few moments, he said charmingly, "I am sorry, I cannot. I am not a good enough actor; I cannot play myself." Our session lasted three and a half hours, punctuated by refreshments of Cuban rum and Coke.

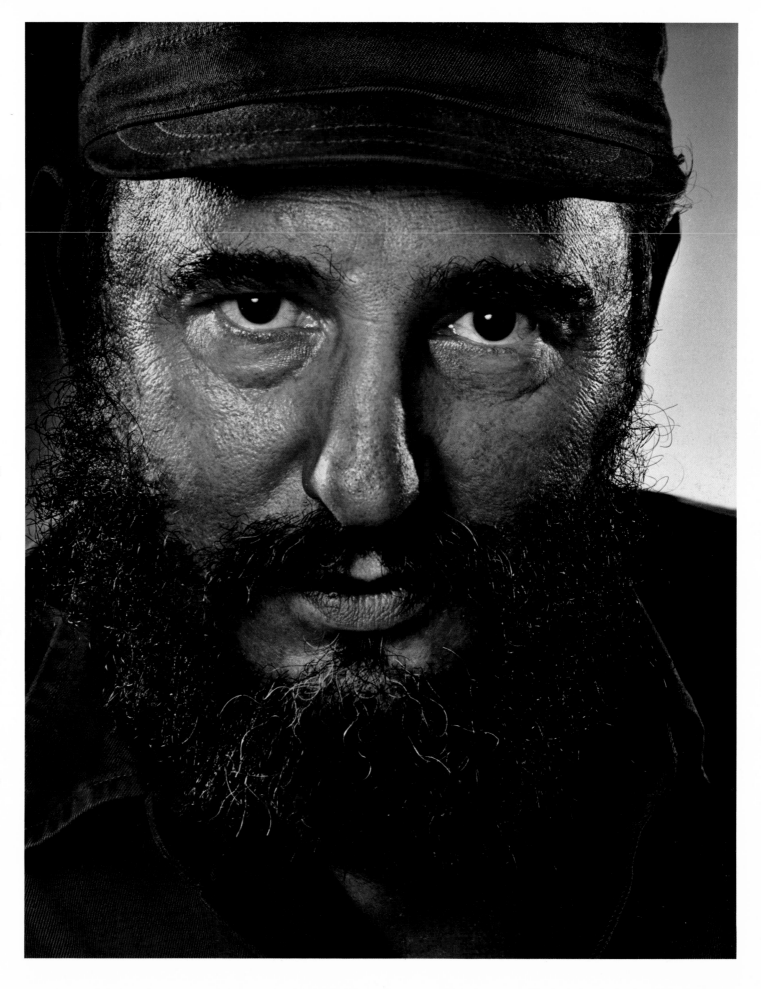

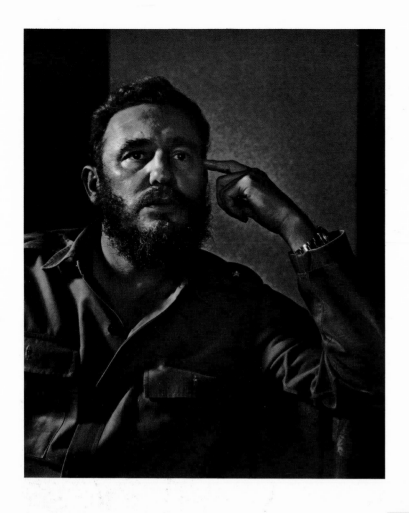
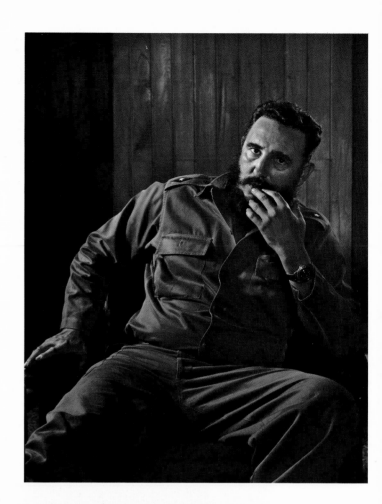
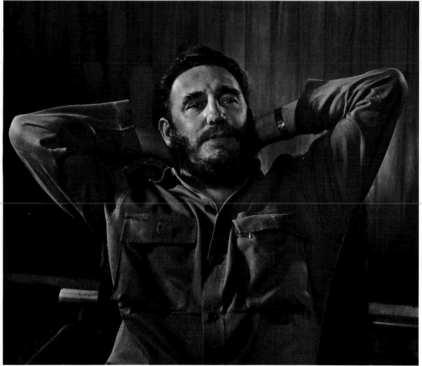

Fidel Castro
1971

Castro's range of literary and cultural interests recalled the middle-class Cuban youth who read widely and studied law. He wanted to know about my experiences with Helen Keller, Churchill, Camus, Cocteau, and most of all about Hemingway, whose home near Havana is a shrine. I was impressed that Castro – now a revolutionary – should still have room in his life for these humanitarians.

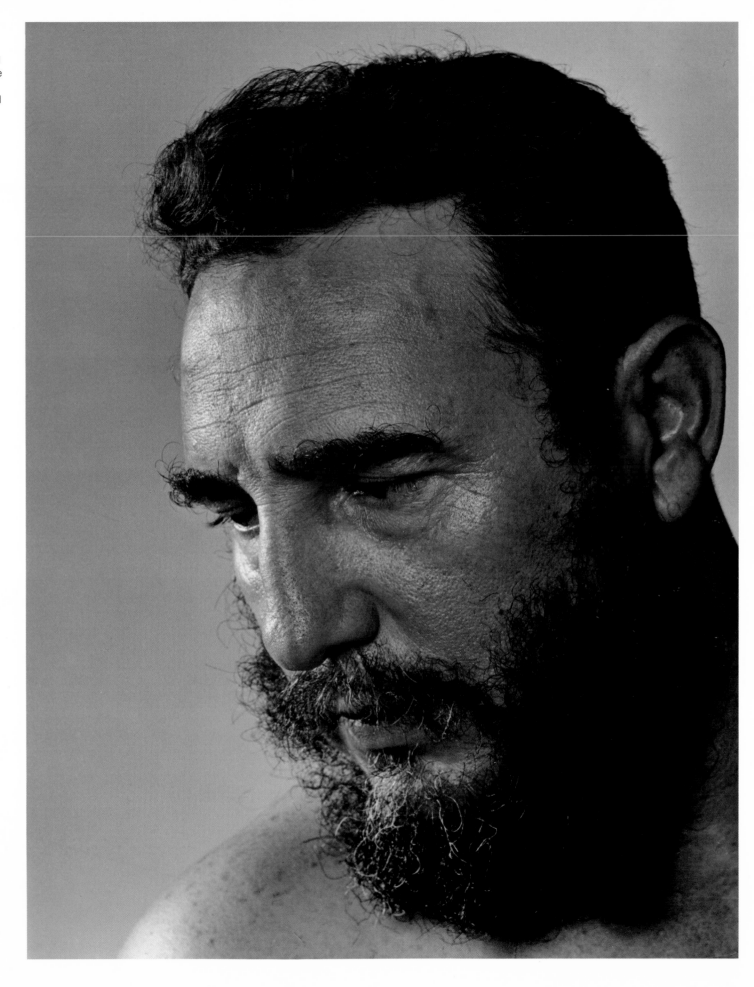

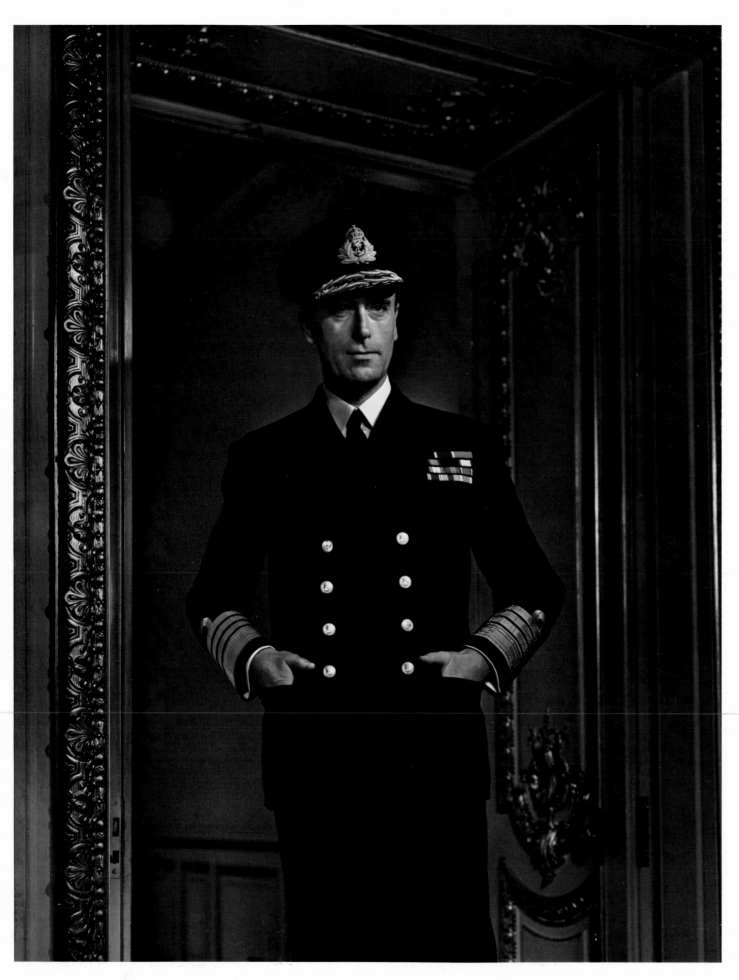

Lord Louis Mountbatten
1943

This was among the first photographs I made during my wartime trip to London. (I was to photograph Lord Mountbatten again, at his invitation, on several other occasions in Canada and England.) During our session, Lord Mountbatten told me of his elation when a long-awaited prototype model of a new aircraft carrier was finally brought to him. Nothing would do but to demonstrate it immediately to the Prime Minister. To Mountbatten's question, "Where is the old man?" the reply was that the "Old Man is in his bath." Rushing past Churchill's astonished valet, he came upon a soaking Prime Minister, who was understandably taken aback. But when Mountbatten floated the little model in Churchill's bathwater, exclaiming, "We've got it at last, sir! This might well be the turning point of the war!" Churchill was all smiles. He proceeded to play with the floating model with childlike abandon, "as if it were a rubber duck."

Margaret Thatcher
1976

Although she was coping with global problems in her office overlooking the Houses of Parliament, England's first woman Prime Minister told me that she had gotten up early, as was her custom, to prepare breakfast for her family.

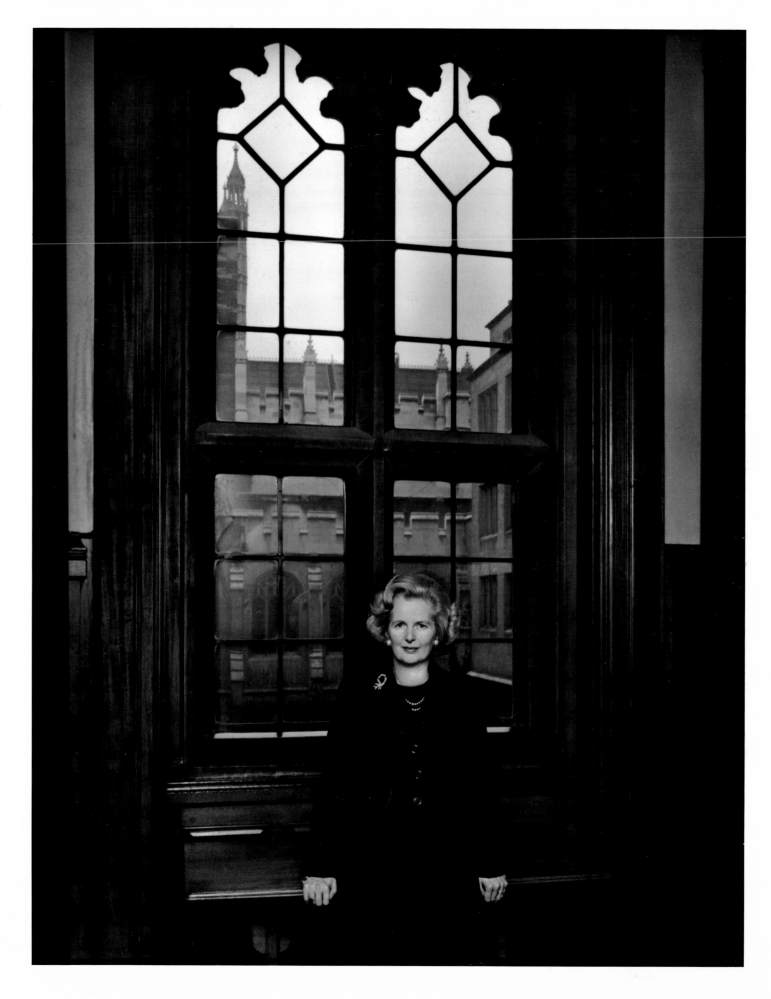

Authors, as a group, are notoriously difficult to categorize. One cannot make sweeping generalizations about their early lives in relation to their work—poverty in childhood may not produce compassion in maturity; about their personalities in relation to their work—an introverted author may write the most Rabelaisian instead of the most introspective of novels; or about their personal relationships with, as the psychology texts put it, "significant others." Stephen Leacock's wit was as whimsical and tongue-in-cheek as his published humor, and Evelyn Waugh was as condescending as his upper-class characters to those he considered his social inferiors—but Ernest Hemingway was the shyest man I ever met. That is why I always look forward to my photographic sessions with authors. Although I have "done my homework" and usually read their books before the sitting, the encounter with the individual personality is always a welcome surprise.

Stephen Leacock
1941

Wit, a quality quite different from humor, constantly bubbled forth even in his casual talk. One evening he decided to take me fishing. Two craft were moored at his dock, a canoe and a motorboat. With my usual impatience, I jumped into the motorboat. "No, no," Leacock shouted, "we're going out in the canoe; I'll paddle." When I asked him the reasons for his choice, he answered: "Because the motorboat always gets there."

After seeing a set of his portraits, he awarded me the Stephen Leacock Non-Existent Gold Medal. Most of these portraits now hang in the library at Leacock's house at Orillia, Ontario, which has been preserved by the Canadian Government as a national shrine.

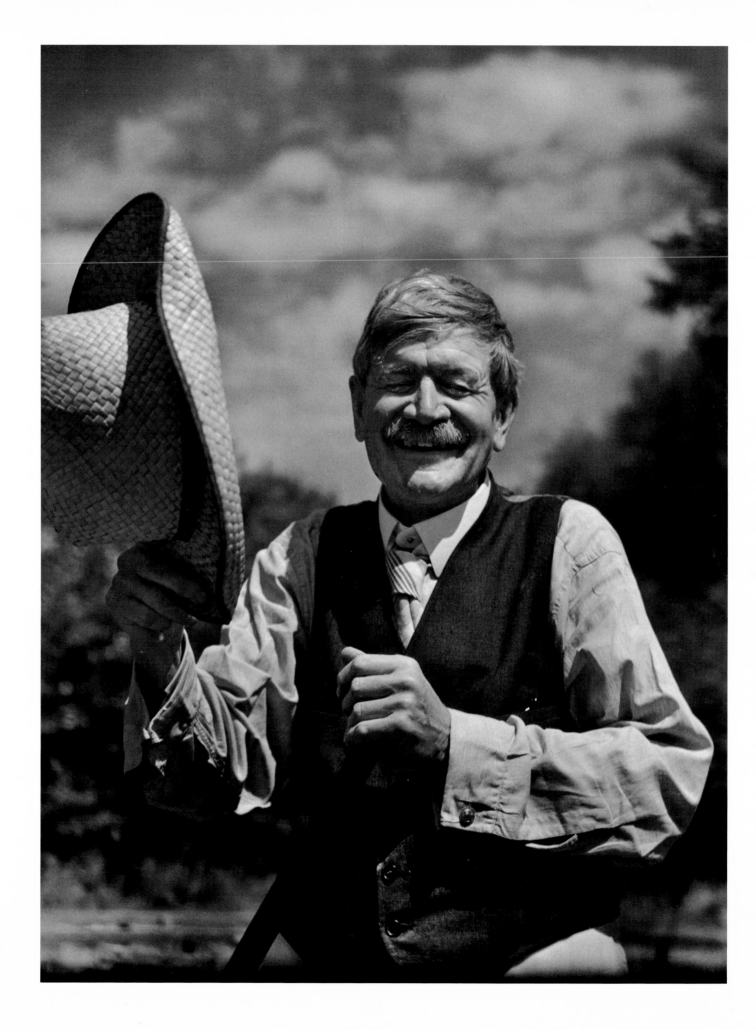

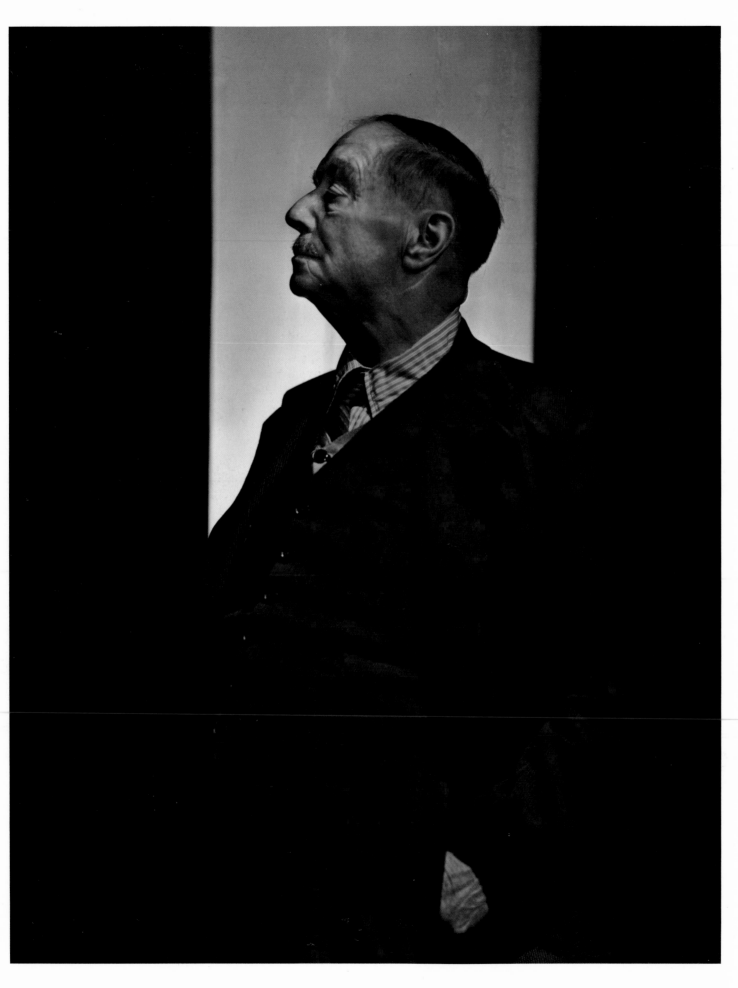

H. G. Wells
1943

When H. G. Wells, the brilliant political journalist and the founder of modern science fiction, met me at his door, his first remarks were about his Irish contemporary George Bernard Shaw, whom I had just photographed. "I see," he sniffed, "you have been wasting your time. When future generations unearth the ruins of London, they will see Shaw photographs, and more Shaw photographs, but, unfortunately, they will take *him* to be the typical Englishman."

The literary rivalry between Shaw, the Irishman from the provinces, and Wells, the London-born former draper's shop assistant, dated from the turn of the century, when the two future prophets of their generation met for the first time as fledgling critics in 1895 at the London premiere of a play by the novelist Henry James.

George Bernard Shaw
1943

Leon Edel, Henry James's biographer, has remarked that Shaw's "way of meeting people was to charm them by being charmed himself." In my first meeting with Shaw he came bursting into the room with the energy of a young man, though he was almost ninety years old. His manner, his penetrating old eyes, his flashing wit, his bristling beard, were all designed to awe me, and in the beginning they succeeded. He obviously loved to act; with me he assumed the role of a harmless Mephistopheles and devil's advocate. He said I might make a good picture of him—but none as good as the picture he had seen at a recent dinner party where he glimpsed, over the shoulder of his hostess, a perfect portrait of himself: "Cruel, you understand, a diabolical caricature, but absolutely true." He had pushed by the lady, approaching the living image, and found he was looking into a mirror! The old man peered at me quizzically to see if I appreciated his little joke. It was then that I caught him in my portrait.

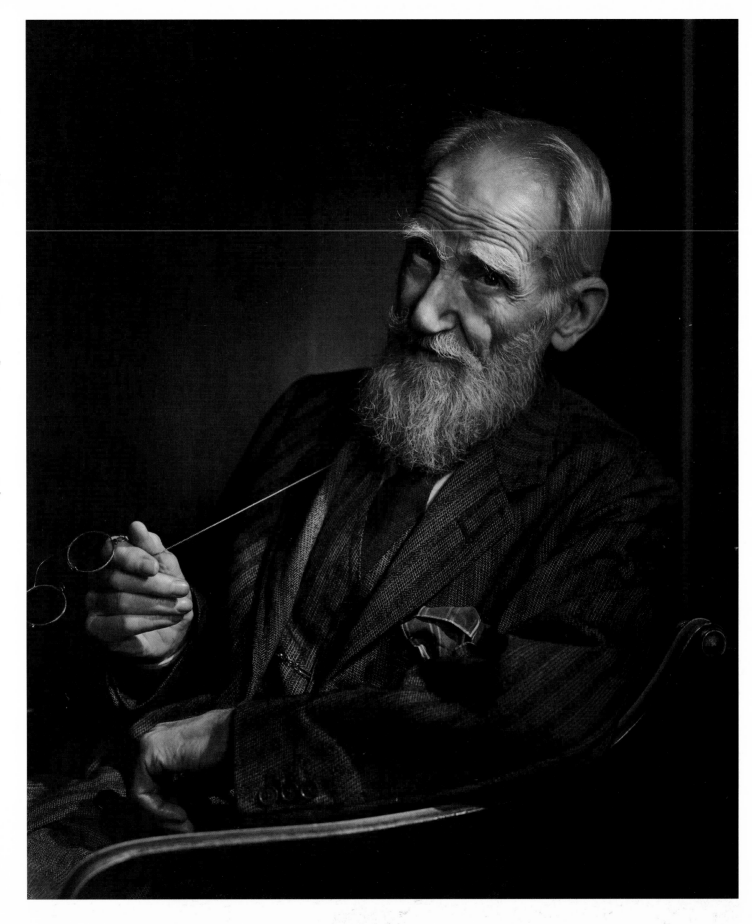

George Bernard Shaw
1943

François Mauriac
1949

Paris was without electric power when I photographed the eminent Catholic writer. My assistant and I had valiantly climbed five endless Parisian flights of stairs with heavy equipment, in the vain hope that electricity would soon be restored. It was late in the afternoon and we would not soon have the opportunity to meet again. So, using a bed sheet borrowed from his housekeeper as a reflector, I caught his aristocratic silhouette in the available light of an open french window.

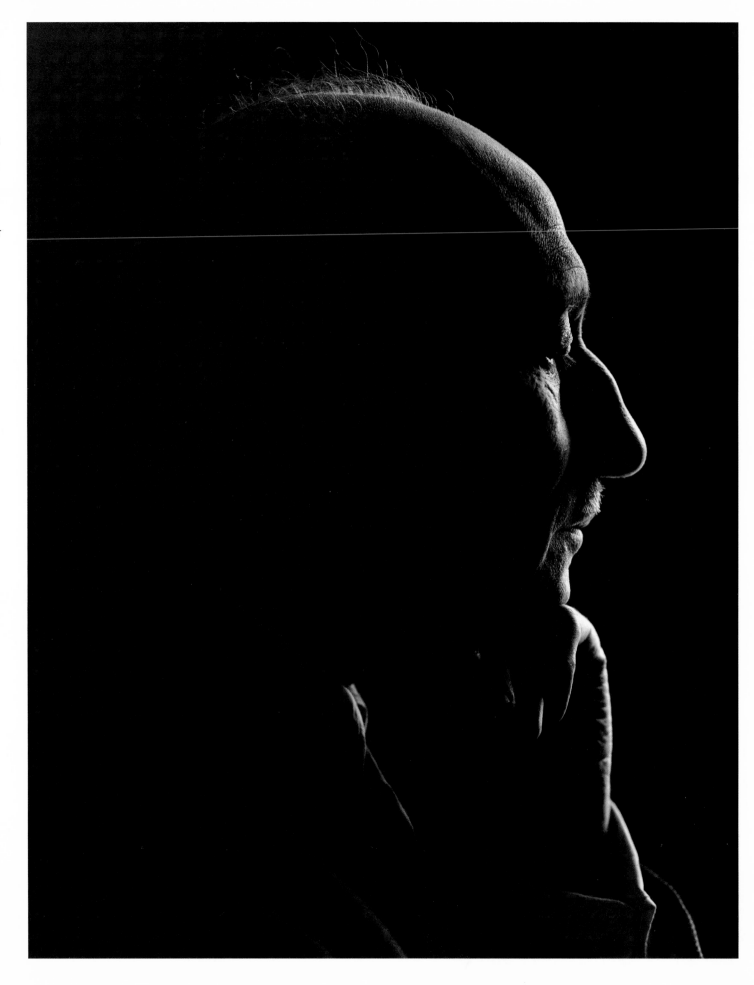

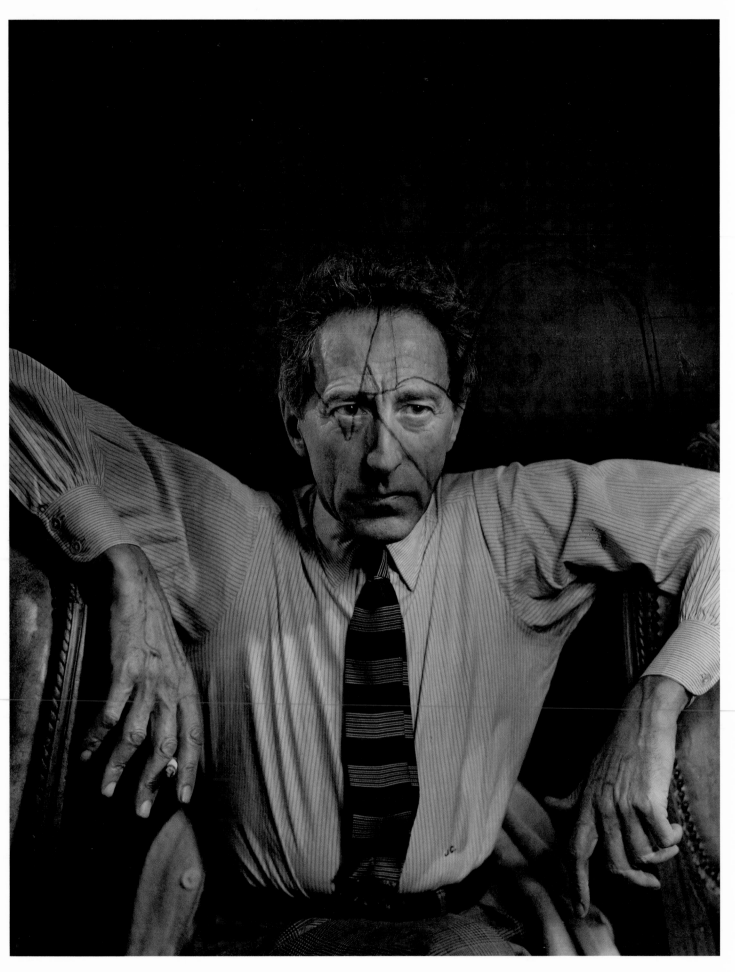

Jean Cocteau
1949

The French master-of-all-arts
—stage and film director,
painter, ceramist, poet—and
insatiable experimenter with
life believed that the state
should subsidize the arts, but
that a creative artist must
never be restricted: "He
must be free to express him-
self without any hindrance
whatsoever."

Albert Camus
1954

The cubicles at Gallimard, Camus's Paris publishers, struck me as an inappropriate setting; his small library, at home, was where he belonged. The Algerian-born novelist, who was awarded the Nobel Prize for Literature in 1957, was strangely prescient about the potential growth of Arab nationalism.

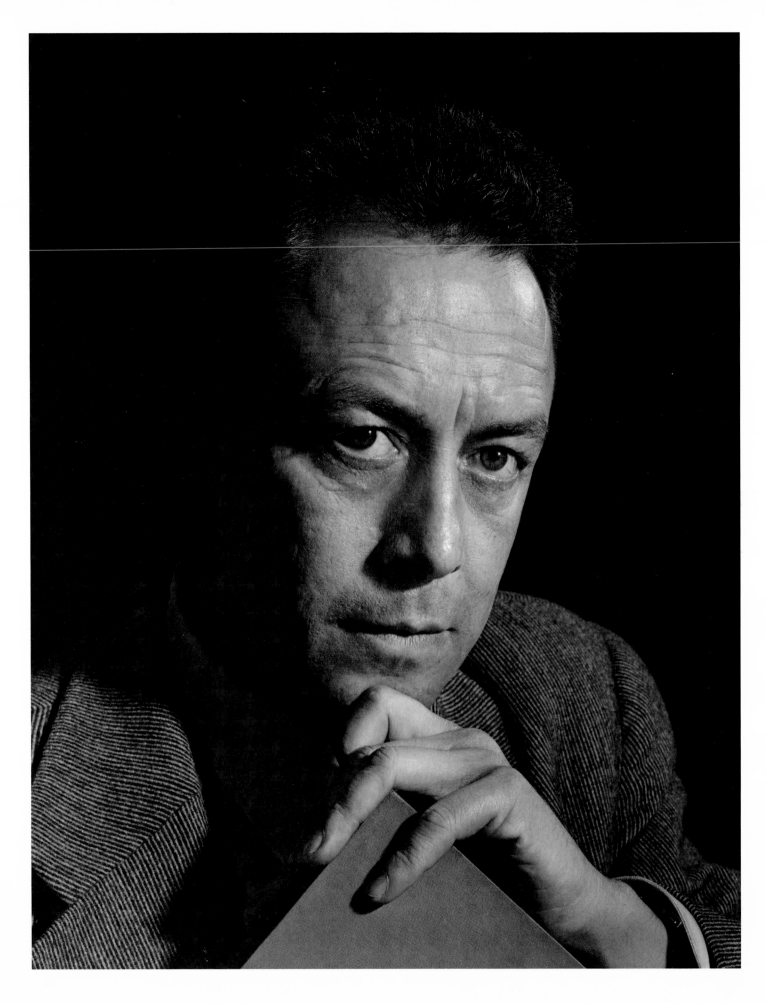

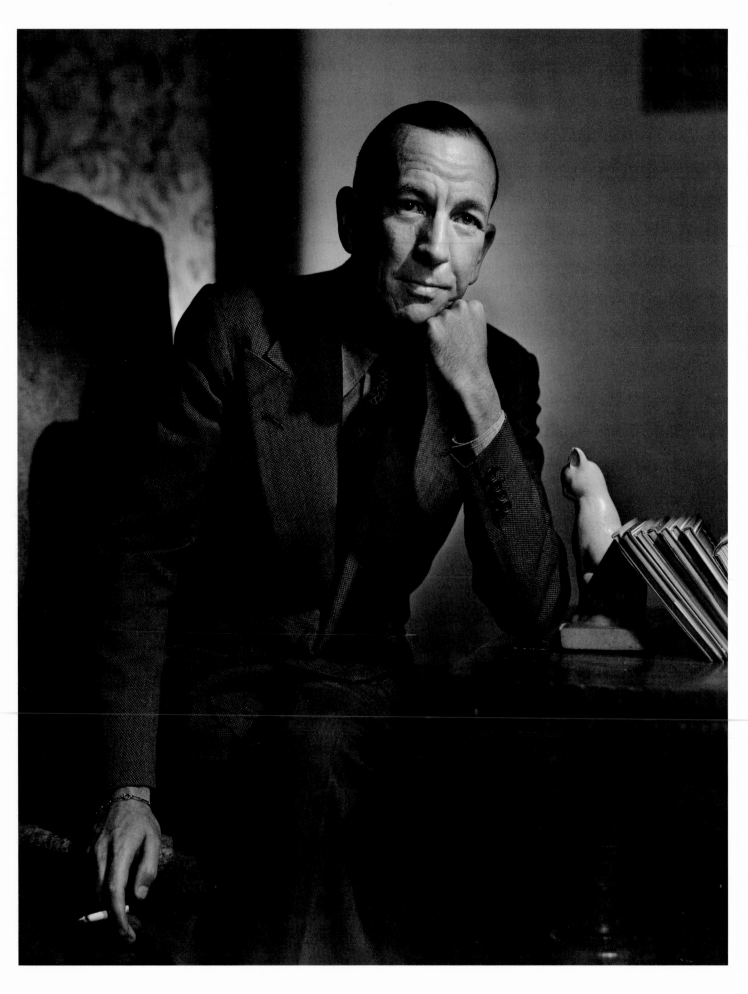

Noël Coward
1943

It was during the London wartime blackout, and the warm elegance of Coward's Mayfair home contrasted sharply with the rubble and gaping holes of the bombed-out streets. This most witty and sophisticated of all theatrical personalities talked with me about his comedy *Blithe Spirit*. Written in less than a week, it was to become the longest-running comedy in British theatrical history. The success of *Blithe Spirit* lifted Coward out of his depression, as he made his emotional transition to the grim reality and letdown of the forties, after the gaiety and the dizzying professional heights of the two previous decades.

W. H. Auden
1972

In Stephen Spender's garden in London, the poet W. H. Auden talked about "coming home." The Oxford University he knew, which he had longed for during bouts of deep nostalgic depression while living in New York, no longer existed for him when he returned to England. He spent two hours talking to my wife – prophetically – about friends who had died. He smoked incessantly, his conversation punctuated by wracking coughs. Meanwhile the light was gone from the garden, and I could take only a quick photograph of a beautiful and ravaged face. "Come soon, come soon," he invited, but I knew I would never see him again.

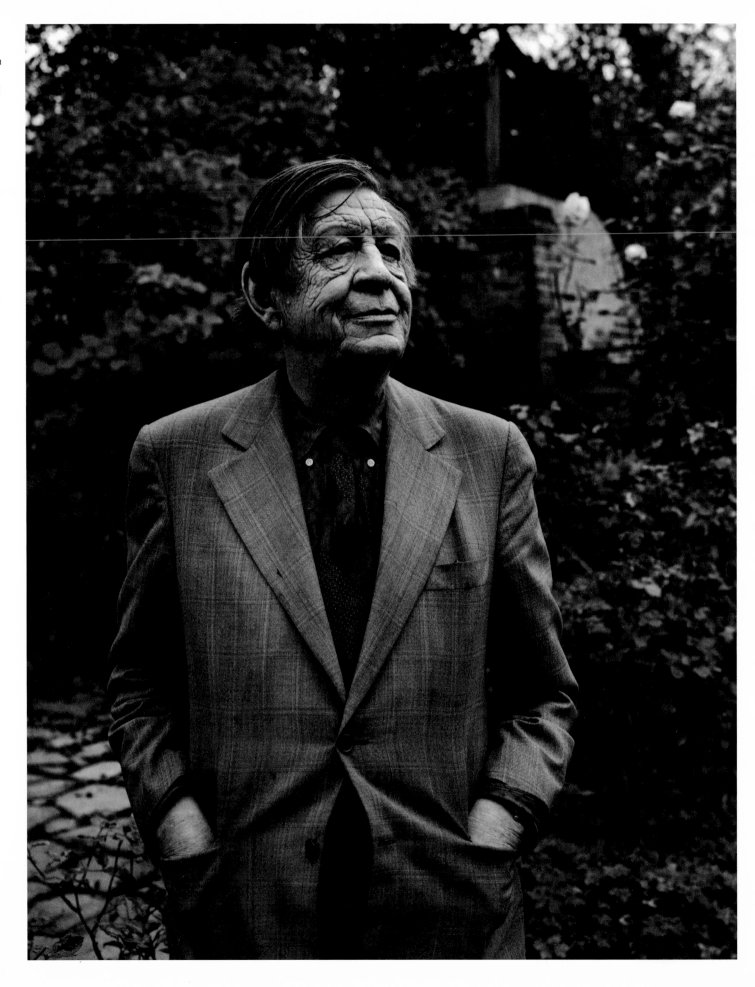

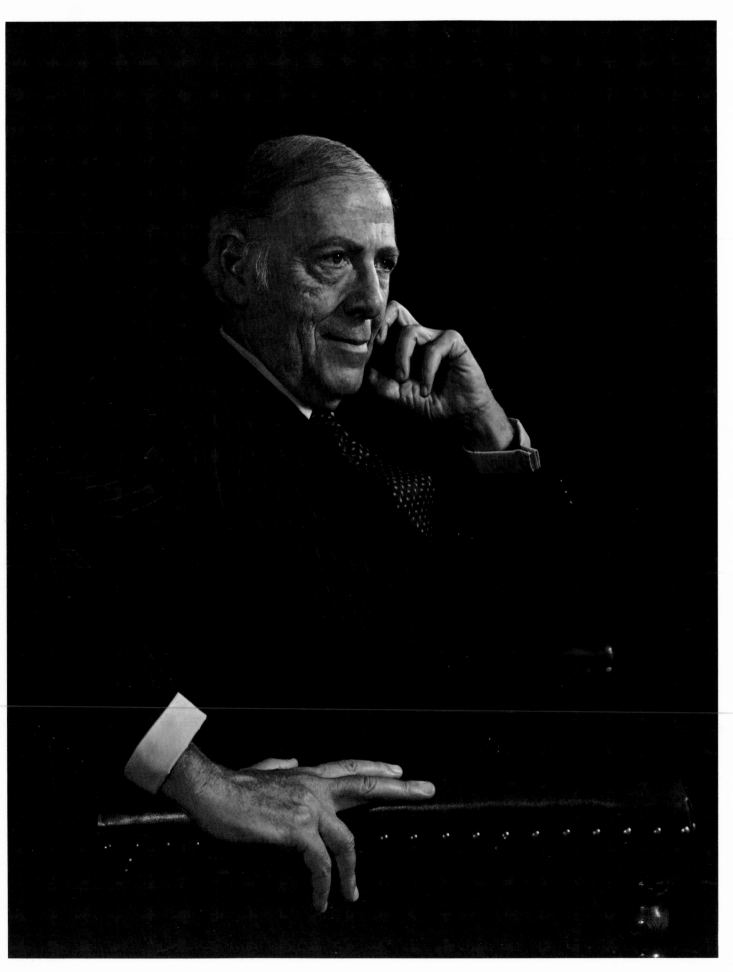

Herman Wouk
1983

What meant most to the author of *The Winds of War* was the appreciation by historians of his meticulous accuracy in depicting the events surrounding World War II.

Helen Keller
1948

On first looking into her blind but seeing eyes, I said to myself of this woman who had no sight or hearing since the age of three, ''Her light comes from within.''

She placed her marvelously sensitive fingers on my face when we met. This was, for me, an emotional experience. I sensed she already knew me.

Her faithful companion, Polly Thompson, dialed Braille into her palm. Helen Keller's kindness and understanding, her alert mind, awed me. I told her this was not the first time we had met, for I knew her through her writing. Among the earliest articles I attempted to read while learning English was her ''How to Appreciate the Beauty of Sunset.'' ''Now having met you in person,'' I said, ''I will no longer think of you in terms of sun*set* but of sun*rise*.'' She quickly replied, ''How I wish that mankind would take the sunrise for their slogan and leave the shadows of sunset behind them.''

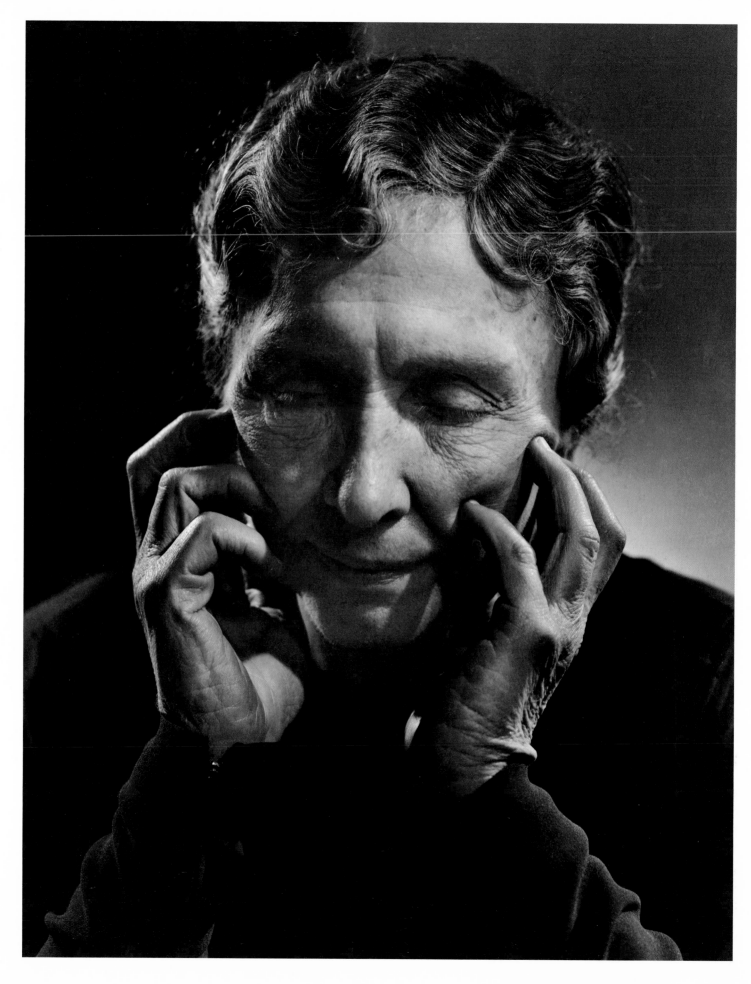

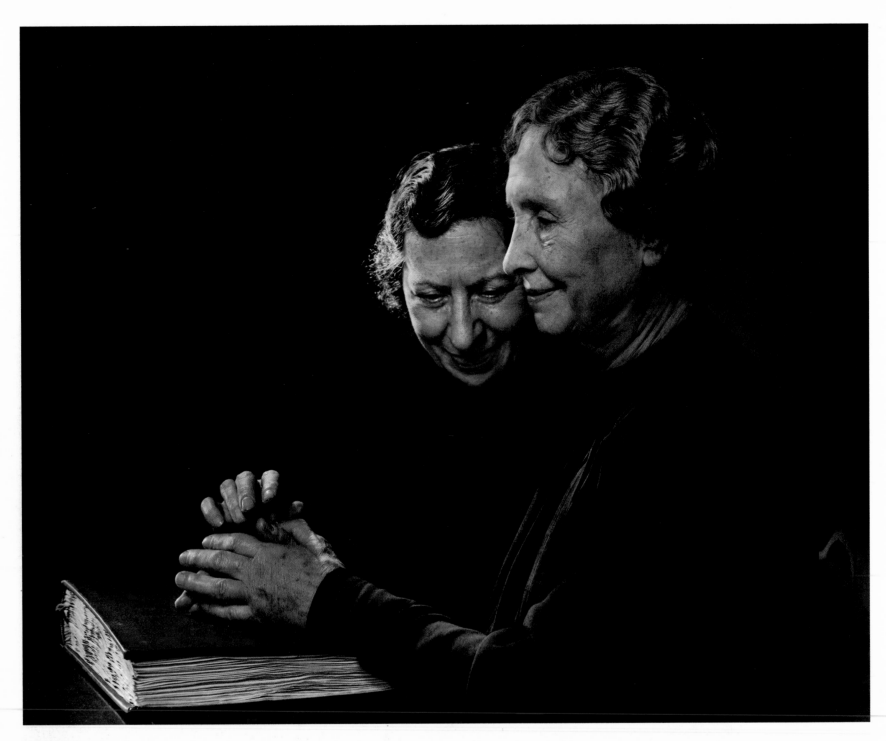

Helen Keller
with Polly Thompson
1948

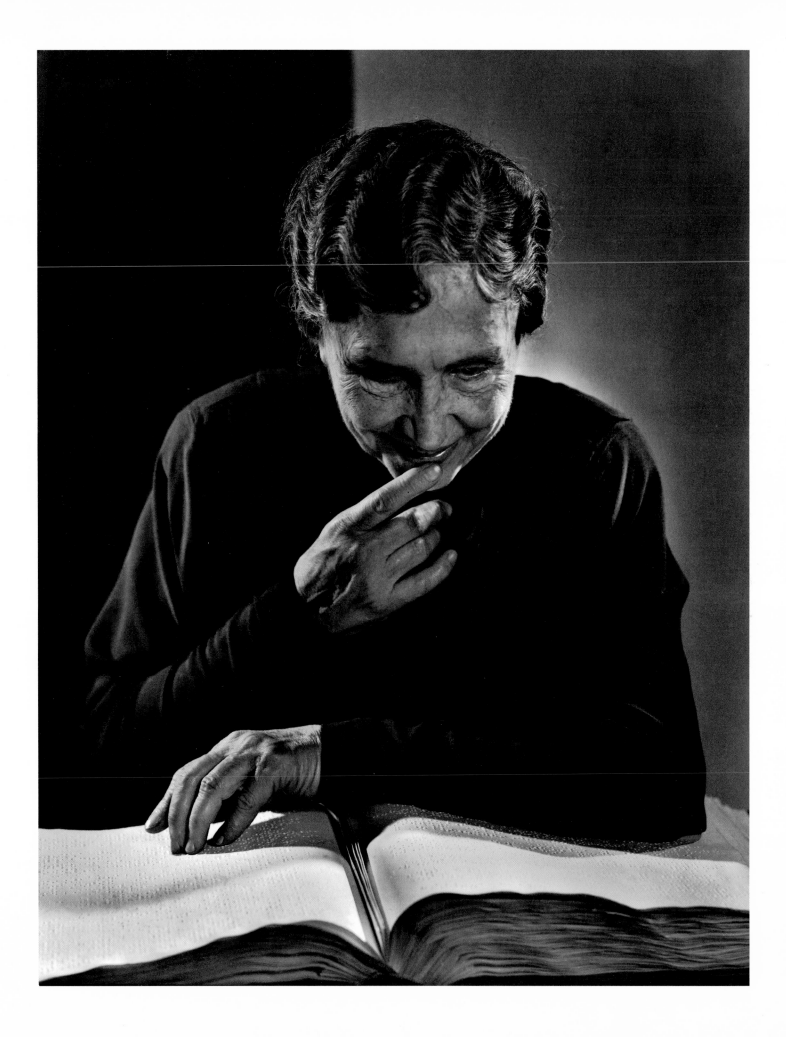

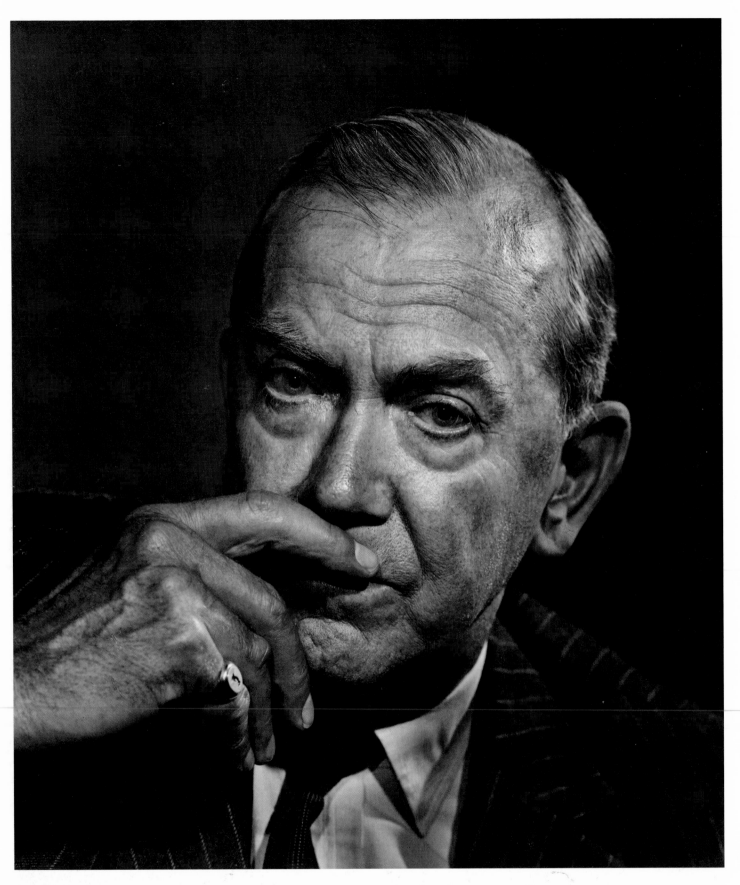

Graham Greene
1964

"Sometimes I wonder," mused the creator of the exalted adventure story, "how all those who do not write, compose or paint ...can manage to escape the madness which is inherent in the human situation."

Margaret Atwood
1977

I photographed this outstanding Canadian author against a circular patchwork quilt crafted in her rural Ontario home. Everything, from its simple furnishings to the duck pond and the fruit trees gracing the property outside, suggested an ideal setting for the concentration and serenity needed for the writer's craft.

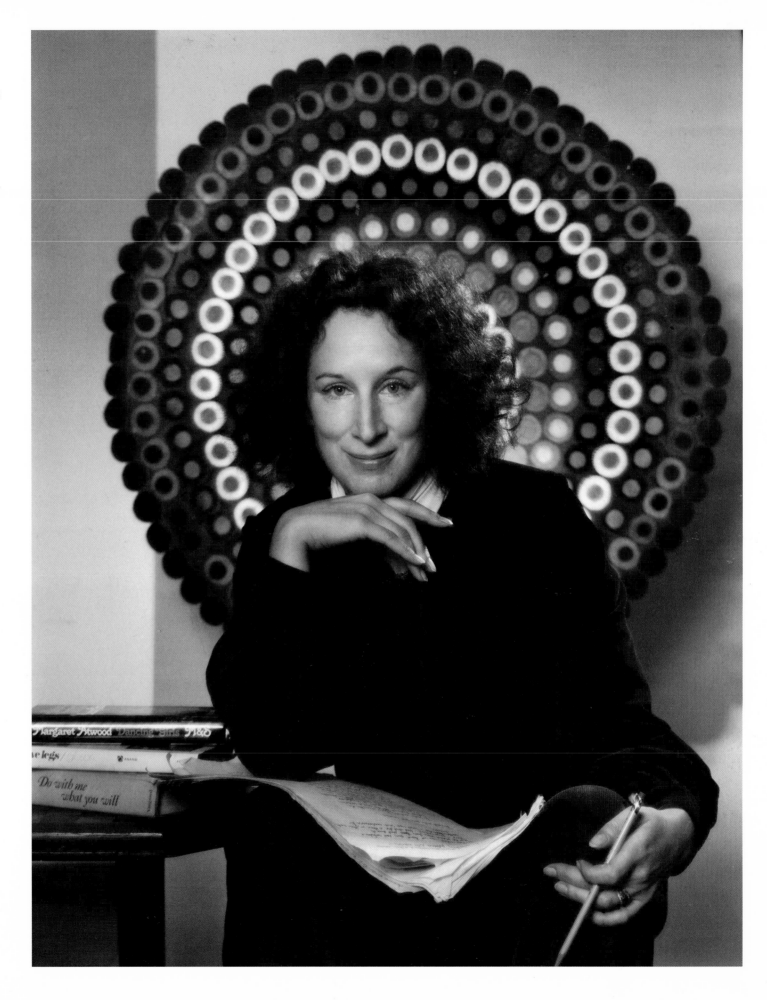

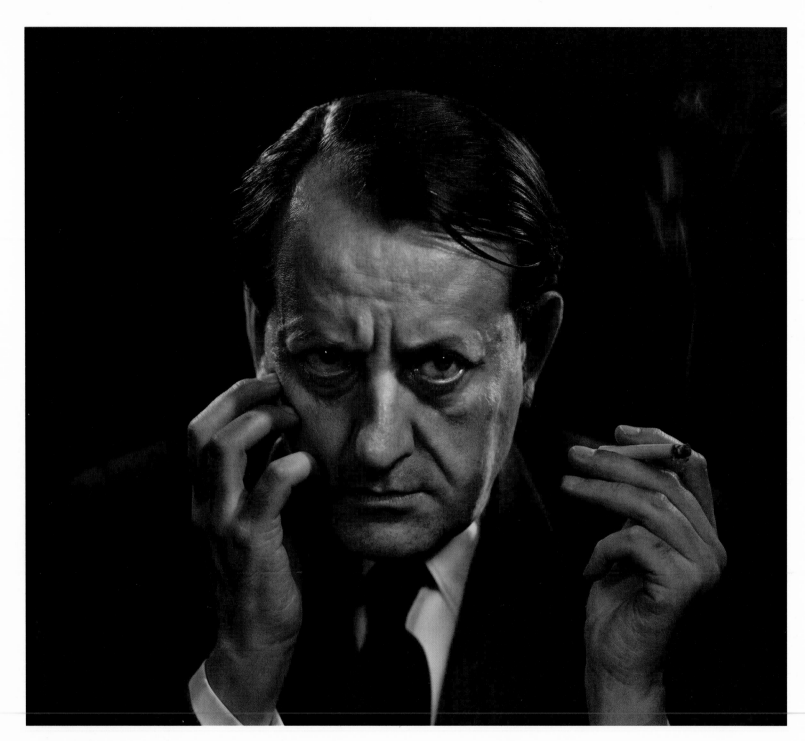

André Malraux
1954

The incredible adventurer, explorer, and Resistance leader. Wounded and taken prisoner in World War II, he was able to return to France. As Minister of Culture he was responsible for restoring the historic monuments of Paris to their original beauty.

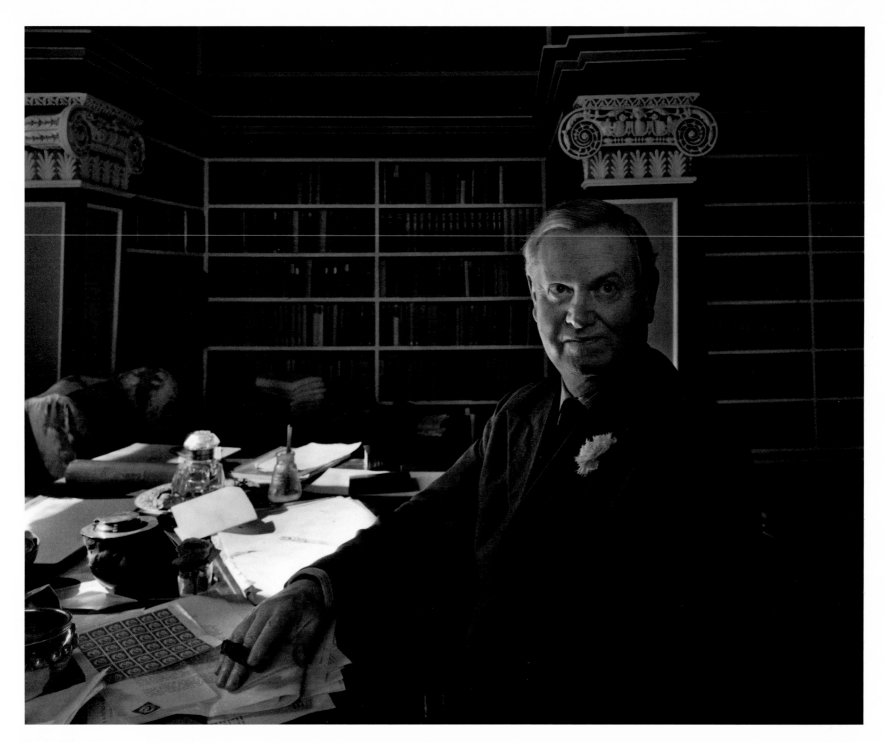

Evelyn Waugh
1964

The author of *Brideshead
Revisited* in the library of his
country estate in Taunton. At
a welcoming gourmet lunch,
he paid finicky attention to
the protocol of dining, the
succession of courses, and
the choice of wine. The quin-
tessential snob, he bounded
down the centuries-old
stone steps to greet us,
but chose to ignore the
extended hand of our driver.

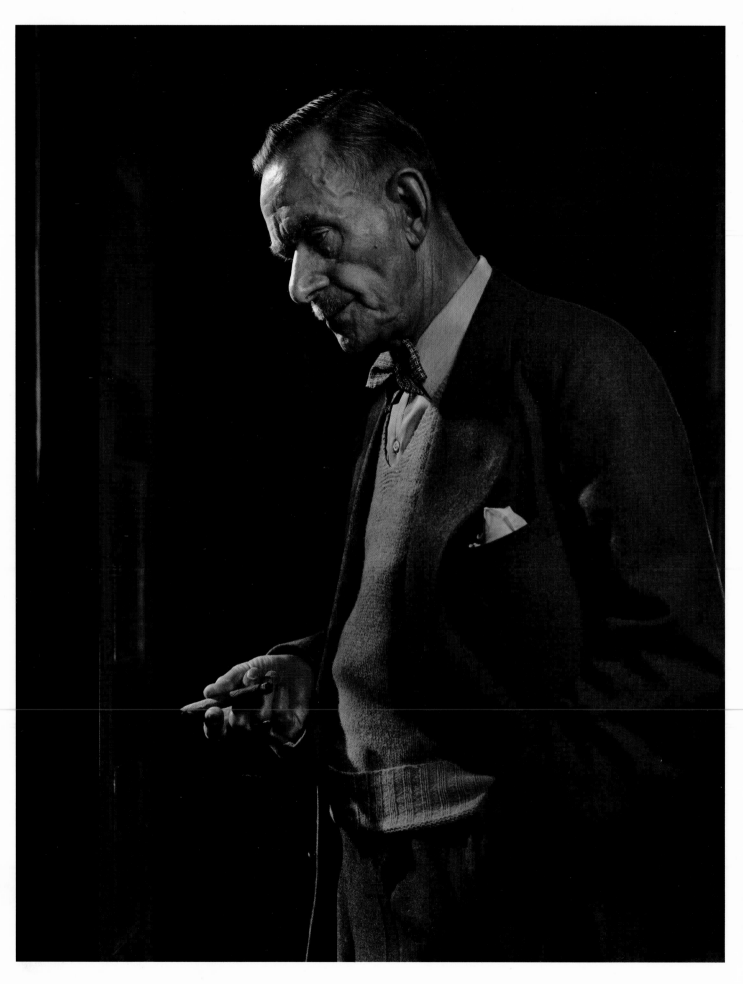

Thomas Mann
1946

The German author of *The Magic Mountain* seemed to have an especially soft place in his heart for the United States, where he had been so warmly welcomed in his exile, and he relished the climate, the scenery, and the spacious freedom of California.

Yasunari Kawabata
1970

I photographed the 1968 Nobelist in Literature and "Living Human Treasure" with a piece from his extensive collection of early Japanese funerary pottery. Kawabata shared with me his plans to devote a section of the library of his seaside home near Kamakura to Western literature and presented me with English translations of some of his works. After reading them, I understood the subtle power of his simple literary images, which, linked together, produce sudden profound insight into the souls of his characters.

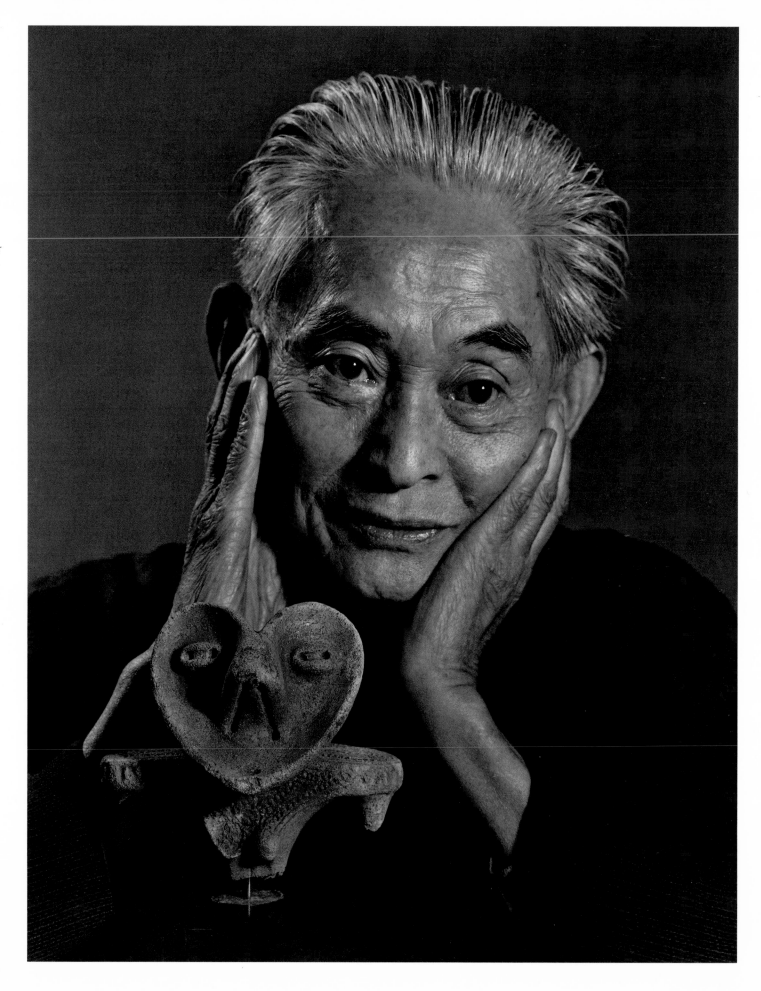

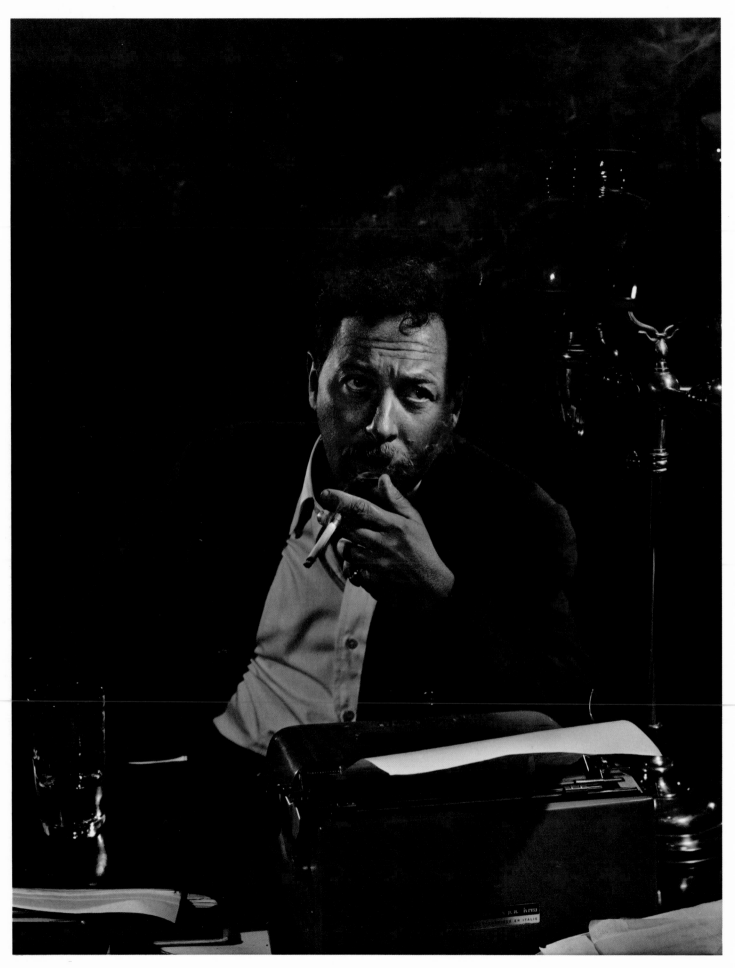

Tennessee Williams
1956

When the Southern play-wright was in the hospital, he called to request that I send him this portrait. "It will help me to remember better times," he explained, "and urge me to be my old self again."

Francis Henry Taylor
1957

To think of Francis Henry Taylor is to remember his dark eyes, luminous with intelligence, and that strong Florentine nose. Art was his life, and to the collection, appreciation, and preservation of great works of art he devoted his energy and discrimination. This photograph was taken in the grand hall of the Worcester Art Museum, a favorite place of his, where he liked to reflect on the famous mosaics from Antioch and the exquisite tapestry of the Last Judgment, both acquisitions he was proud to have made as director of the museum.

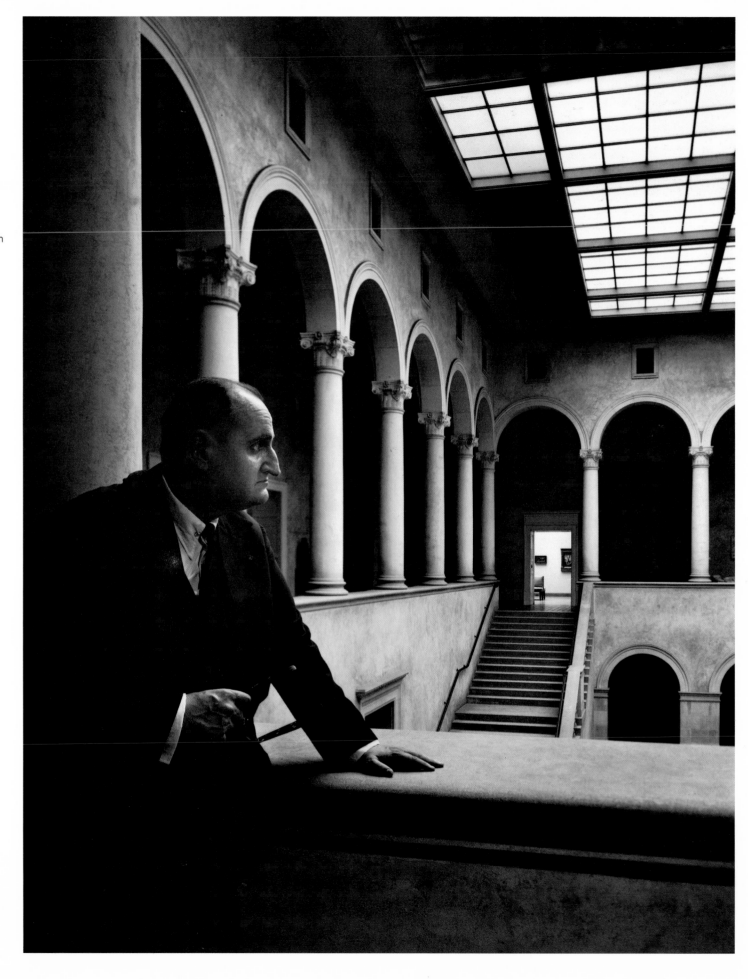

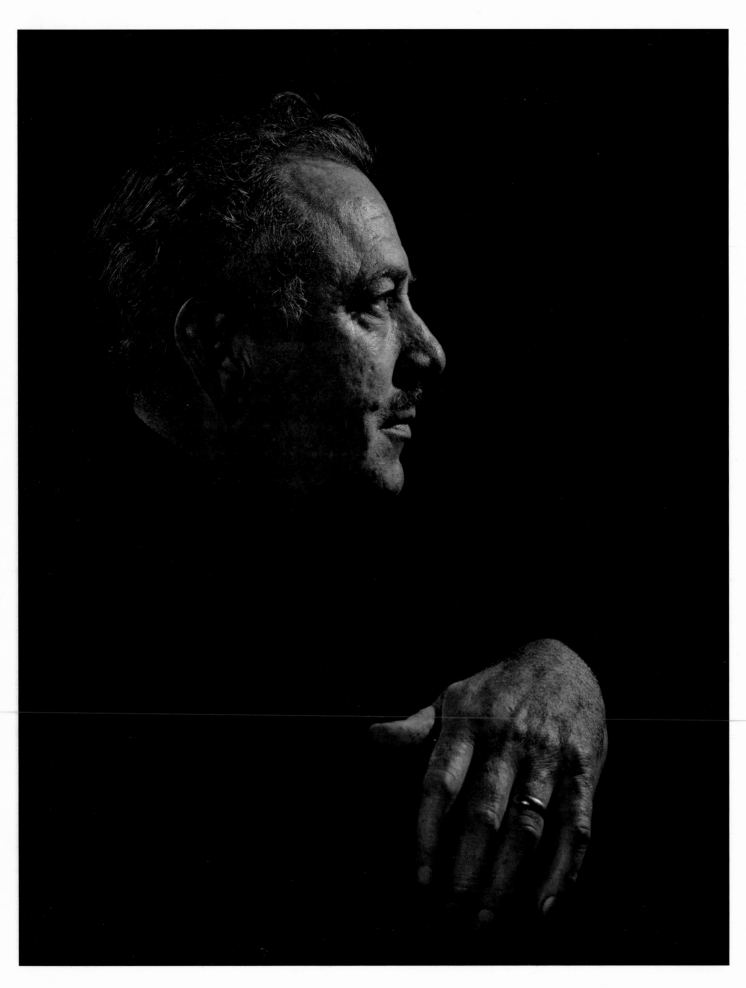

John Steinbeck
1954

Art Buchwald, after interviewing me during his Paris *Herald-Tribune* days, introduced me to John Steinbeck. The author of *The Grapes of Wrath,* creator of earthy characters in his novels of California's interior valley and the Monterey coast, spoke of his interest in marine biology. When he saw this portrait of himself in a black turtleneck, he remarked that, appropriately, it made him look like a sailor.

Ernest Hemingway
1957

I expected to meet in the author a composite of the heroes of his novels. Instead, in 1957, at his home near Havana, I found a man of peculiar gentleness, the shyest man I ever photographed – a man cruelly battered by life, but seemingly invincible. He was still suffering from the effects of a plane accident on his fourth safari in Africa. I had gone the evening before to La Floridita, Hemingway's favorite bar, to do my "homework" and sample his favorite concoction, the daiquiri. But one can be overprepared! When, at nine the next morning, Hemingway called from the kitchen, "What will you have to drink?" my reply was, I thought, letter-perfect: "Daiquiri, sir." "Good God, Karsh," Hemingway remonstrated, "at *this* hour of the day!"

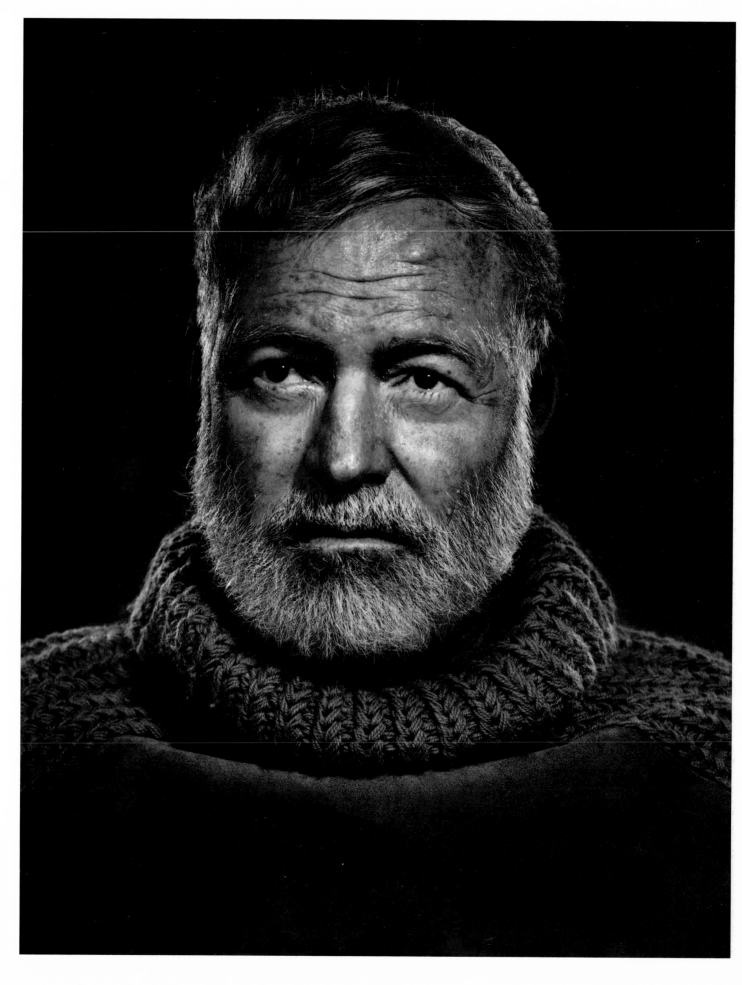

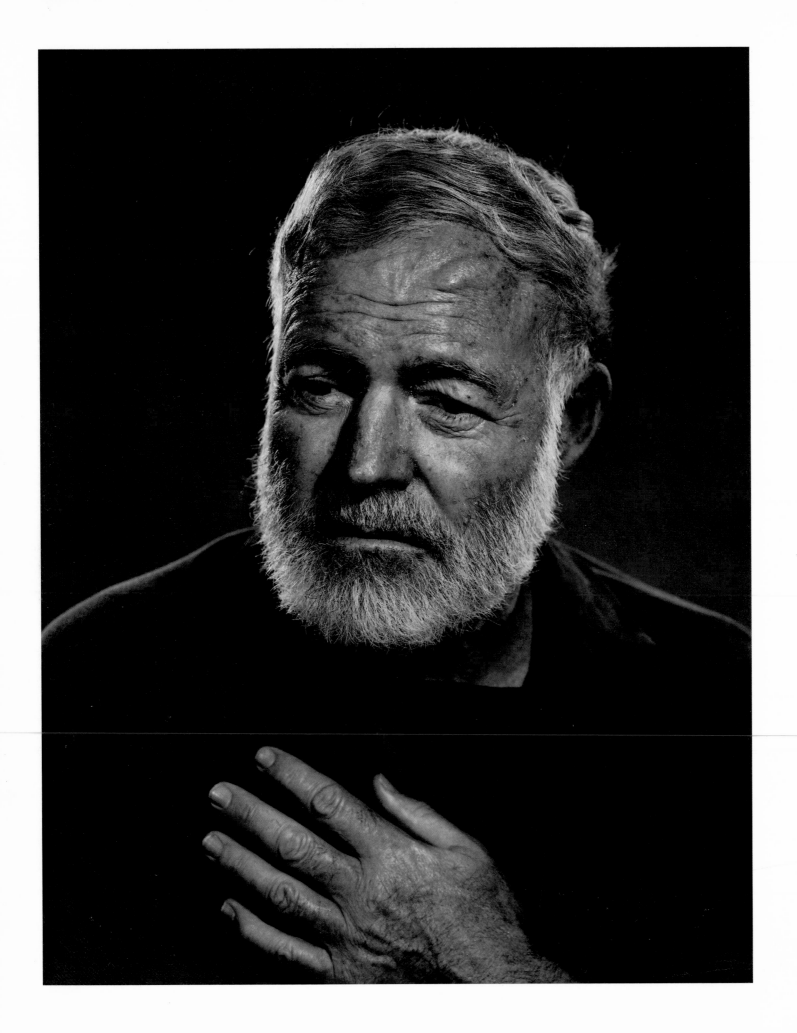

Ernest Hemingway
1957

"I don't drink while I write.
You can't write serious stuff
and drink."

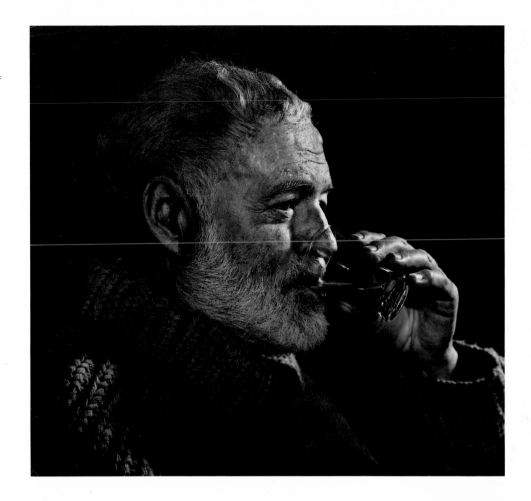

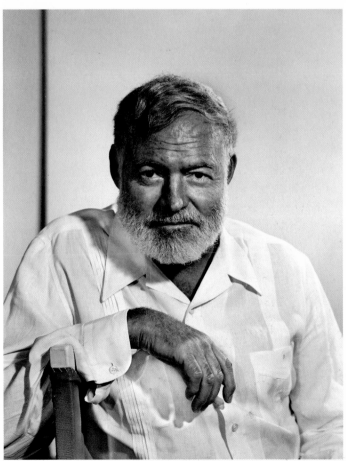

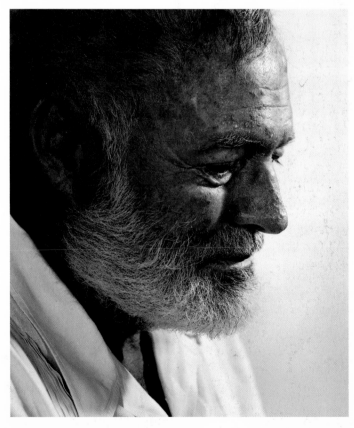

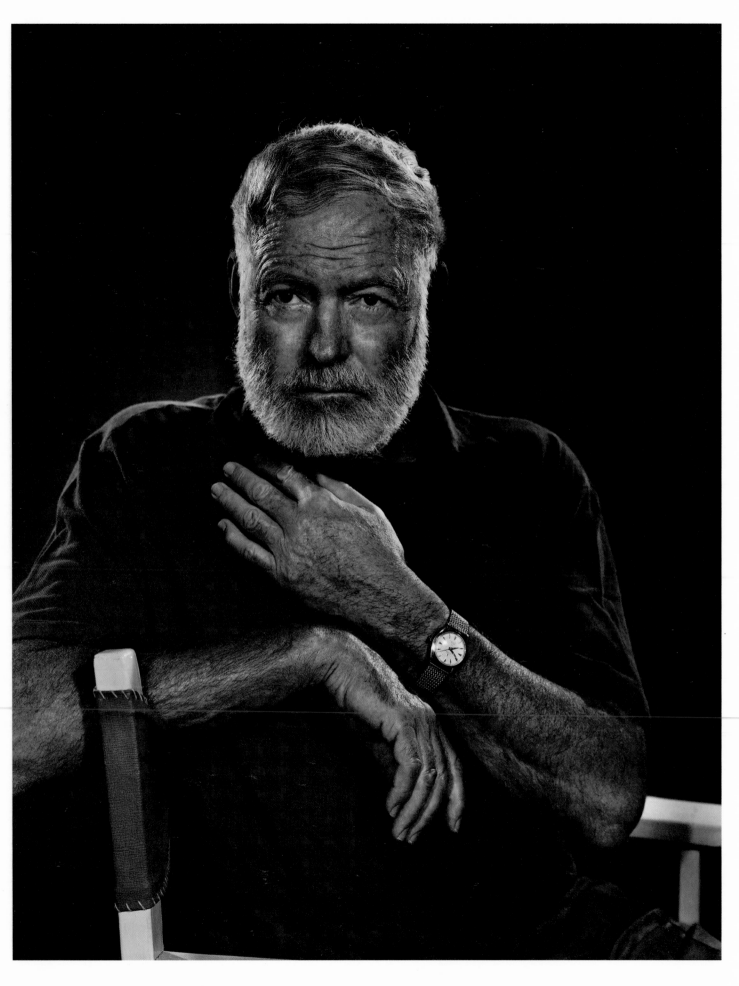

Ernest Hemingway
1957

He did not like to talk about his work. Once he had written a book, he said, it went out of his mind completely and no longer interested him. "I must forget what I have written in the past, before I can project myself into a new work."

What did he think, I asked, about the large tribe of writers who imitate his style? The trouble with imitators, he said, was that they were able to pick out only the obvious faults in his work; they invariably missed his real purpose.

Hands give clues to the entire personality – the
subject's mood, attitude, tension. They are, for me,
almost a barometer of a person's being, a distillation of
the whole. Except in rare instances, I never set out to
photograph hands alone; they are always a complement
to the total image.

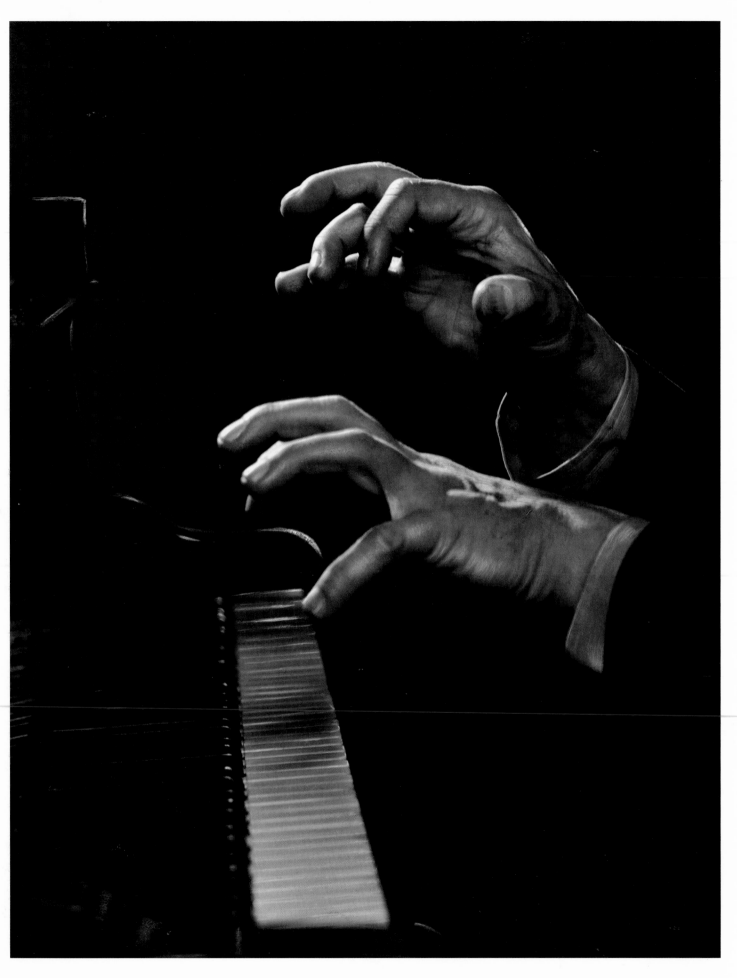

Artur Rubinstein
1945

He was engrossed in playing
a wartime concerto of Proko-
fiev, the hands poised as if to
pounce on the chord.

Helen Keller
1948

The light seemed to come from within – sight and hearing had passed into her hands A portrait of her hands was as important as a portrait of her face – hands that created light out of darkness, sound out of perpetual silence, and alone brought this woman into communion with nature and her own kind.

Senior Citizen
1948

These were the hands of toil in the earth over many years.

Moira Shearer
1954

An arrested attitude as the English ballerina completed a pirouette.

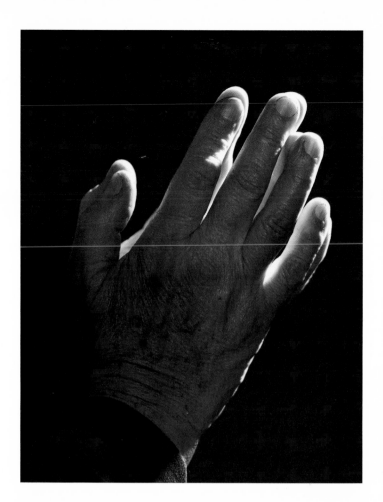

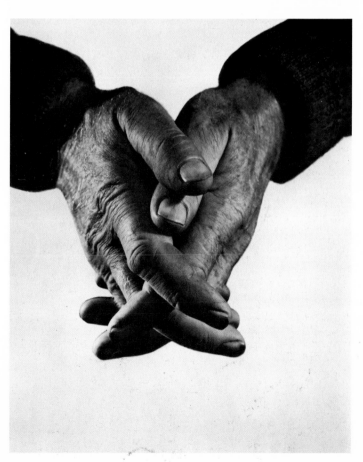

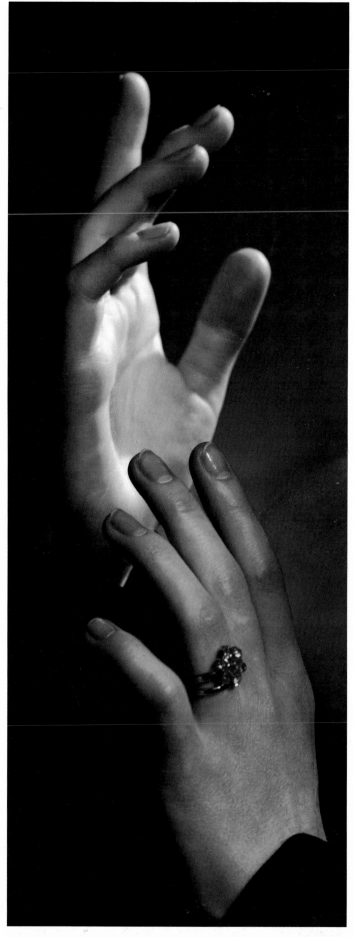

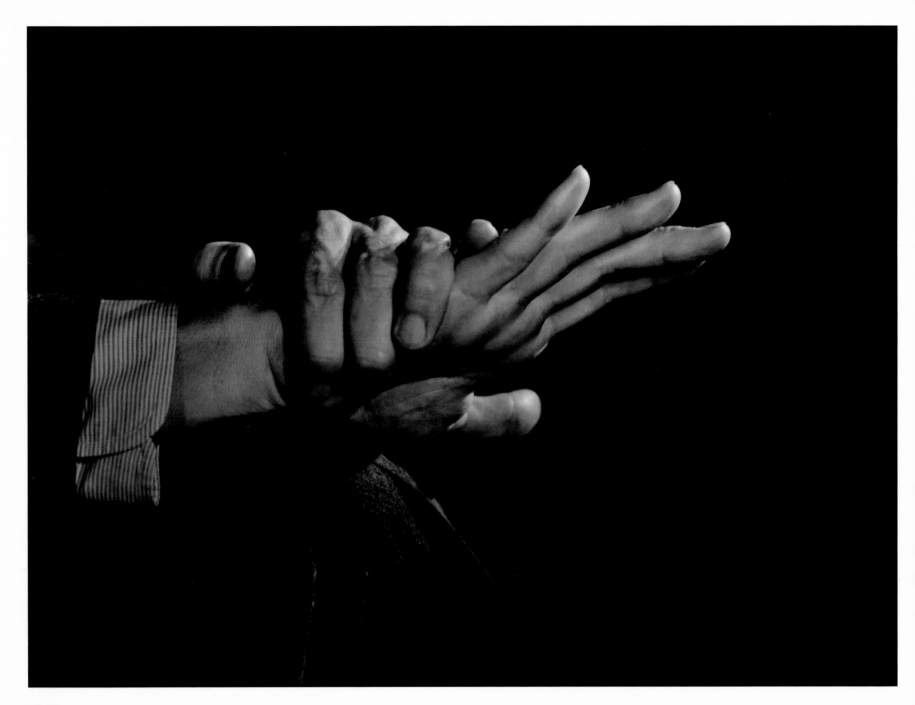

Mel Ferrer
1956

As he sat for me, he rested
his expressive hands on his
knee and talked about his
latest role.

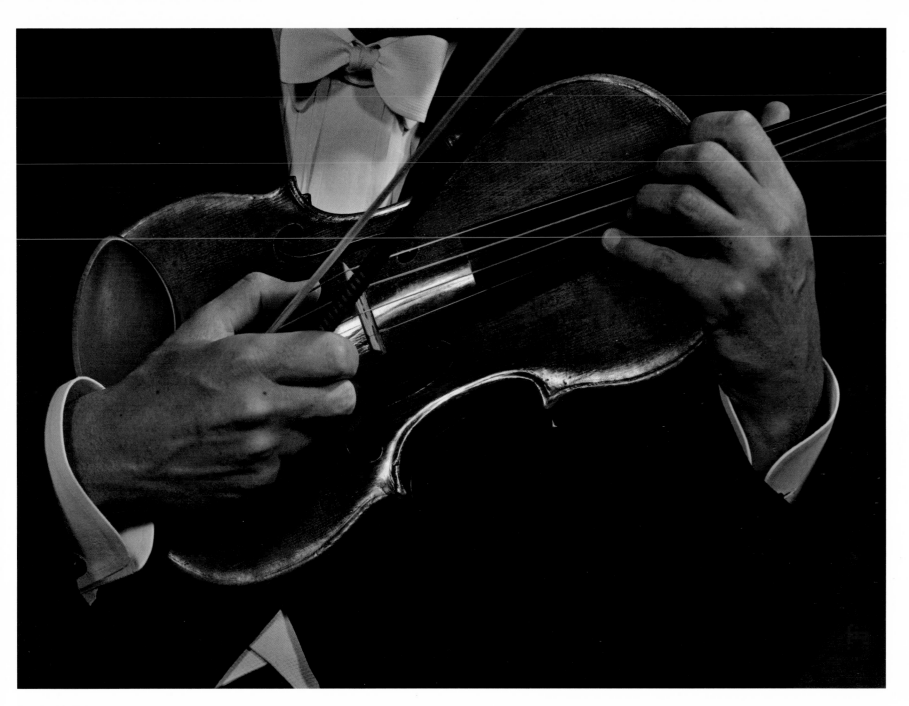

Jascha Heifetz
1950

Only moments before this
photograph was taken, his
household staff, accustomed
to the violinist guarding his
hands, looked on in shock
and amazement as Heifetz
helped me move a piano.

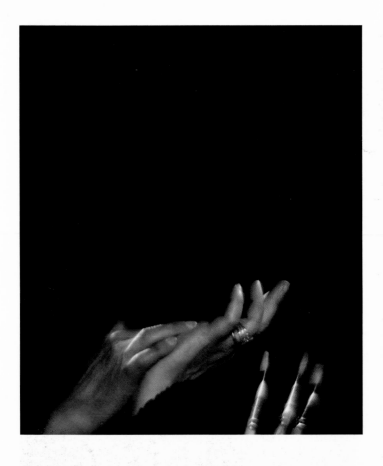

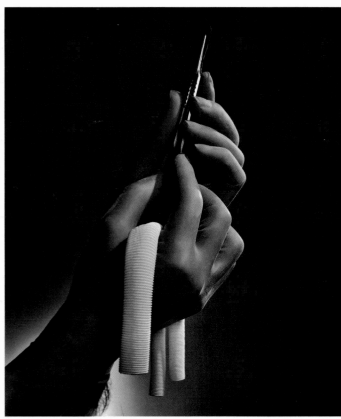

Viera da Silva
1965

One of the foremost artists of our day, a woman of grace and sensitivity, she presented us with a tiny canvas depicting raucous New York traffic viewed from her hotel window.

Michael De Bakey
1969

In Houston, Estrellita and I witnessed the miracles of the exploration of outer space at NASA and the wonder of man's triumph over the formerly forbidden inner space of the human heart at the Methodist Hospital. In sterile cap and gown, at his invitation, we often watched our friend Dr. Michael De Bakey perform open-heart surgery. His gloved hands hold the scalpel and the Dacron implant that will repair and allow blood to flow through the patient's formerly diseased aorta, the large artery leading away from the heart.

Anna Eleanor Roosevelt
1944

The eloquent hands of a compassionate woman, a humanitarian who carved a magnificent career from the trauma of a difficult childhood

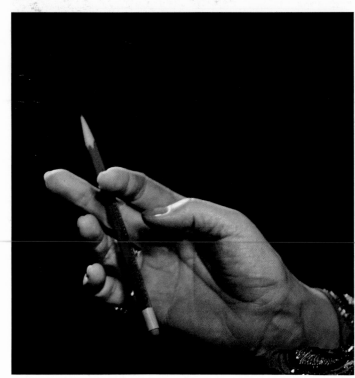

Albert Schweitzer
1954

These are the hands of ''Le Grand Docteur,'' musician, theologian, and healer, whose inscription on the lamp outside his jungle hospital at Lambaréné exemplified his approach to life: ''Here, at whatever hour you come, you will find light and help and human kindness.''

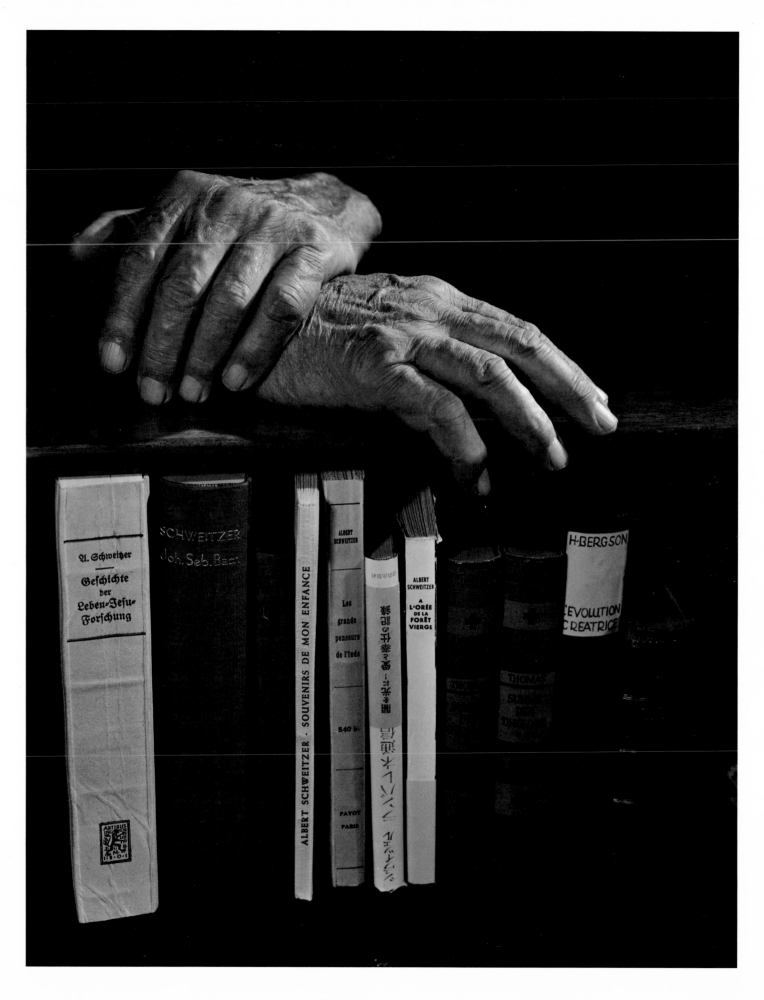

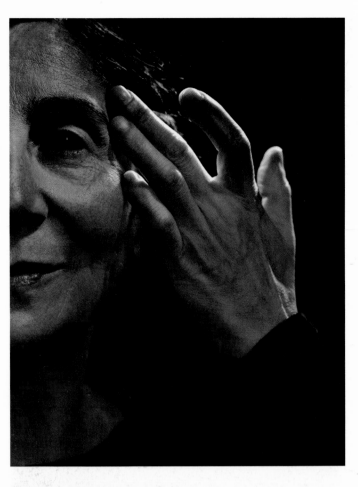

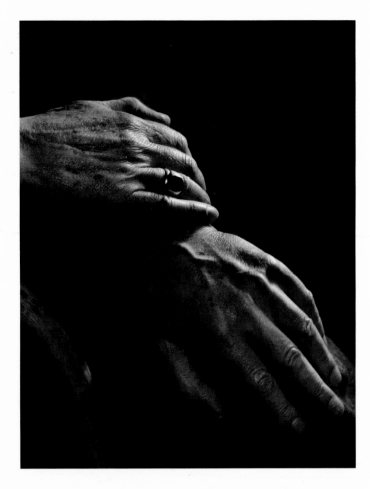

Wanda Landowska
1945

The high priestess of the harpsichord, uncompromising in her quest for perfection.

Thomas Mann
1946

The renowned German author, on seeing the photographs of his hands, which seemed to reveal both his strength and his delicacy, wrote to me, "The magnificent study of my hands… reminds me of a drawing by Albrecht Dürer."

Kurt Weill
1946

His musical versatility was phenomenal: his compositions ranged from operas and symphonies to ribald ballads, from oratorios to satirical cabaret songs. The German-born Weill, once in America, so absorbed the popular idiom that he helped revolutionize the musical theater.

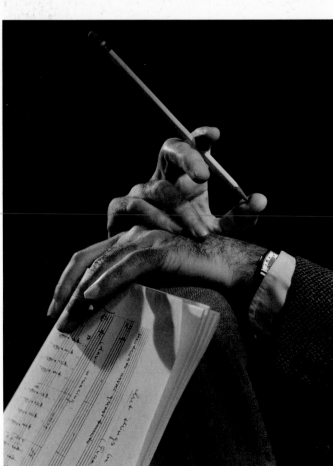

Gratien Gelinas
1945

The French-Canadian actor
Gratien Gelinas in his favor-
ite character of Fridolin.

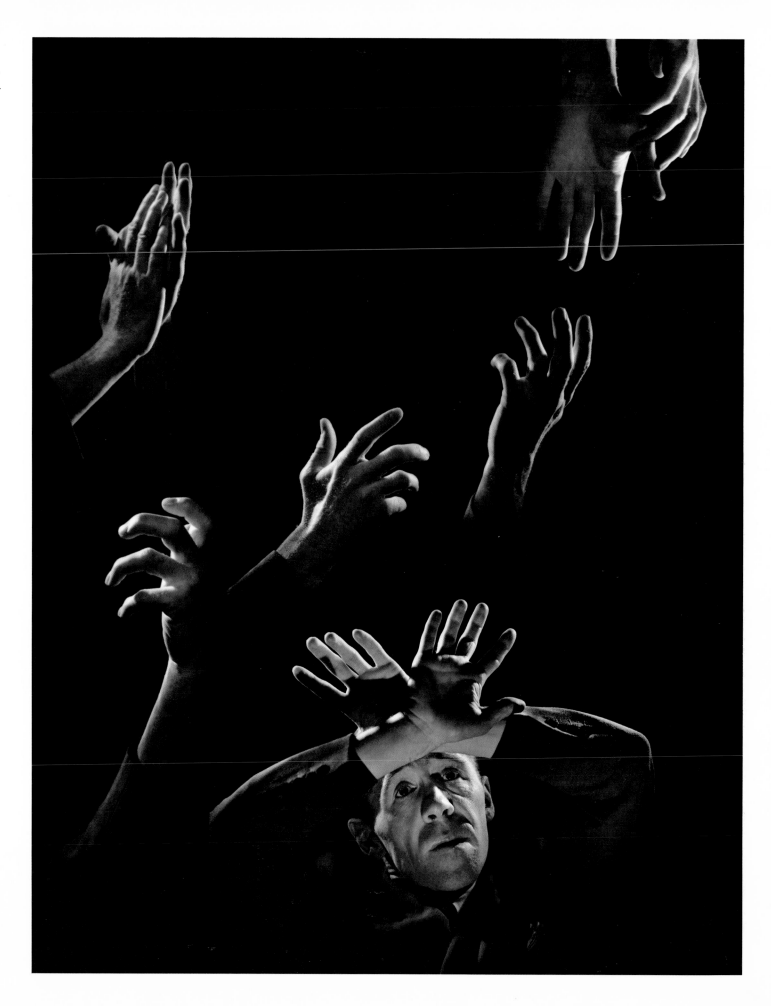

Muhammad Ali
1970

"I am America. Only, I'm the part you won't recognize. But get used to me. Black, confident, cocky; my name, not yours; my religion, not yours; my goals, my own— get used to me. I can make it without your approval. I won't let you beat me!"
—Muhammad Ali

6 On Assignment

The photographs in this section were taken on assignment across Canada, the United States, Europe, and as far away as Zululand. While the human face has always been a great challenge to me, whether the subjects are famous or unknown, I welcome the opportunity to try to capture the moods and personalities of cities, landscapes, and industries. It offers a change of pace, new problems to solve, and sometimes the chance to explore a part of the world I have never before visited.

Just as in my first award-winning landscape as a neophyte photographer, I saw the landscape in relation to human beings, so it was with my later photographic observations. The monolithic shapes of the steel or automotive industry I preferred to view in the context of the people whose work made them vital.

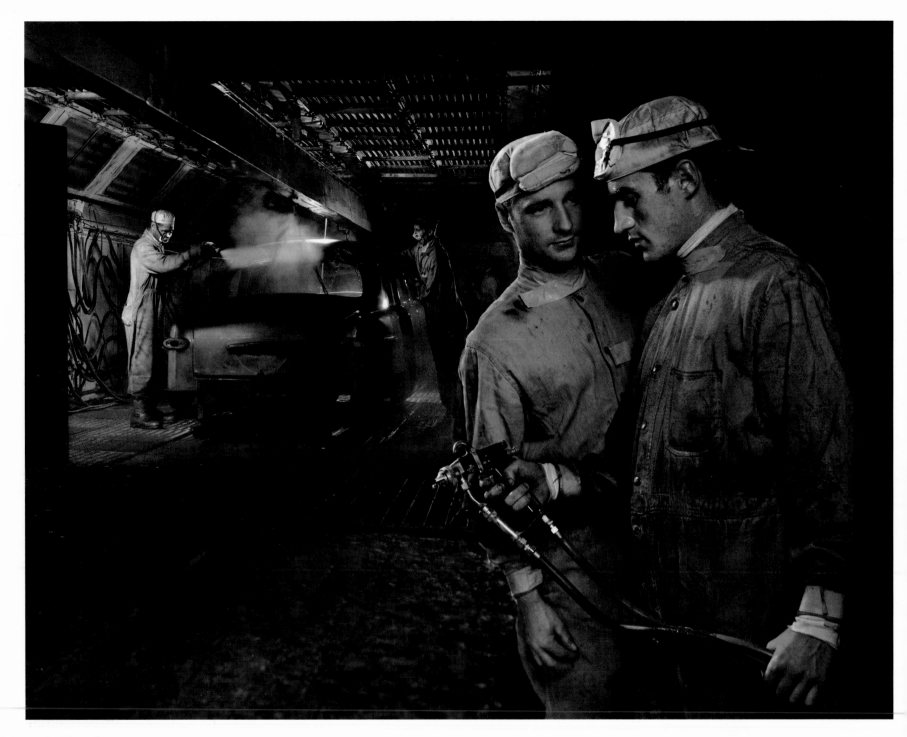

Ford of Canada
1951

The garb of the spray
painters and their intense
momentary involvement
with each other reminded
me of two surgeons consult-
ing in the operating room.

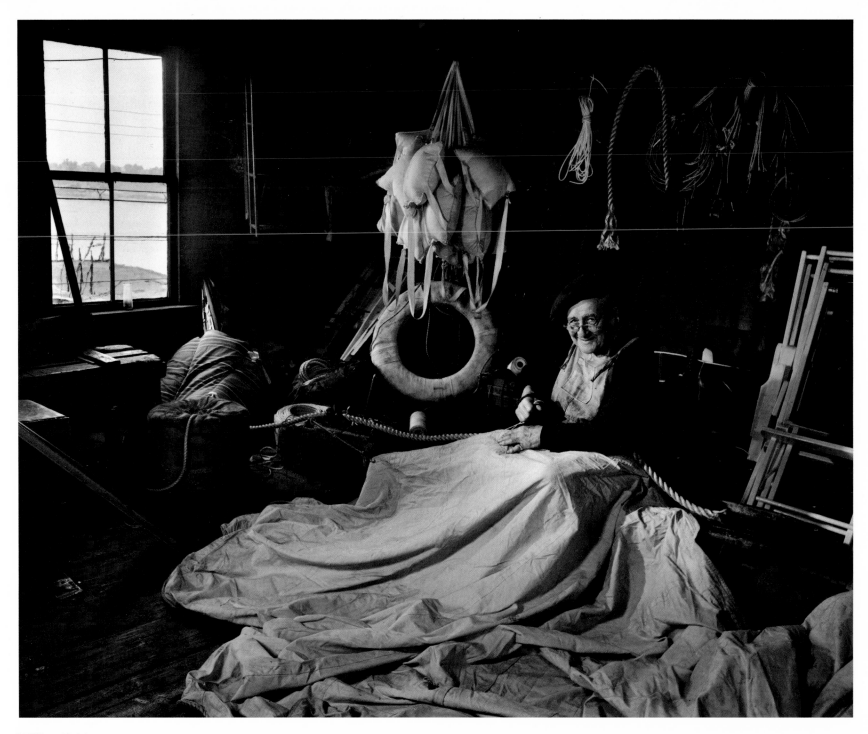

William Holder
1953

I traveled across Canada for *Maclean's* magazine in 1953 to try to capture the spirit of sixteen cities. In St. John, New Brunswick, I found the last surviving sailmaker, a twinkly Scotsman stitching sails as his forefathers must have done for the great whaling ships in the nineteenth century.

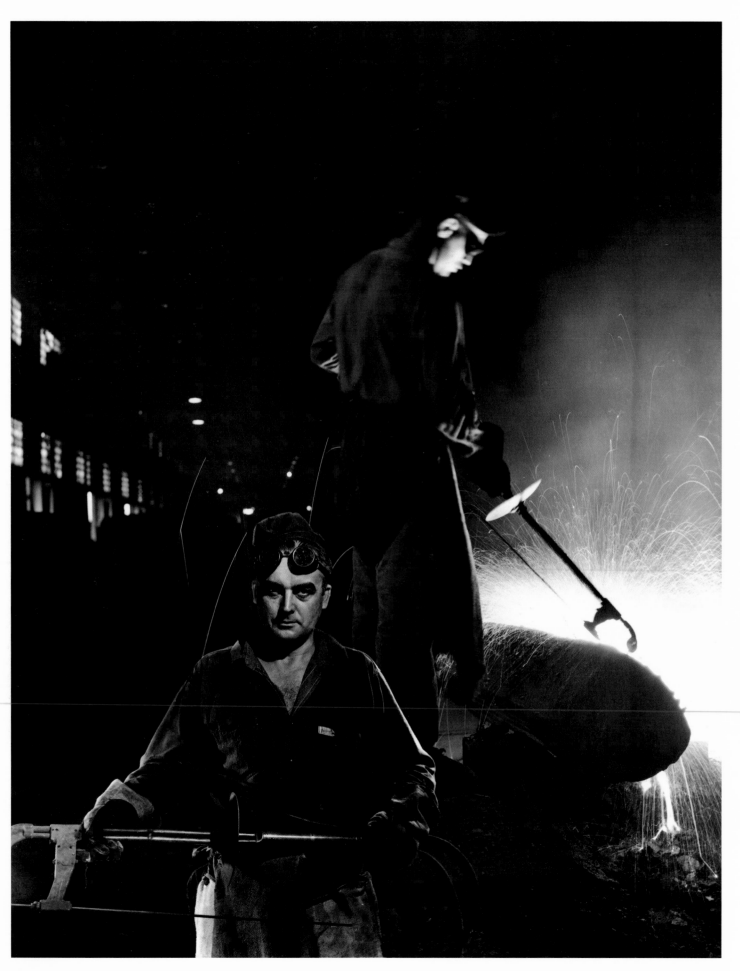

Atlas Steel
1950

In the steelworkers, I found aristocracy of spirit and a sense of pride in their jobs.

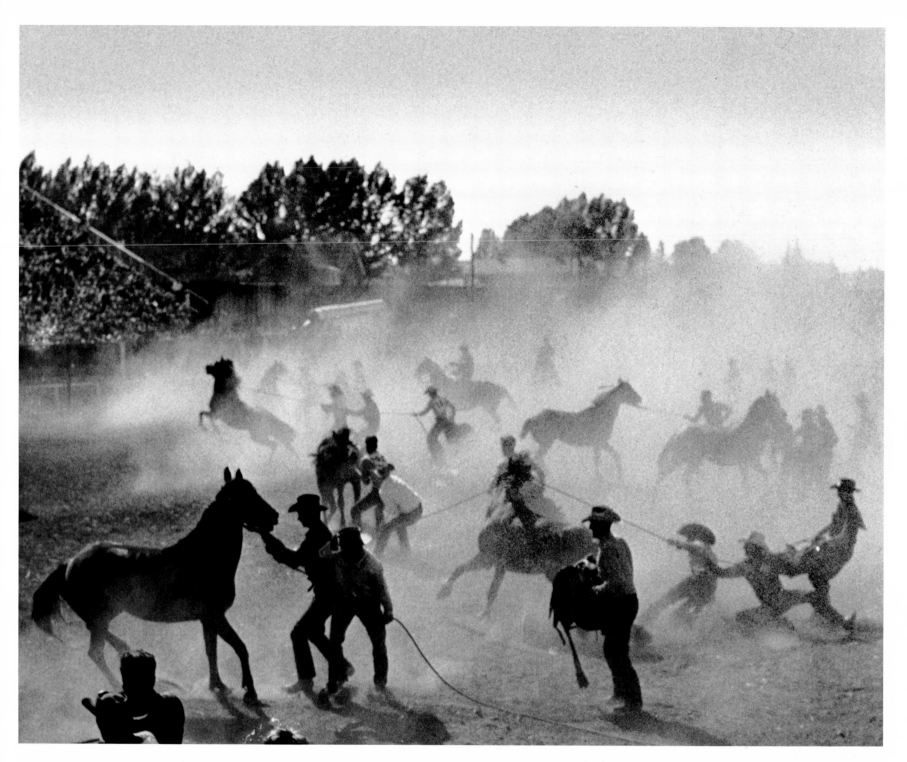

Calgary Stampede
1953

For a week every July, the
bustling Canadian city is
transformed into a free-
wheeling Old West rodeo,
full of exuberant high spirits
and chuckwagon hospitality.

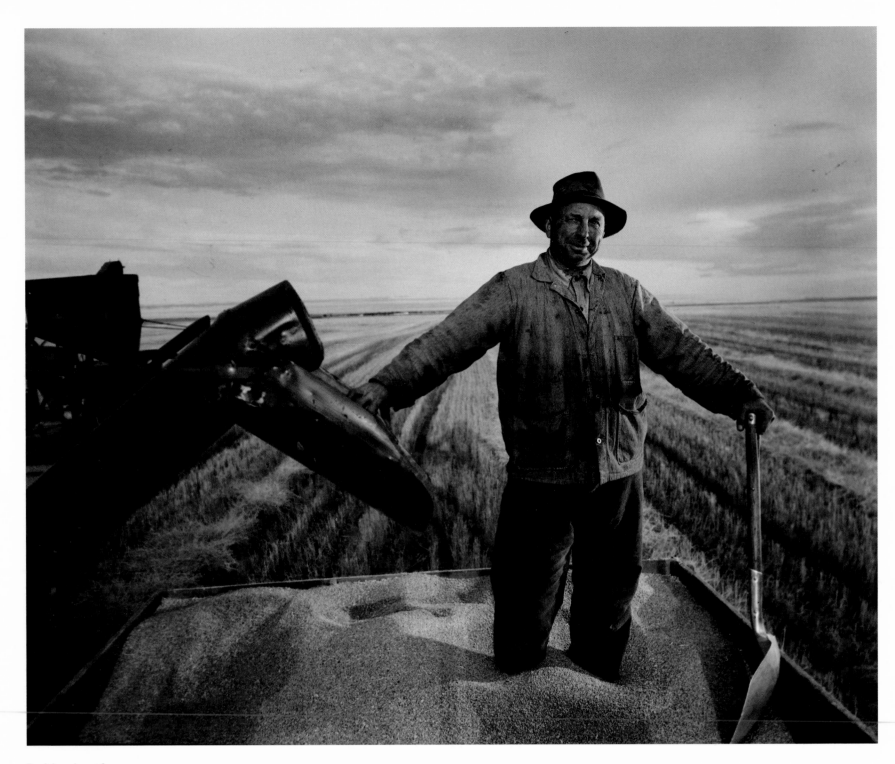

**Prairie wheat farmer,
Regina**
1953

He came from the Ukraine
to Canada, and through his
industry and the opportuni-
ties of the new world he
became wealthy, but he still
loved the contact with the
land and the feel of the grain.

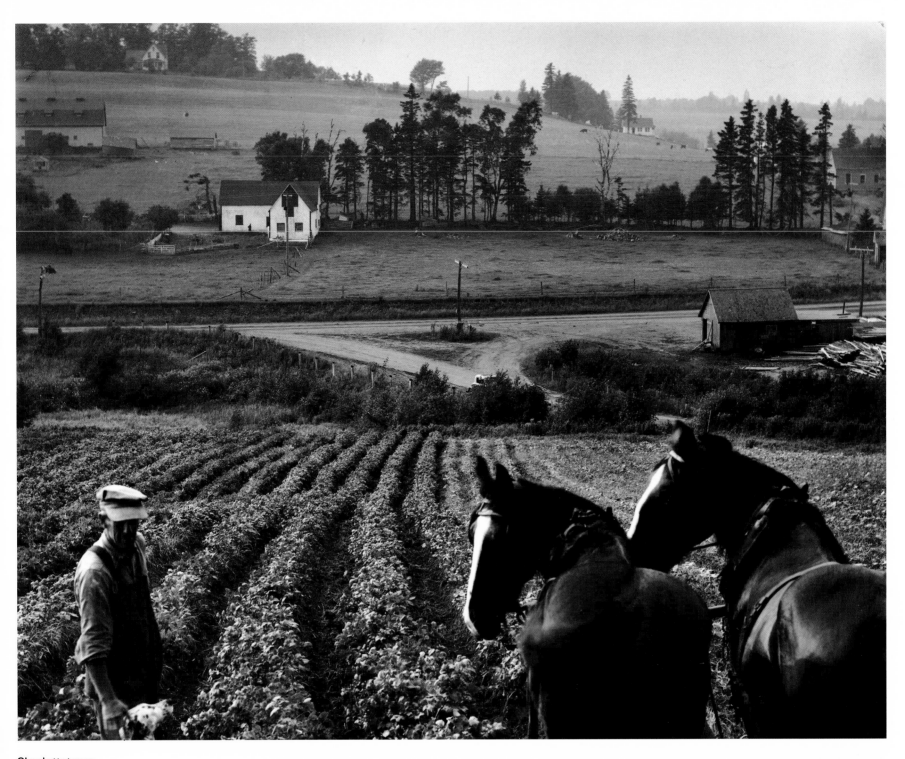

**Charlottetown,
Prince Edward Island –
horses and farmer
1953**

There are some places in the
world today where one feels
that time has stood still and
that we are back in a simpler,
gentler era.

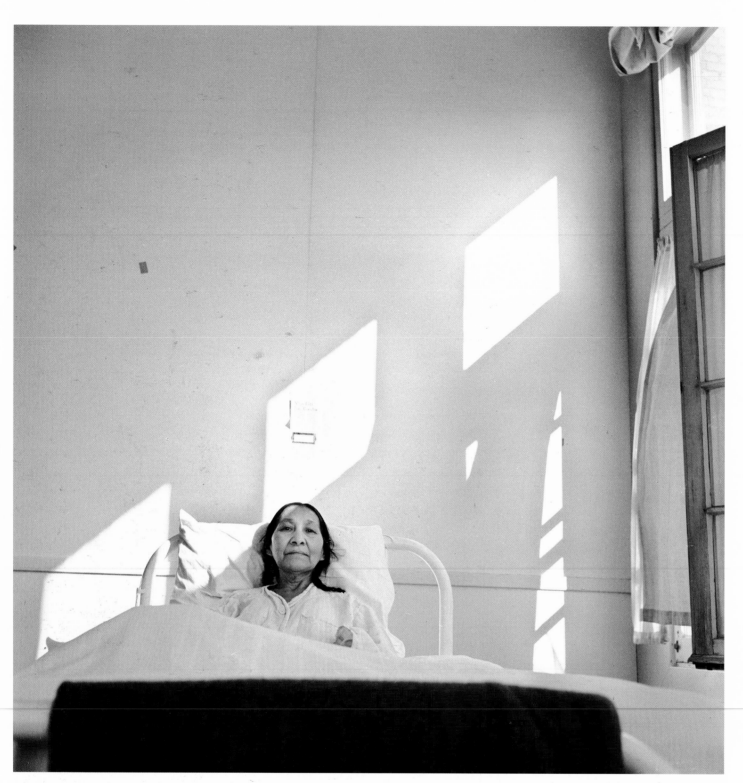

Eskimo woman
1953

A plane from the Province of Alberta routinely flies on a mission of mercy to the Northwest Territories to pick up native people to receive medical treatment in Edmonton. Although she was small in stature, this Eskimo woman's serenity of spirit was not overwhelmed by the immensity of the hospital.

Indian man
1953

To an Edmonton hospital he brought all of his worldly belongings wrapped in a knapsack, his name on a label, and a worn white cane.

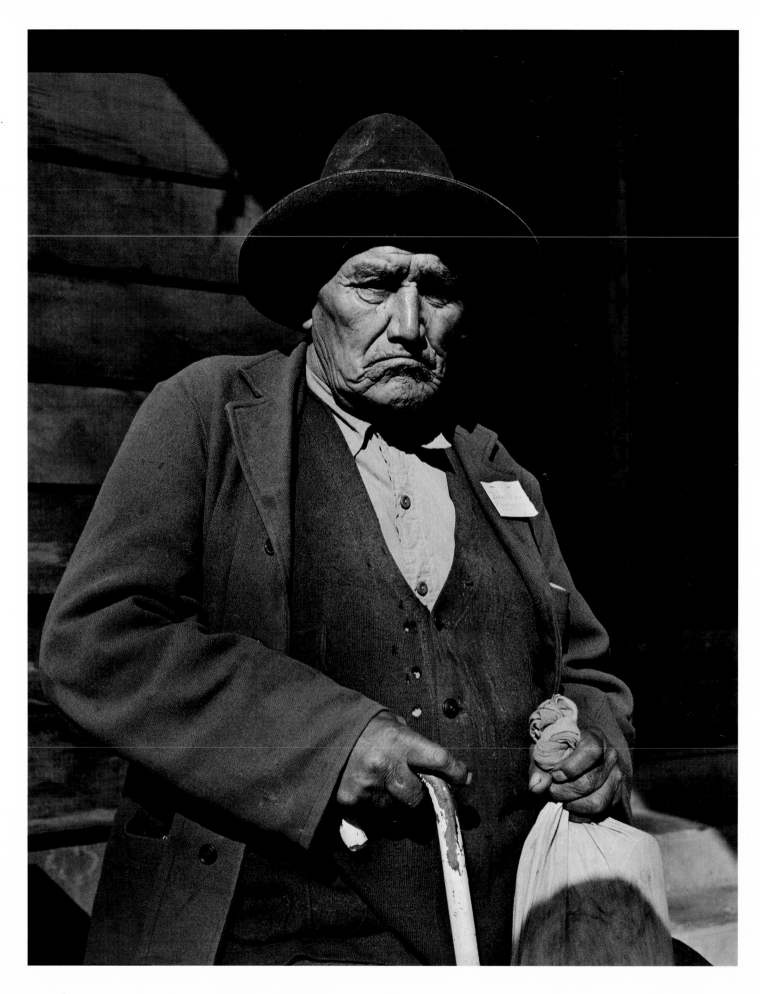

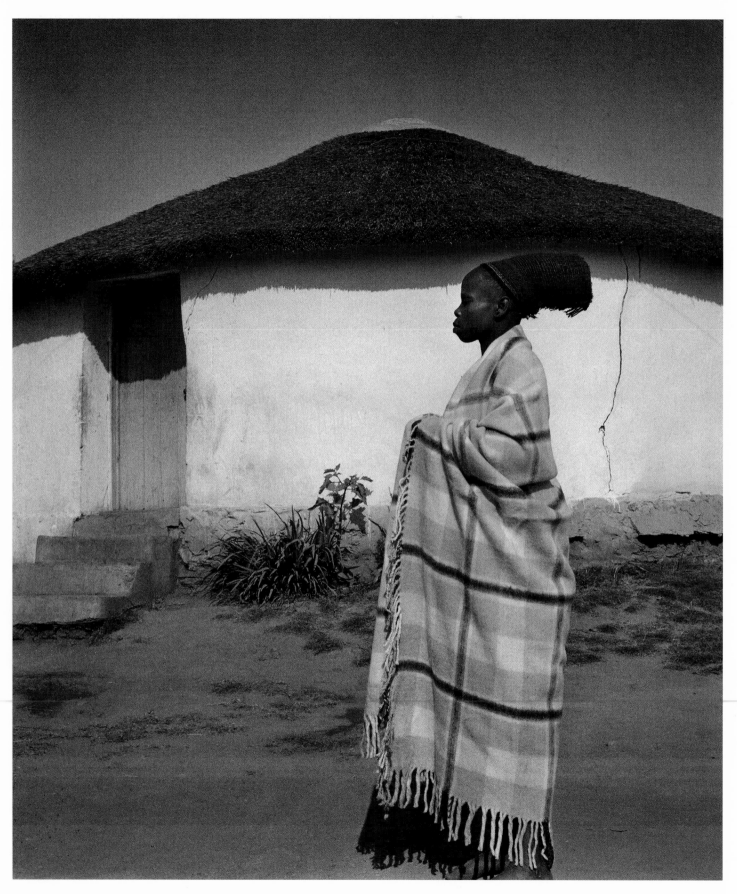

Zulu married woman
1963

The Zulu woman outside her kraal wore her Hudson Bay blanket with as much pride and dignity as if she were being presented at court.

Zulu women with gourds
1963

With his characteristic flavorful turn of phrase, the ebullient producer Joseph E. Levine invited me to go on location in South Africa. "Shoot what you want, Karsh," he said…pause… "as long as it spells *Zulu*!" The movie, now a late-show television classic, was filmed at Rorke's Drift (now Natal National Park) where in 1879, a small garrison of two hundred and fifty British soldiers fought so gallantly against a band of four thousand Zulus, led by King Cetewayo, that, at day's end, the Zulus retreated out of sheer respect for their valor.

The Zulu extras were brought from their kraals several hundred miles in the interior, and were making their first contact with the outside world. Many of them had never seen a camera, and all communication was through interpreters, but it was impossible to become exasperated; they were magnificent people.

The actor playing Cetewayo, Chief M. Buthelezi, was an Oxford-trained direct descendant of Zulu royalty; he is now a political force in South Africa. At his invitation I traveled with him in Zululand, and I was his guest at his home one weekend.

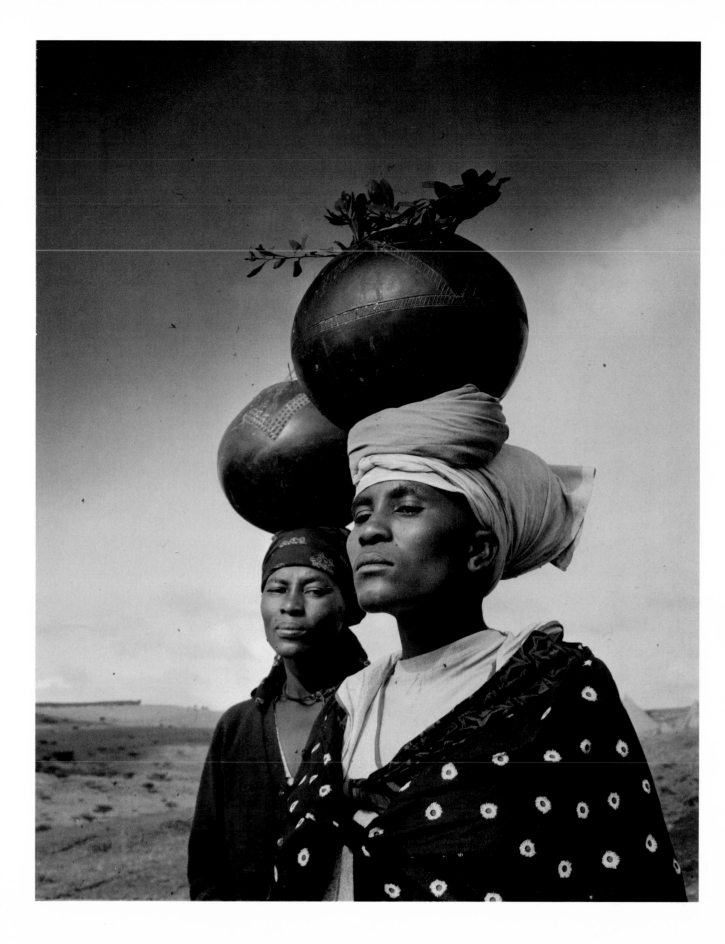

Albert Stockli
1968

At the Four Seasons restaurant in New York the decor and uniforms of the staff are changed each season, with flowering trees in spring, green trees in summer, autumn leaves in the fall, and evergreens in winter. There, several of my books have been launched, and important birthdays and anniversaries celebrated. Albert Stockli was their inspired, innovative executive chef, responsible for adapting the native menus of other countries to the sophisticated palates of New Yorkers. A personal friend, he was the soul of impulsive generosity.

Stephen Moomjian
1979

The call came from a proud father in San Francisco. Would I photograph the members of his family? Stephen was the youngest – an energetic little boy in perpetual motion, full of the joy of life, persuaded to alight for one fleeting moment on his nonstop itinerary so that we might become friends.

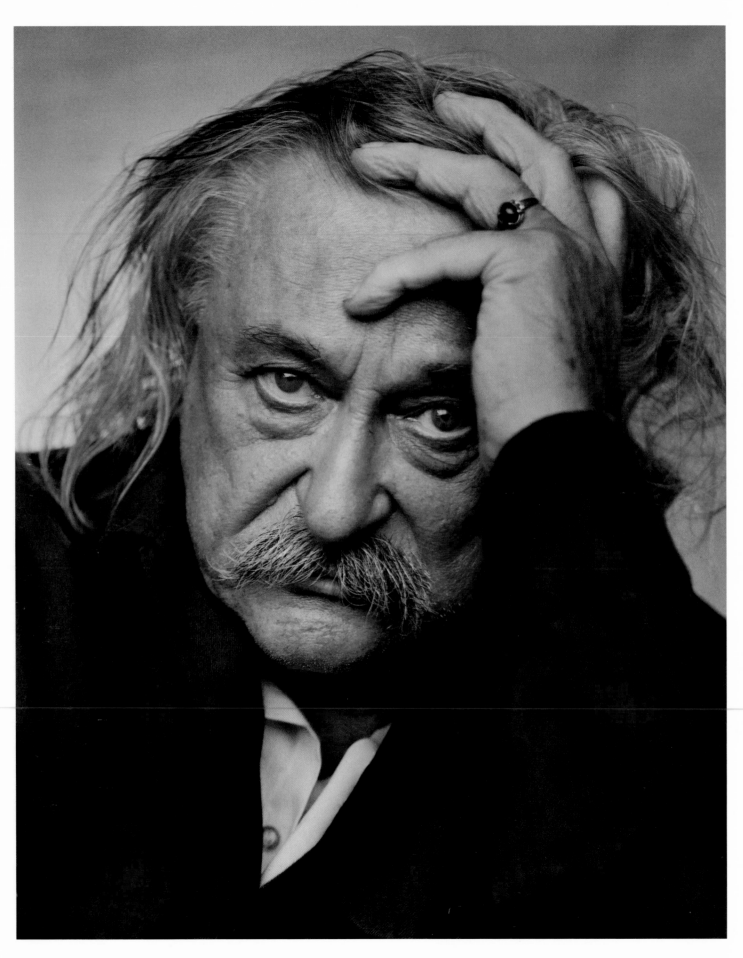

Jacques Lipchitz
1966

Our rapport and comprehension of each other was instantaneous when we met at his home on Hastings-on-the-Hudson. He knowledgeably shared with us his second exquisite, painstakingly assembled collection of artifacts from man's ancient past – the first having been lost in the ravages of war. As I was photographing him he said he would like to sculpt me. I took it as a gracious remark of the moment and was surprised when, some weeks later, the voice of Jacques Lipchitz came booming over the telephone. In his heavily Russian-accented English he avowed, "Come to Italy, Karsh, I really mean it!" The following summer I went to Tuscany to the Tommasi Foundry, where he cast his monumental pieces. Long daily work sessions with him were relieved by bucolic luncheons in a restaurant whose ceiling was a grape arbor, amid country workmen who could have stepped from the pages of Vergil's *Georgics*. He and his artist wife, Ulla, entertained in their restored villa in the nearby hill town of Pievedi Camiore, filled with fifteenth-century furniture and African sculpture. Memorable for me are the evenings I shared with Lipchitz and his friends, which included his colleagues Henry Moore and Marino Marini, watching the changing Renaissance landscape from his loggia.

With artists I feel special rapport; since they understand the process of creativity, I have always found them to be silent allies on the other side of the lens. With Jacques Lipchitz and Pablo Picasso, especially, it is as if we collaborated on the photography; we could have changed places in an elaborate mental counterpoint. Wherever I have gone to photograph artists – whether to the New Mexico desert with Georgia O'Keeffe; the Tuscan jewel town of Pietra Santa, which Marino Marini, Henry Moore, and Jacques Lipchitz made their summer headquarters; to Paris, from the sparse elegance of Pierre Soulages's studio to the bedlam of genius surrounding Man Ray; to Connecticut and Josef and Ani Albers's Cape Cod – Bauhaus cottage, I have always found kinship, understanding, and in many instances, lasting friendship.

Besides my special relationship with my master, Garo, my friendship with Edward Steichen over a period of forty years was meaningful to me. As an aspiring young photographer, during my apprenticeship, I was given an introduction to him by Garo, and my eagerness to meet him was fused with trepidation as I made my train journey from Boston to New York, where Steichen was creating one photographic masterpiece after another for Condé Nast Publications. When a young photographer comes to me with his portfolio today, I can well understand how he must feel. Steichen took time to sit down with me. Smoking his favorite Camel cigarettes, one after another, he spoke about how photography was the easiest – and most difficult – of all professions. He told me the now-famous story of having been asked whether success in photography was due to luck, a question to which he unhesitatingly replied, "Yes, it is – but have you noticed how that luck happens to the same photographers over and over again."

Augustus John
1954

The acknowledged master of twentieth-century portraiture made it clear that he had little use for most contemporary painters. The old masters – Michelangelo, Raphael, Reubens and Rembrandt – he spoke of with candid idolatry. He had a special affinity for gypsies and enjoyed painting them most of all.

Georgia O'Keeffe
1956

To photograph this remarkable artist I went to Abiquiu, New Mexico, where O'Keeffe had settled ten years earlier. Her sparse adobe home with wide windows overlooking the mountain was almost completely devoid of ornaments. I expected to find in her personality some of the poetic intensity of her paintings. I found intensity, but the austere intensity of dedication to her work. Her friend and fellow artist Anita Pollitzer says that she is so in love with the things she does that she subordinates all else to win time and freedom to paint. I decided to photograph her as another friend had described her: "Georgia, her pure profile calm, clear; her sleek black hair drawn swiftly back into a tight knot at the nape of her neck; the strong white hands, touching and lifting everything, even the boiled eggs, as if they were living things – sensitive, slow-moving hands, coming out of the black and white, always this black and white."

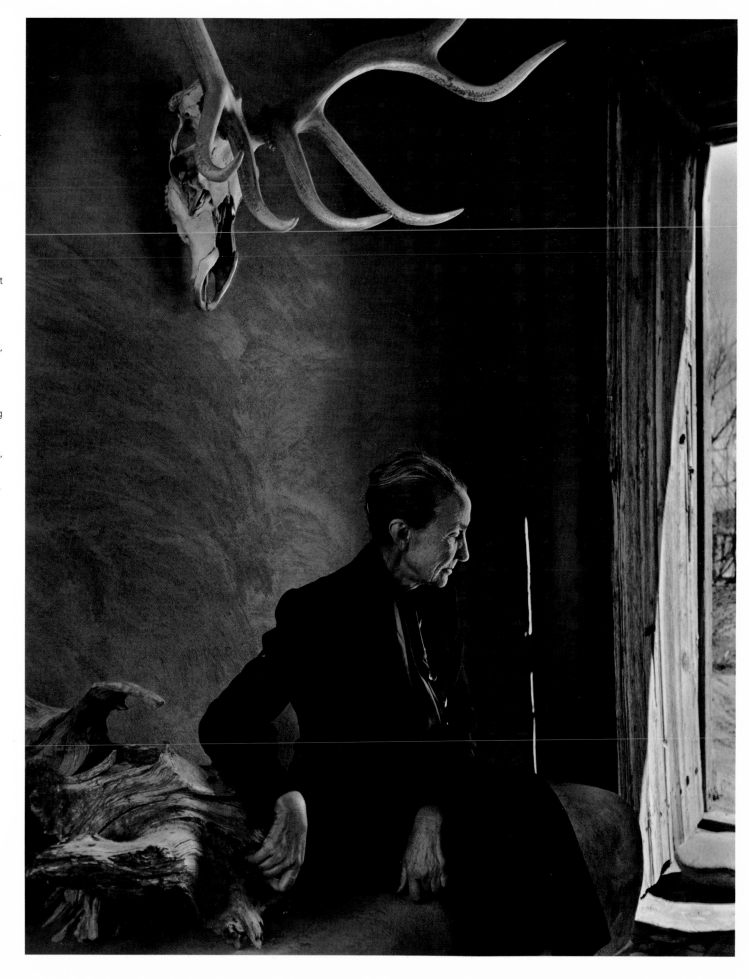

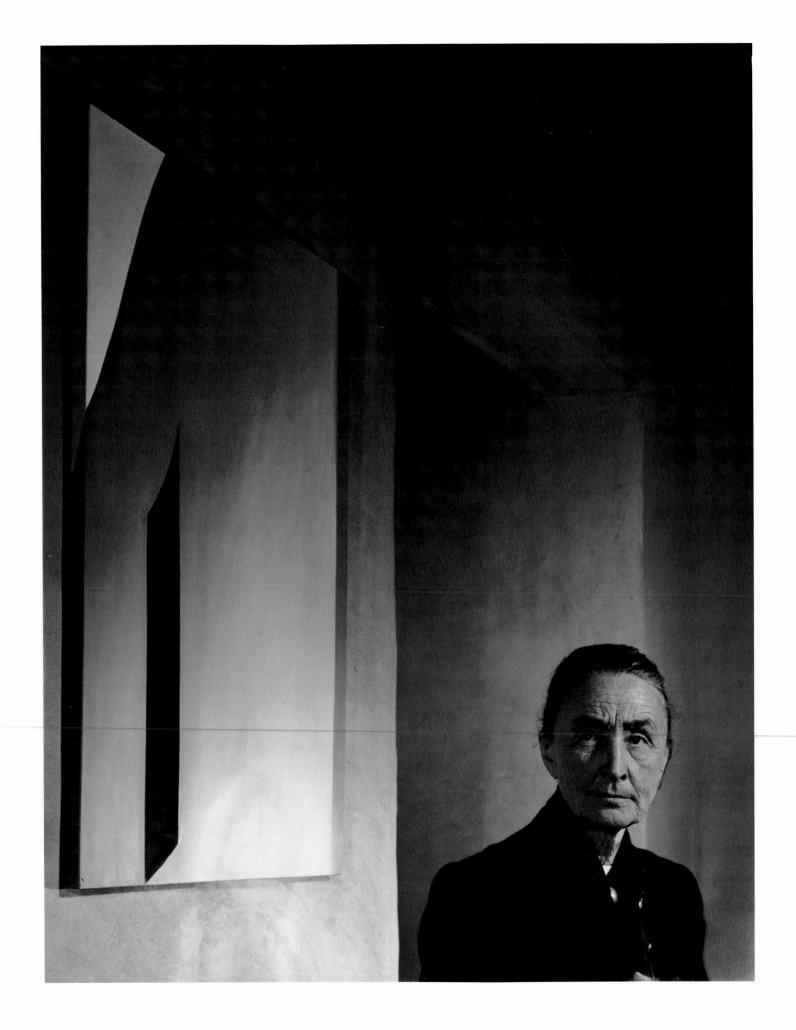

Georgia O'Keeffe
1956

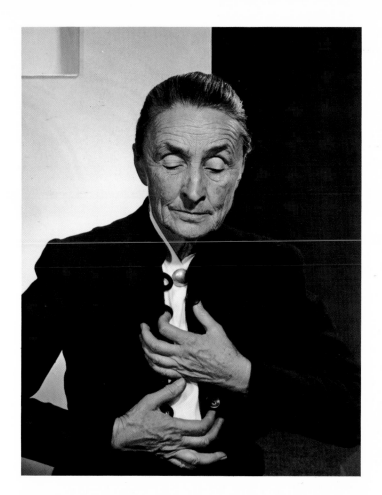
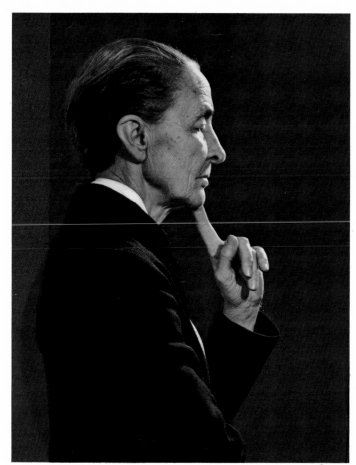
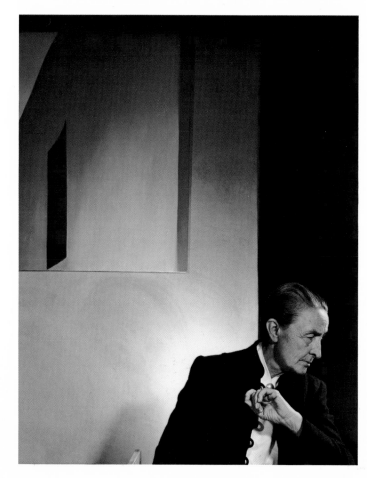

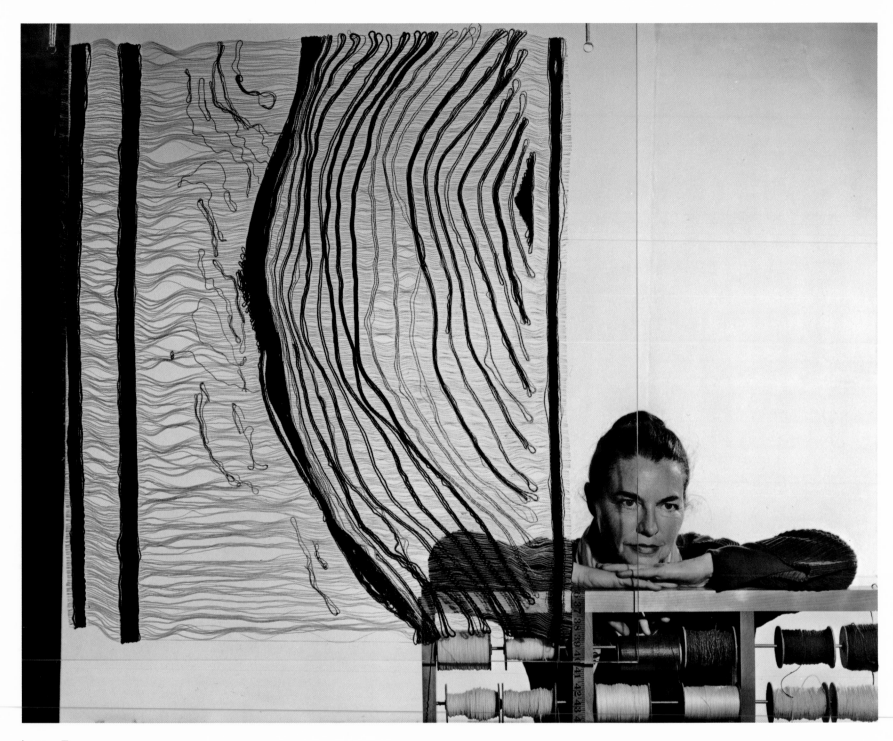

Lenore Tawney
1959

Lower Manhattan and SoHo
were not yet fashionable for
artists when I photographed
this gifted weaver in her
Bowery loft.

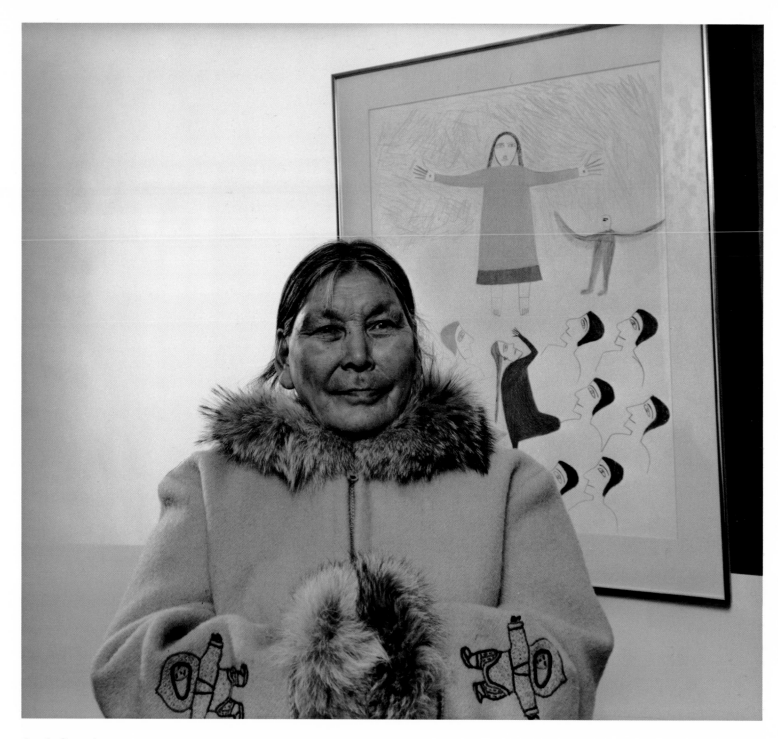

Jessie Oonark
1979

It is only since 1957 that the Canadian James Houston encouraged the Eskimos to put down on paper "what was inside them." Jessie Oonark comes from Baker Lake, and the artistic productions of this community are among the most mystical of the works of the Inuit cooperatives. In Baker Lake, she is known as a good witch, who depicts in her prints the world of shamans and spirits, the mythos of her race. Behind her is her version of the Resurrection, her contribution to a new Bible illustrated by native peoples.

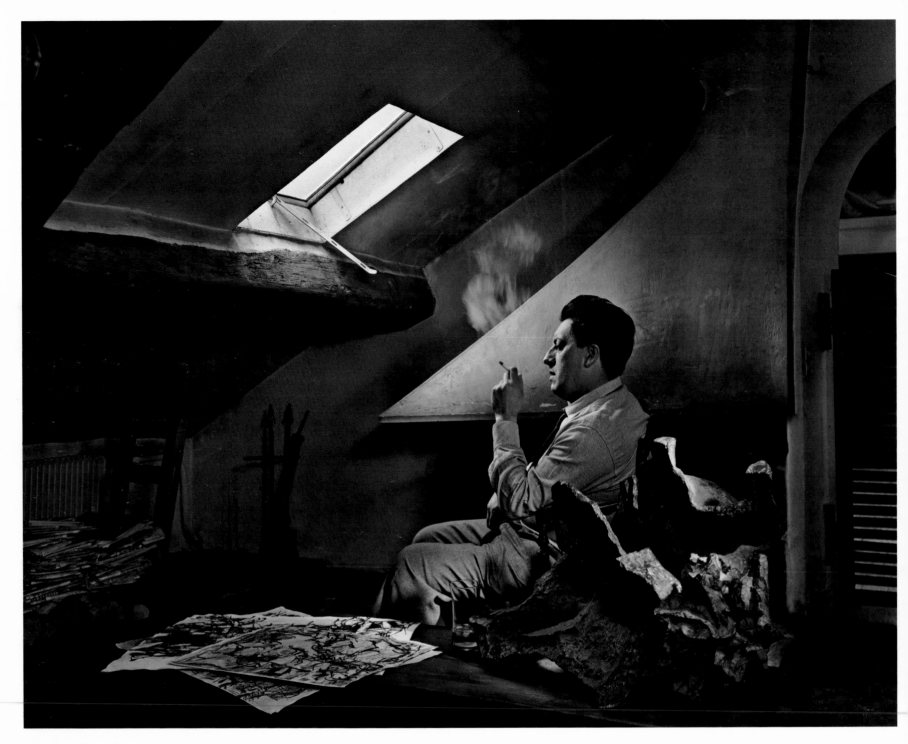

Jean-Paul Riopelle
1965

He has about him a gallant, courtly quality – a born gentleman in the guise of rough-hewn cavalier. His working method is erratic and rapid, much like the way he drives his Bugatti along the narrow, gravel-strewn roads of France. He will go for weeks, or even months, without lifting a brush. Then will come a period of intense, almost frenetic activity when art simply explodes in him. He will paint for weeks; he will not eat; he will not sleep; he will cover canvas after canvas with his highly individual, textured interlacings of bright impasto. Only when the compulsive surge has been fulfilled will his creative labors also subside.

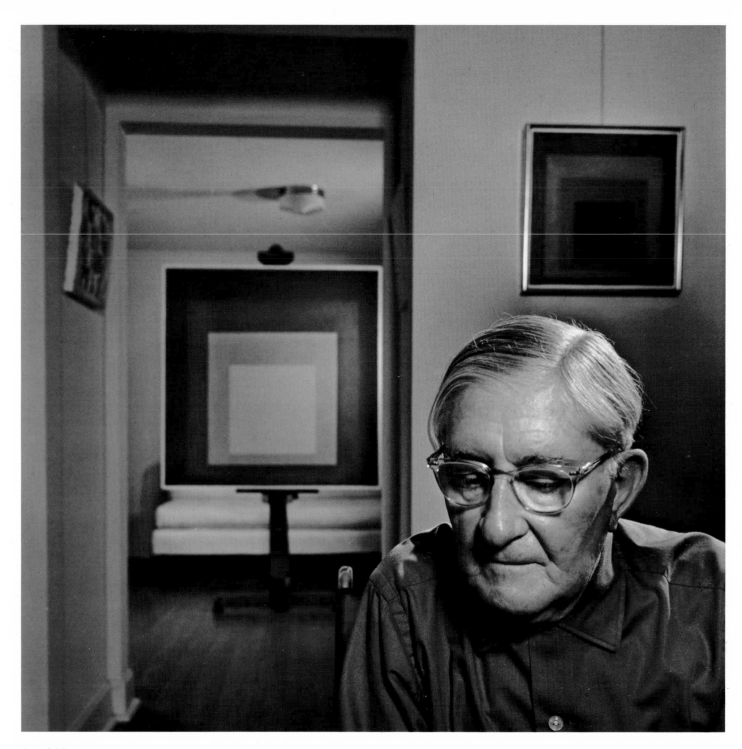

Josef Albers
1966

A stimulating and controversial teacher, this German-born painter has brought order into our perception of color in *Homage to the Square,* a series concretely illustrating his theories. The exterior of Albers's home near New Haven was a typical Cape Cod cottage. To step over the threshold was to enter the Bauhaus of prewar Germany. Albers, a Professor of Art at Yale, and his wife, Ani, a noted weaver, welcomed us on a hot July day. When we paused during our photographic session for a respite from the extreme heat, Ani came down the stairs with two freshly laundered white shirts, one for her husband and one for me. The Alberses spoke of their first years in America at Black Mountain College, where they had come to teach after having been rescued from the Holocaust through Abby Aldrich Rockefeller's committee. Their first summer loomed endless before them for they had no money to travel. Ten of their students promptly invited their by-then-beloved teachers to spend one week as guests with each of their families. "We really learned about the spirit of America," Ani said, with tears in her eyes, "the generosity, the caring."

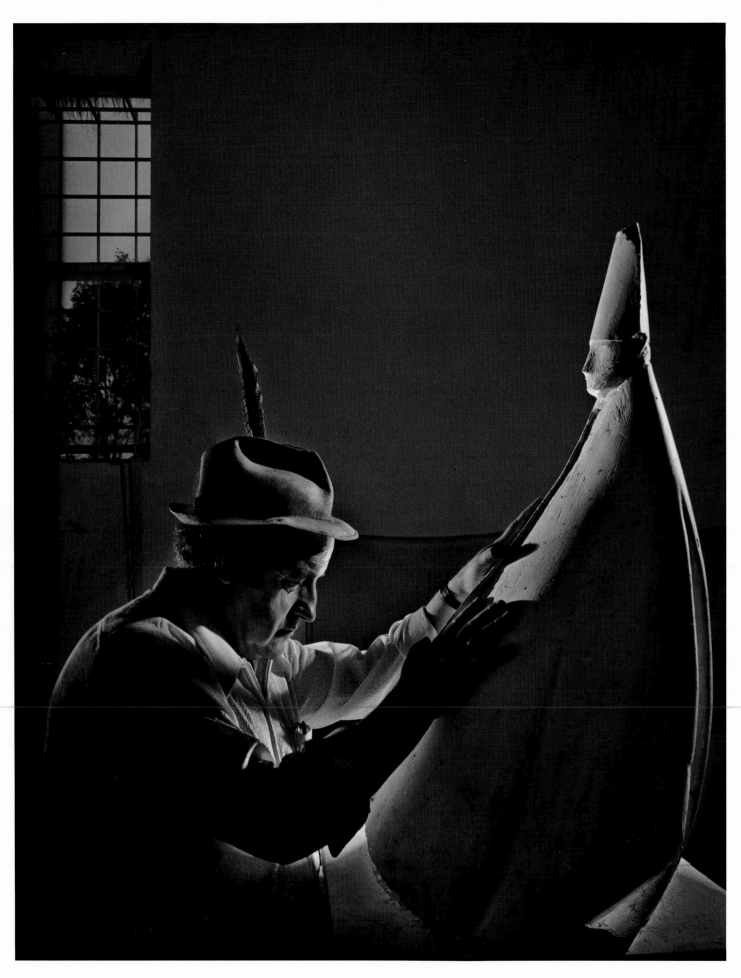

Giacomo Manzù
1970

Manzù's fascination with cardinals stems from his youth in the medieval hill hown of Bergamo. The processions of clergy moving with stately grace in their gorgeous pyramidal robes etched themselves on his inner eye.

Alberto Giacometti
1965

Shortly before his death I photographed a pain-wracked Giacometti surrounded by his elongated sculptures of his brother, Diego. Afterward, we talked quietly in the narrow street, where the tranquil blue sky made more poignant the transience of life.

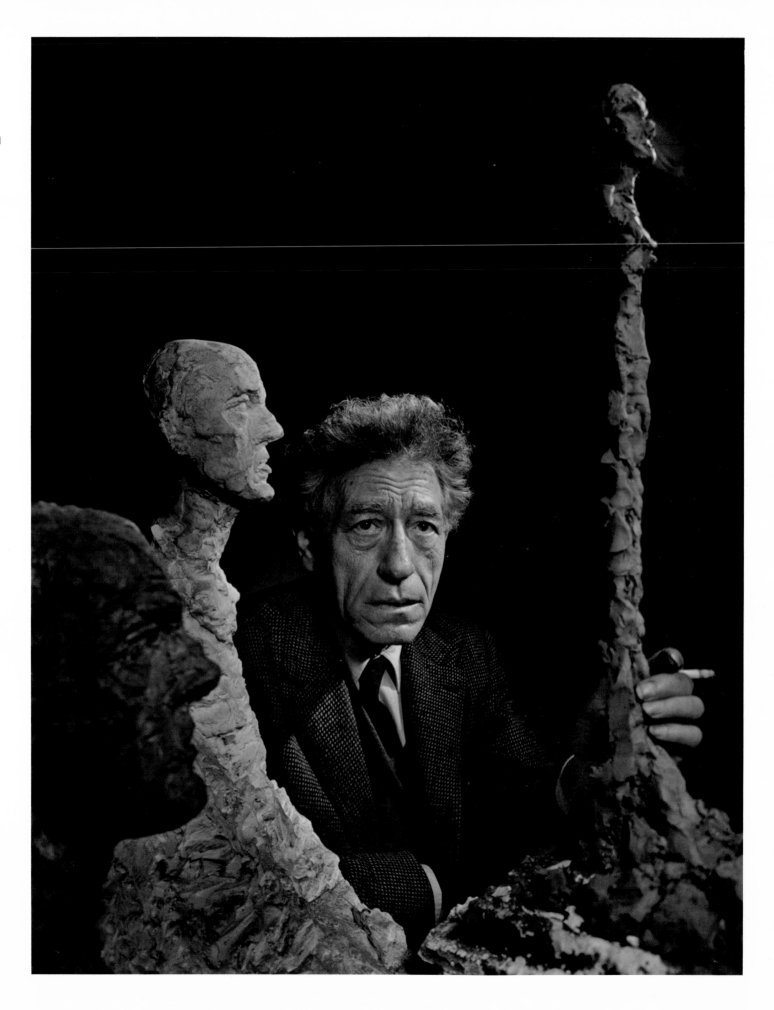

Nahum Gabo
1966

The Russian Constructivist sculptor and his long-lost brother, the artist Anton Pevsner, were finally reunited in America after his brother recognized one of Gabo's works in an exhibition.

Pablo Picasso
1954

To everyone's amazement, the "old lion" not only kept his photographic appointment with me at his ceramic gallery in Vallauris, but he was prompt and wore a new shirt. He could partially view himself in my large format lens, and intuitively moved to complete the composition.

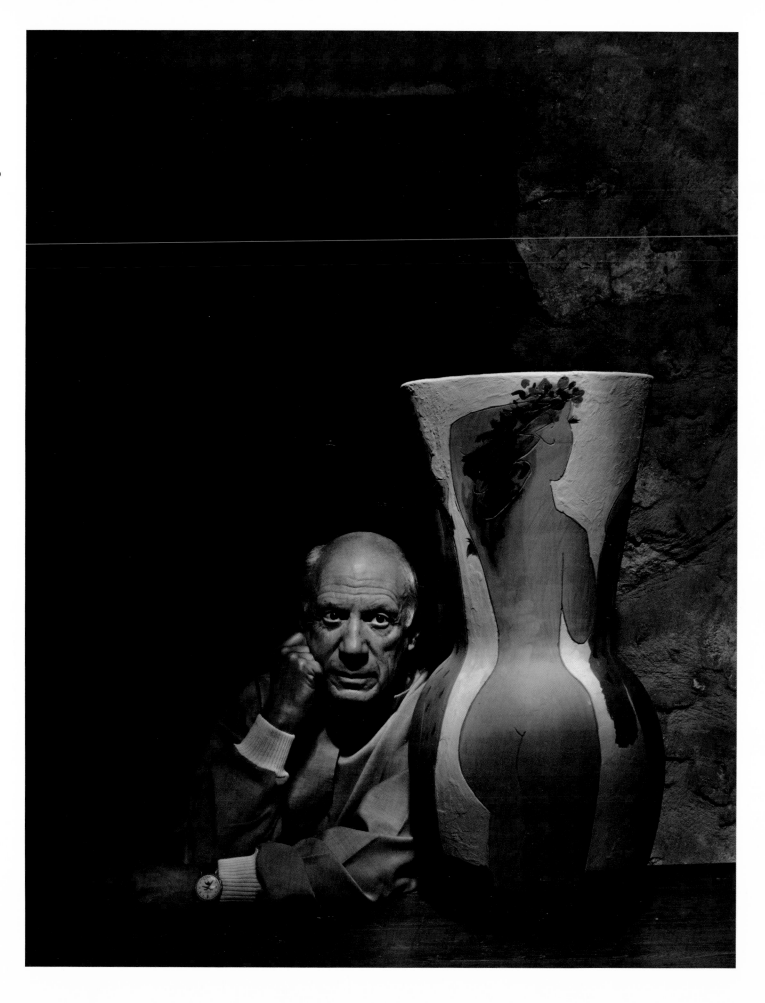

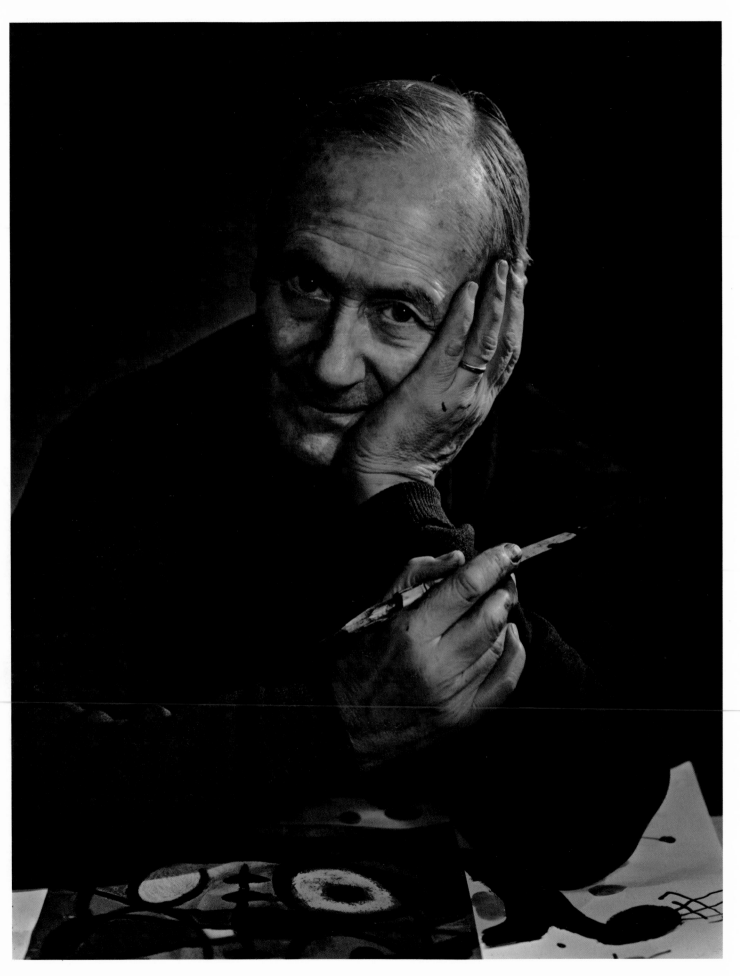

Joan Miró
1965

Although he painted his inner fantasies with the brightest colors, the great Surrealist arrived at Galerie Maeght self-effacing and subdued, dressed like a banker on holiday. Only when I suggested to him that he don his work clothes did his childlike whimsy assert itself and his humor peeked through.

Photographer, painter, Surrealist, Dadaist, pioneer in cinematic techniques who chuckled at "becoming a legend in his own lifetime." This inventive artist and lovable human being said to me, "I have no problems, only solutions."

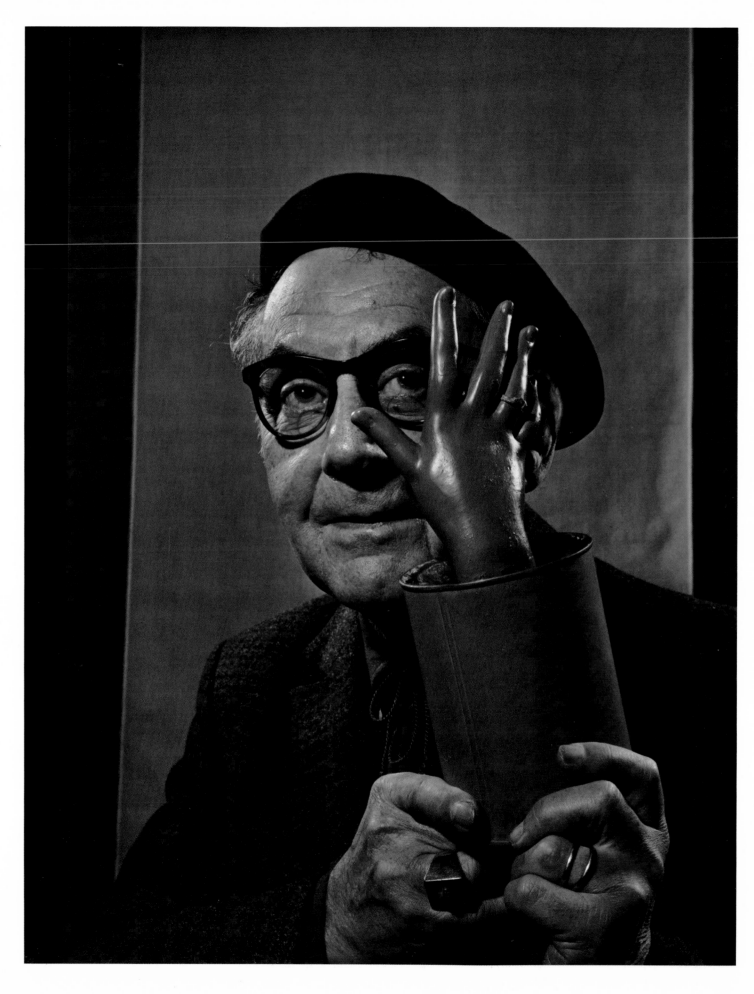

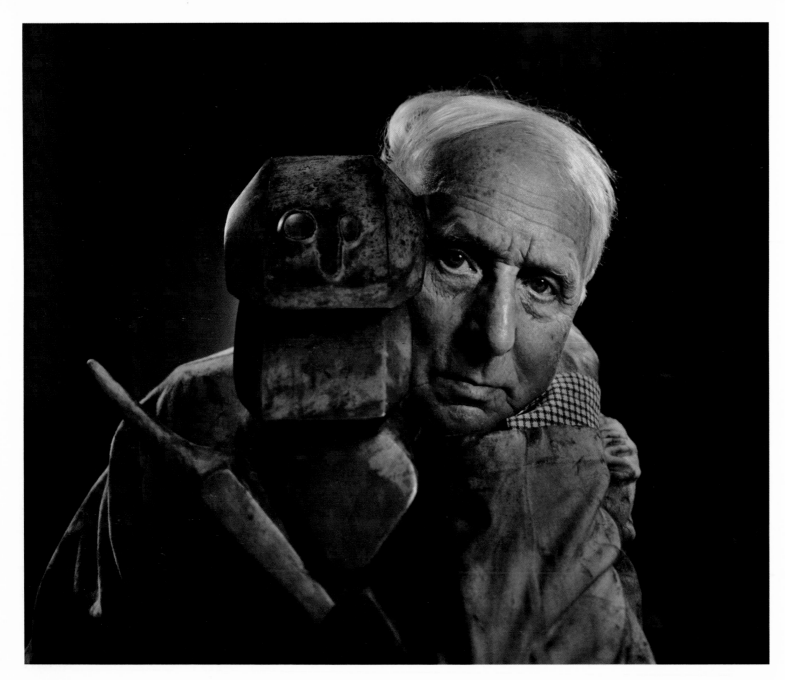

Max Ernst
1965

The aging pioneer of Dada-
ism and Surrealism lived in
Tours in a château furnished
with élan and imagination –
and a tiny mobile, a
treasured birthday gift from
his friend and neighbor,
Alexander Calder.

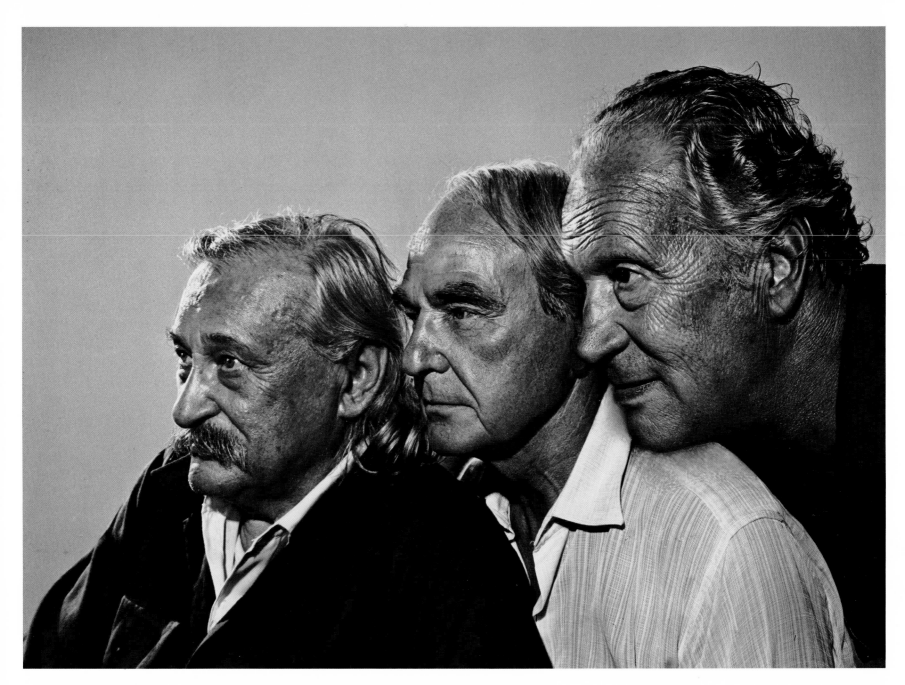

Three Men on a Mountain:
Jacques Lipchitz,
Henry Moore, Marino Marini
1970

One splendid summer in
Tuscany at the suggestion of
my friend Sir Denis Hamilton
of the London *Times,* three
giants of contemporary
sculpture, warm friends and
respectful of each other's
genius, gathered at Marino
Marini's home for photog-
raphy, after we had all jour-
neyed to the Carrara marble
quarries.

Ansel Adams
1977

A superb photographic artist and my caring friend, he always remained true to his vision and to preserving the grandeur he captured in his unsurpassed testaments to the glory of nature.

Emilio Greco
1970

In his sculpture, this mystical gentle artist from Siracusa combines Japanese refinement of line with Western sensuality. During the sessions in which he invited my wife to be sculpted, she taught him George Gershwin songs and he produced a portrait bust of lyric beauty.

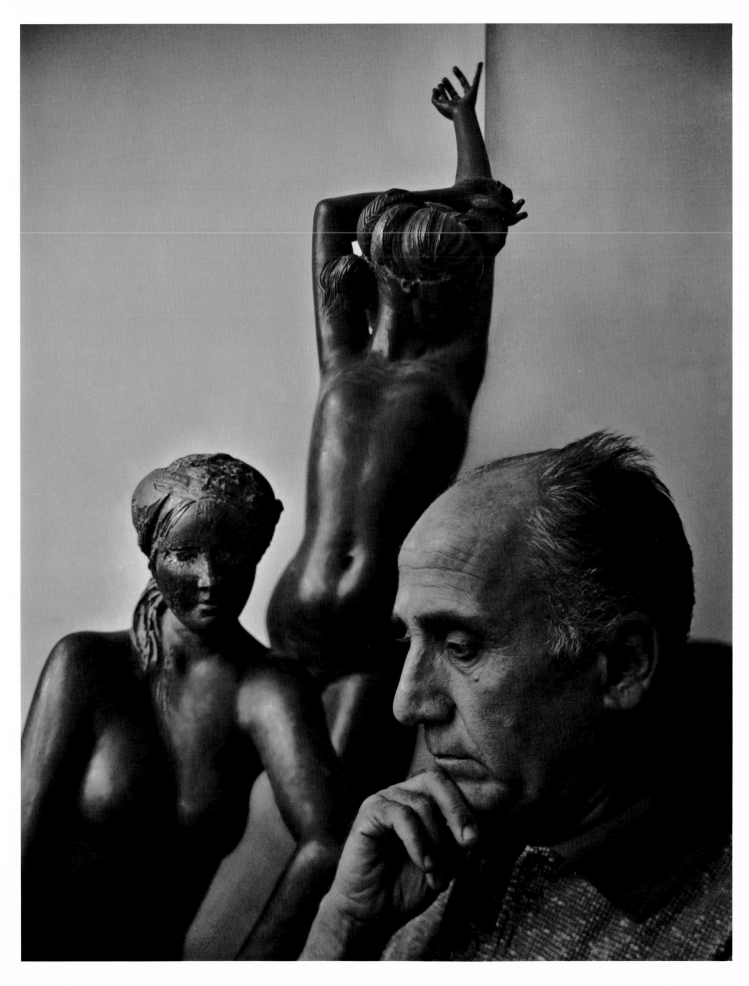

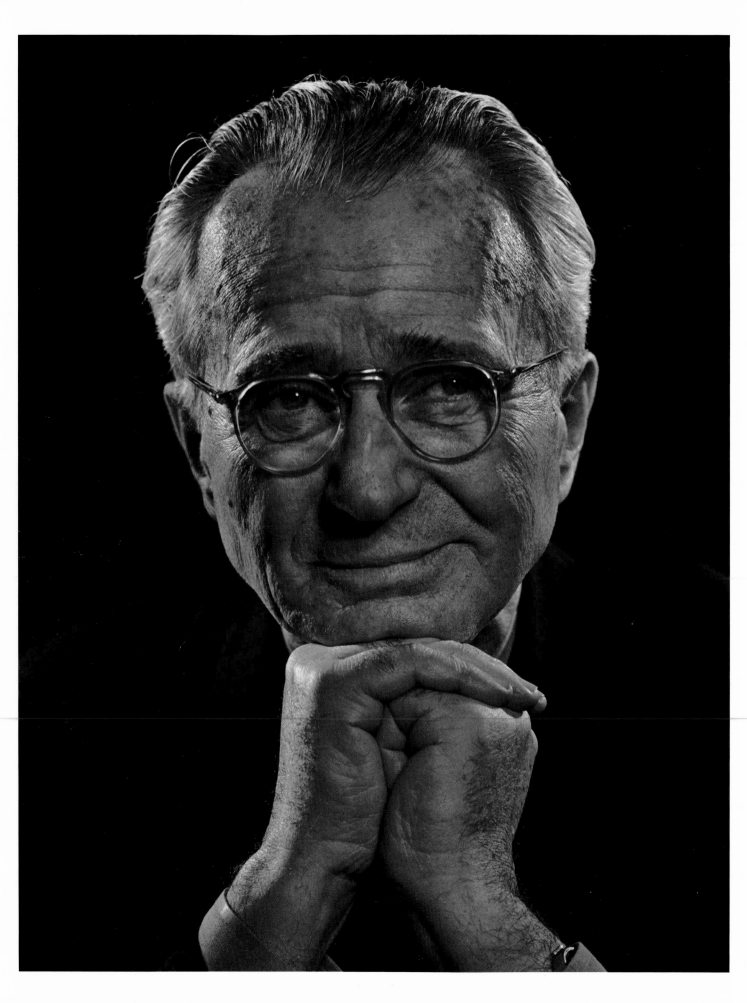

Edward Steichen
1944

Steichen pioneered in establishing photography as an art. He brought to every branch of photography his inventive genius. I was commissioned to photograph him during the Second World War, when he was a Naval Commander. The prospect of photographing such a giant was awesome. I was so tense and nervous that the first unsatisfactory result made me timorously request a second sitting, to which a patient and understanding Steichen acquiesed. Years later we were to laugh about this when my wife Estrellita and I were guests of Steichen and his wife Joanna at their Ridgefield, Connecticut, home in the 1960s. Steichen told me he had feelings similar to mine when he was a young photographer in pre-World War I France. "I got as far as the iron gate near Monet's château," Steichen reminisced, "and the day was hot and my equipment heavy – but I was too in awe of the great artist even to ring the bell."

Edward Steichen
1965

In his later years, Steichen
resembled an Old Testament
patriarch.

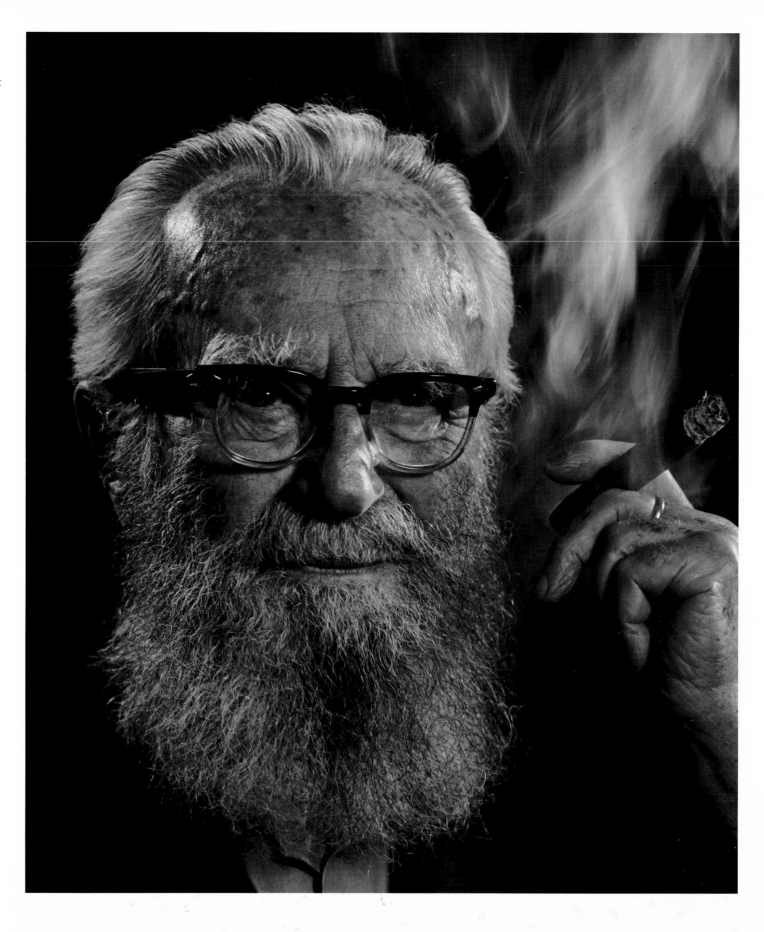

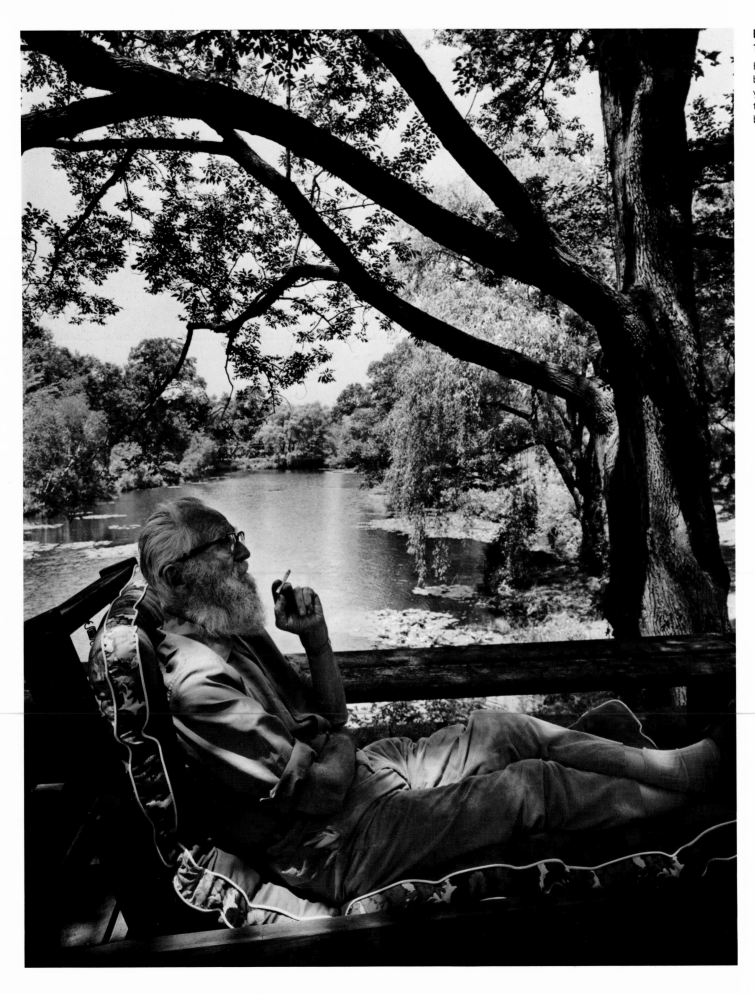

Edward Steichen
1967

His beloved shad blow tree bloomed only a few days a year, and Steichen reveled in the poignancy of its transient beauty.

Edward Steichen
1970

On one of my last visits to
Steichen, he felt premoni-
tions of death and showed
me the rock under which he
would have liked to be
buried.

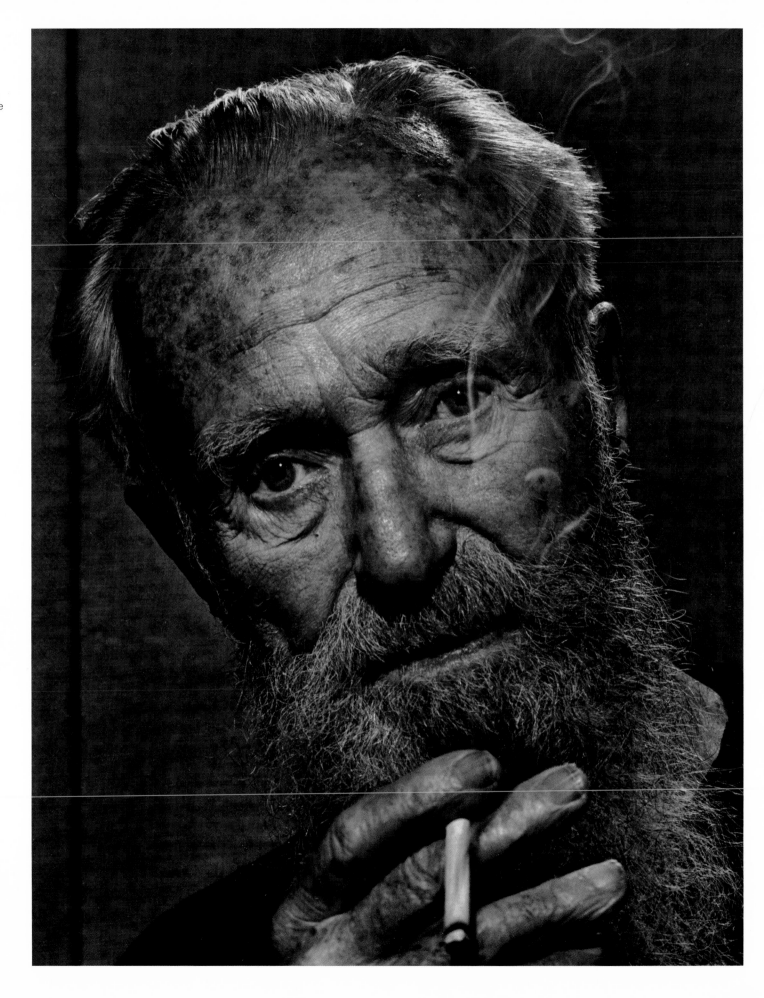

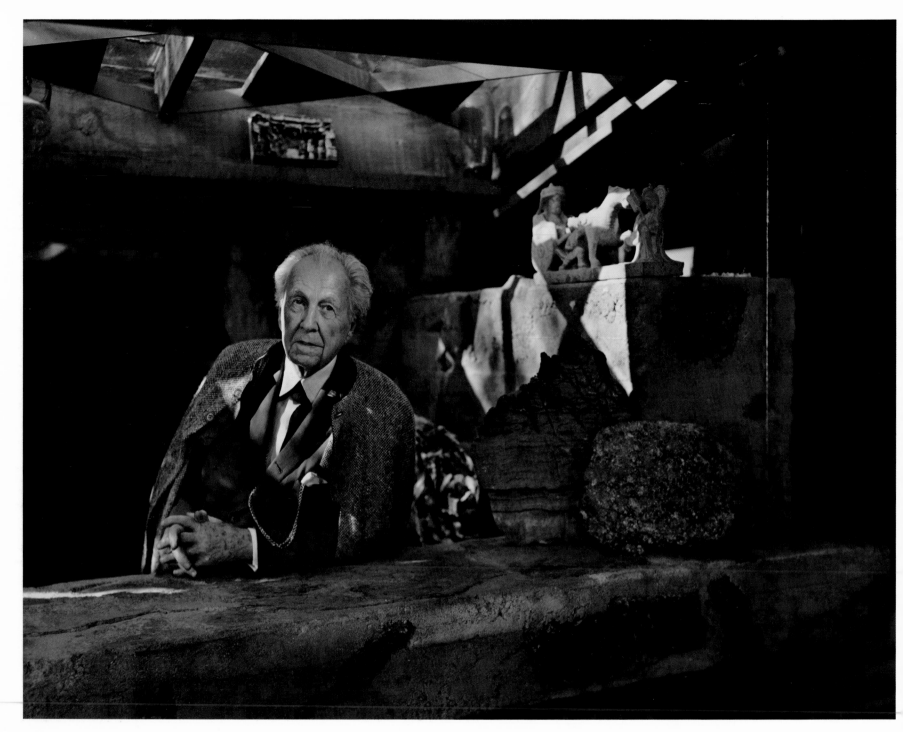

Frank Lloyd Wright
1954

At Taliesin West, his winter
home in Arizona, the flam-
boyant proponent of organic
architecture decried men
who ''scramble through life –
cutting themselves off from
the divinity within.''

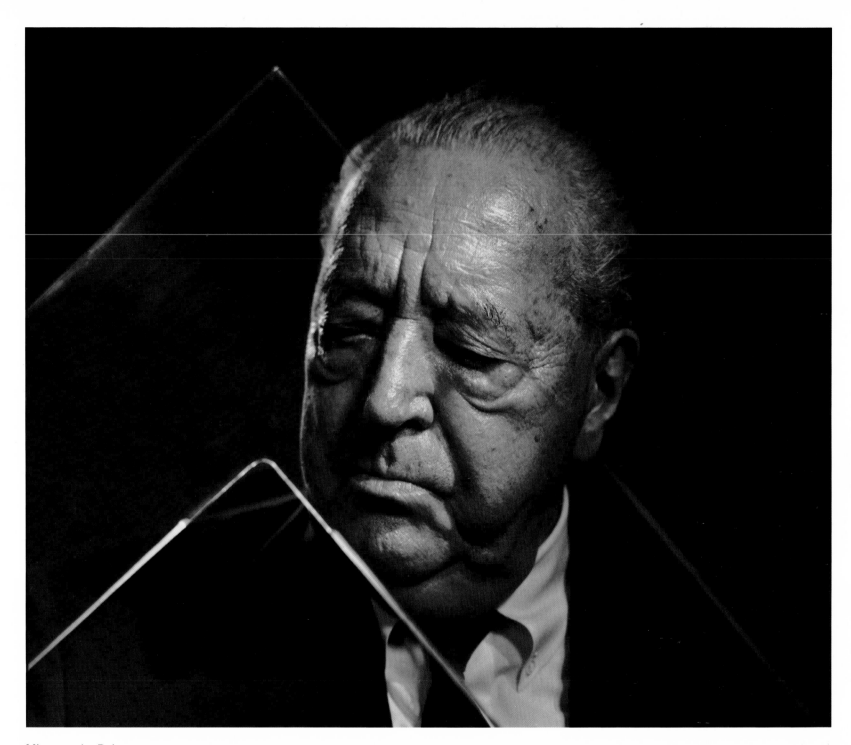

Mies van der Rohe
1962

His Chicago apartment was, paradoxically, in a most traditional building. Adorned with oil paintings by his friend Paul Klee and rows of Kurt Schwitters collages, his apartment was reminiscent of his Bauhaus background, a setting as pure and structural as Van der Rohe's revolutionary buildings of glass and concrete.

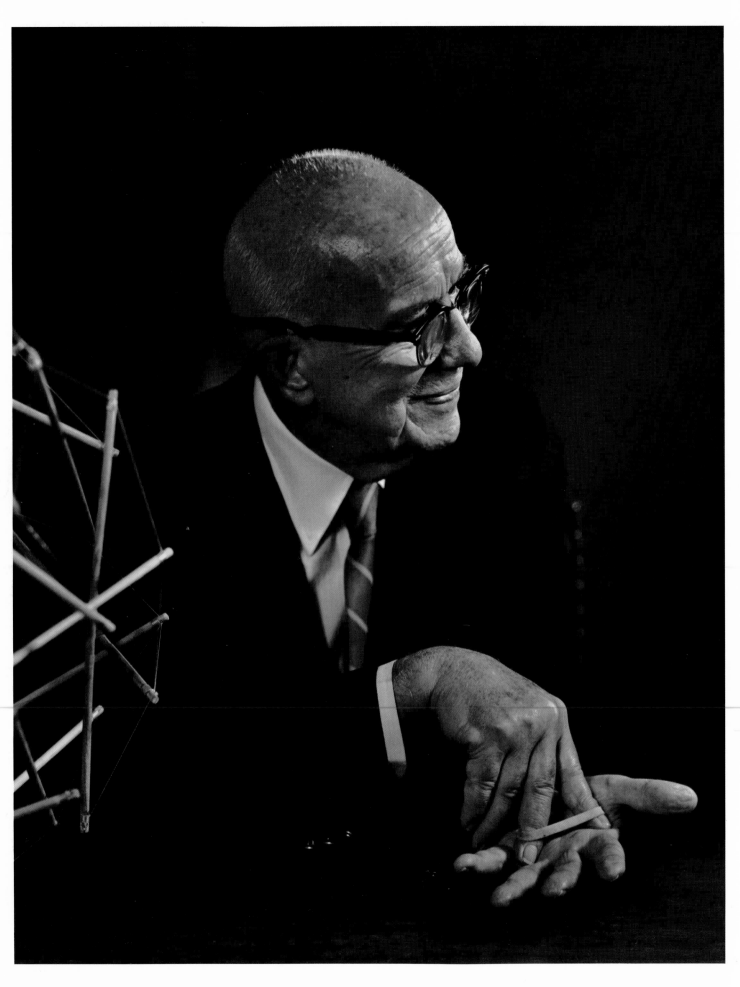

Buckminster Fuller
1980

"This man is of the sort we now call original men…the first peculiarity is that they communicate with the universe at first hand."
—Thomas Carlyle

Philip Johnson
1979

I asked this master of con-
temporary architecture
whether a twentieth-century
place of worship could be
designed whose exterior
would be as beautiful as its
interior. "No," he replied,
"this is not the Middle Ages,
and we no longer build
Gothic cathedrals."

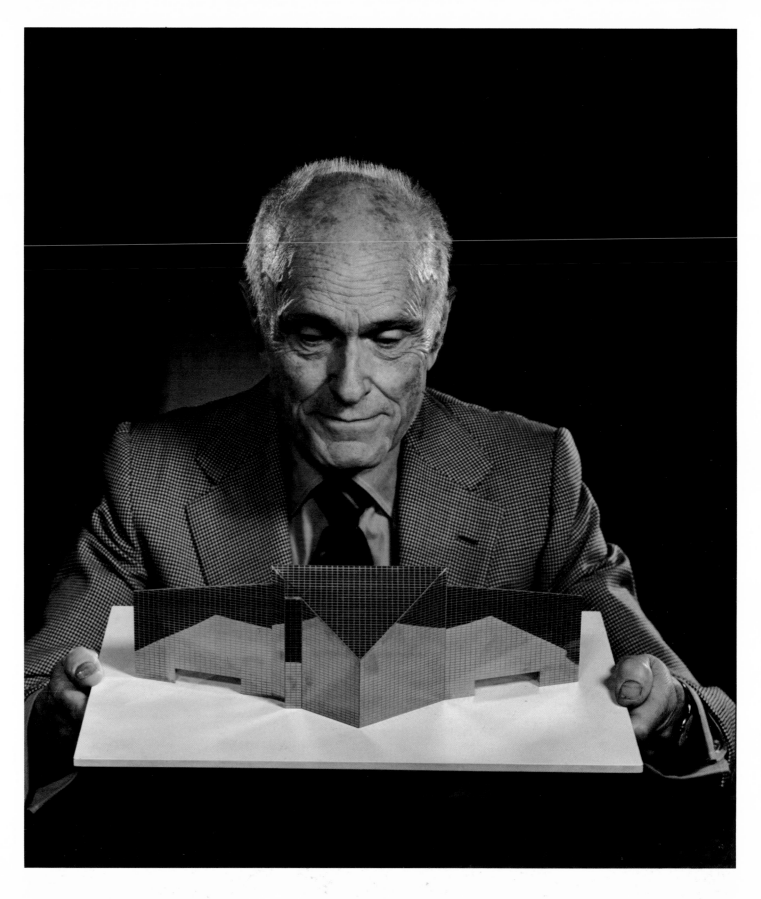

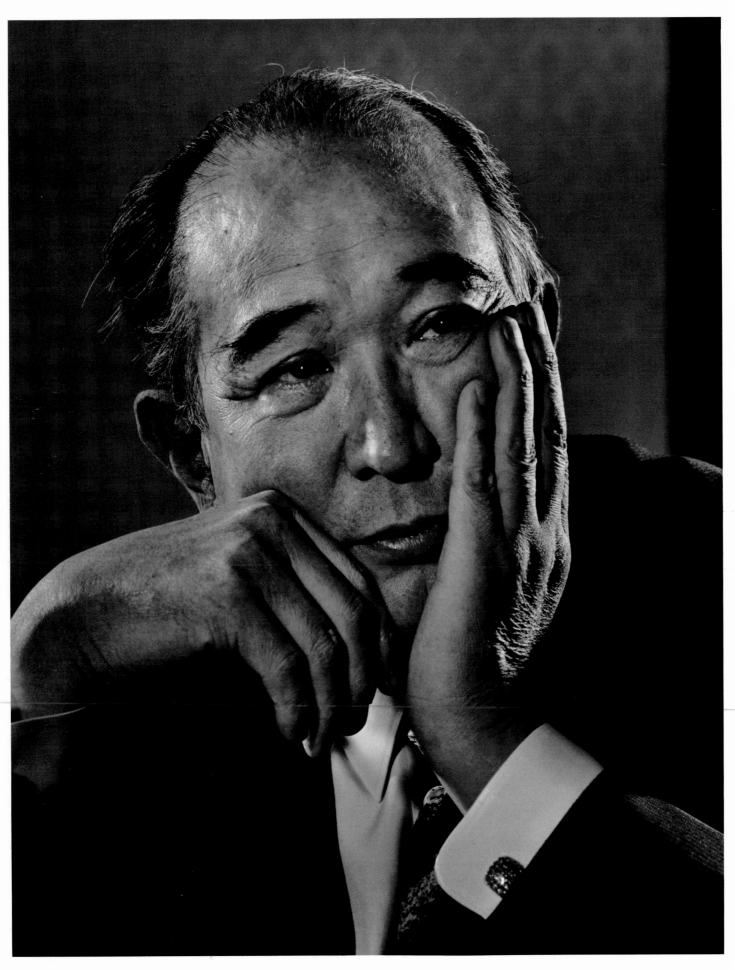

Akira Kurosawa
1969

One of Japan's ''Living Human Treasures'' and a master of the cinema. At the time of this portrait, he had just emerged from a period of intense self-doubt to produce yet another classic film destined to be studied by students of cinematography the world over.

Andy Warhol
1979

His world recognition began as glorifier of the Campbell's Soup can. He is ubiquitous, the perennial guest of those who influence our era. In this age of instant communication, he remarked prophetically, "everyone will be world-famous for fifteen minutes."

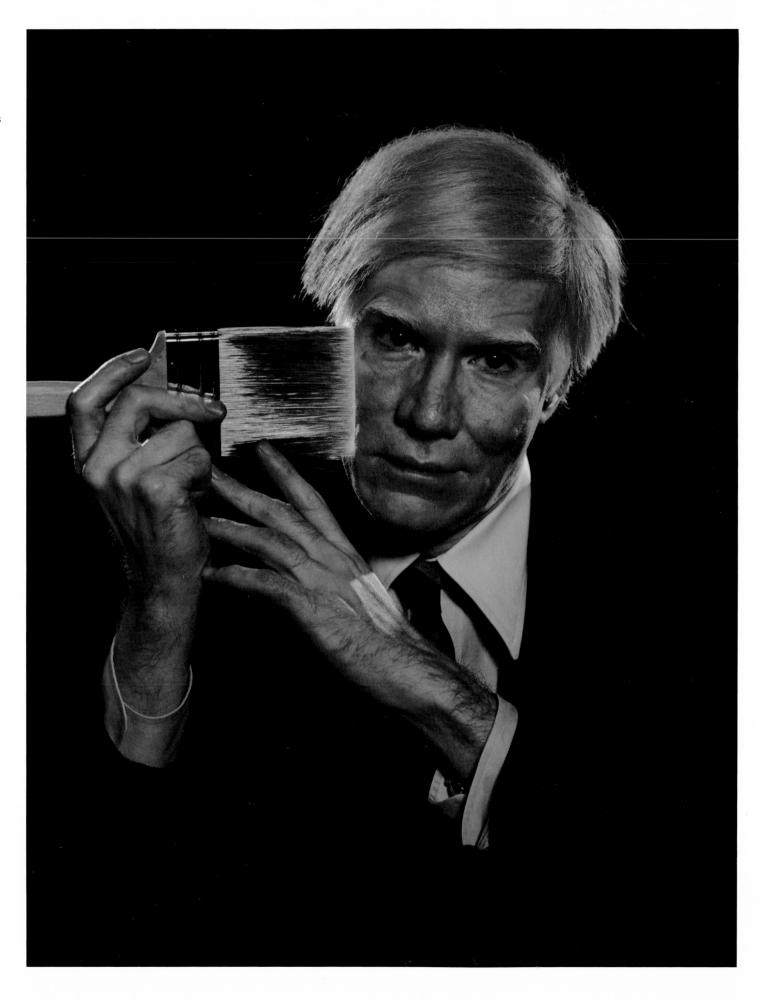

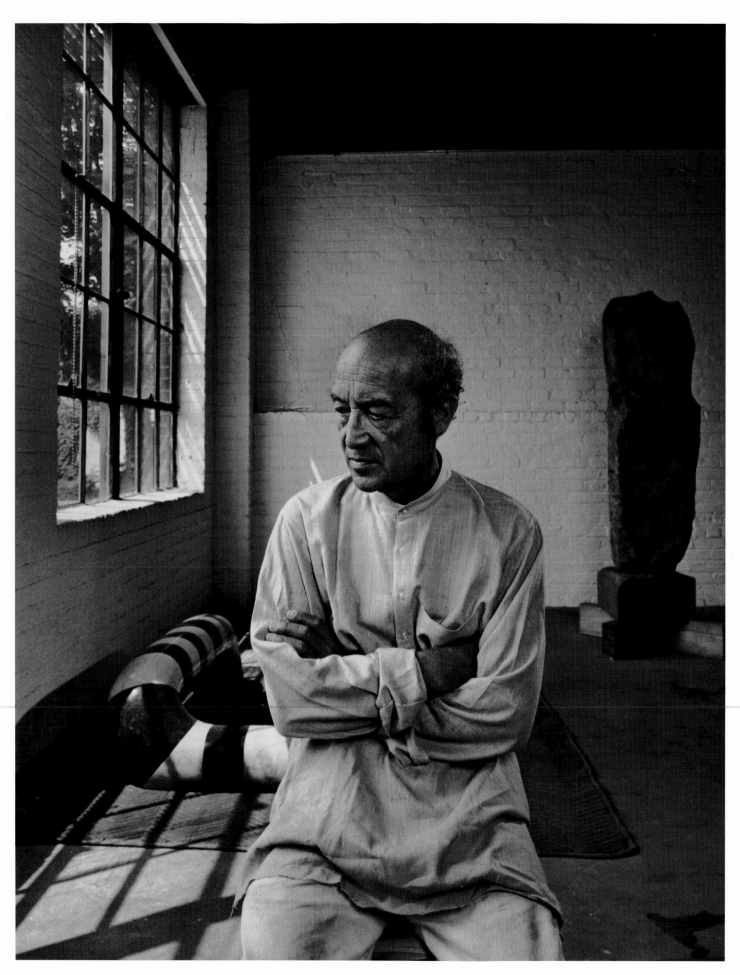

Isamu Noguchi
1980

Whether the subject of America's best-known sculptor is a children's playground, a lamp, a chair, a fountain, all partake of whimsical inventiveness. He spends half the year in Japan and the other half in the United States – reinforcing his ties with both traditions of his Japanese-Irish heritage.

Pierre Soulages
1965

The elegant French abstract painter welcomed me to his newly renovated Paris studio. He assumed a relaxed pose which contrasted with the geometric angles of the ceiling beams.

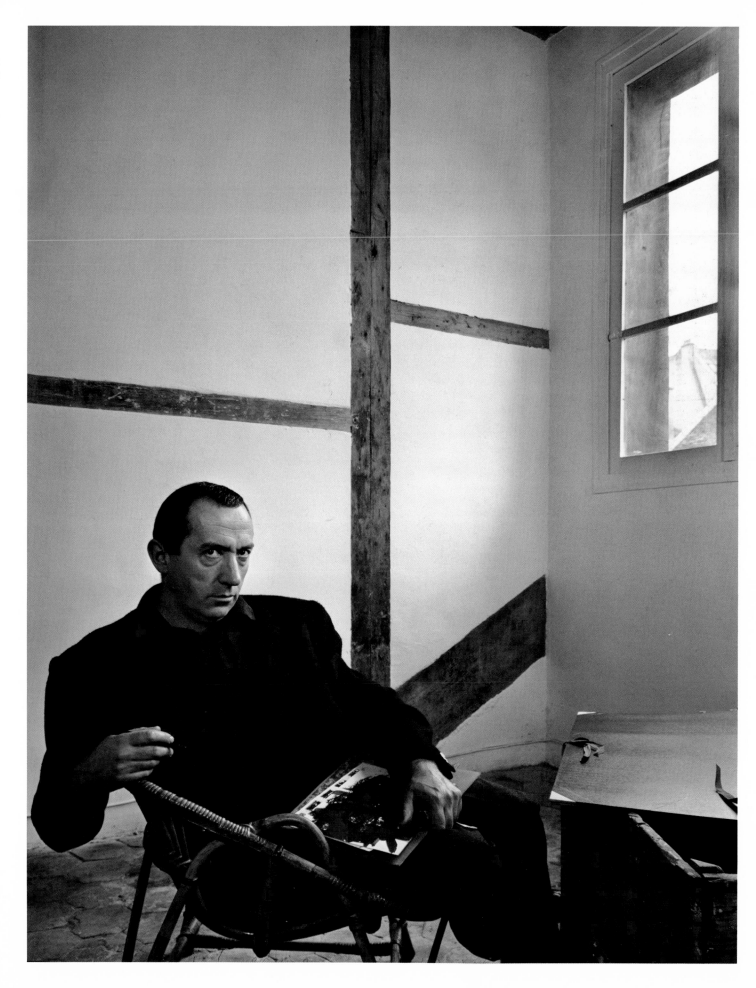

8 Scientists and Physicians

My fascination with scientists may well stem from my original desire to be a physician. Therefore, it has been especially meaningful to me to portray those men and women who are devoted to the art of healing. I have had the privilege of being welcomed into their consulting rooms, operating theaters, and laboratories where significant advances for the benefit of human welfare were being accomplished. Although these men and women differ in their outlook and personality, they are united by their common desire to relieve suffering. In the healing arts I have found that the greatest physicians were the ones who had compassion and cared deeply for their patients. Treatments and illnesses may change, but the very special relationship between the doctor and the patient will always be the cornerstone of medicine. I have often thought of this special relationship, when the rapport between the photographer and the sitter is not unlike that established in a doctor's consulting room, where a patient does not fear to reveal his inner self to a trusted physician.

Thomas S. Cullen
1947

This Johns Hopkins surgeon, whose book on gynecology was the standard text for years, was a splendid example of a physician who cared. He brought a hopeful atmosphere of warmth and reassurance into the sickroom. To a poor woman, apprehensive about the extent of her forthcoming surgery and the size of her bill, he said, "I think I know what you want me to do–as much as necessary, but as little as possible." I later learned that the payment Cullen received for her operation was his most cherished fee–a sack of hickory nuts, which the woman's grateful husband placed on his doorstep on Christmas Eve.

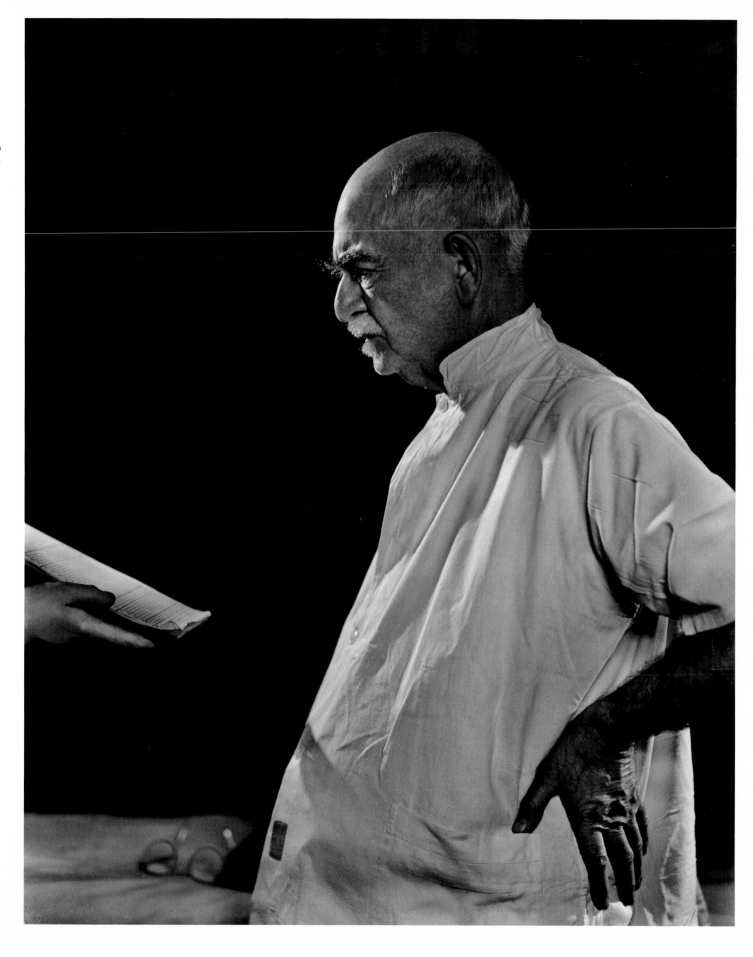

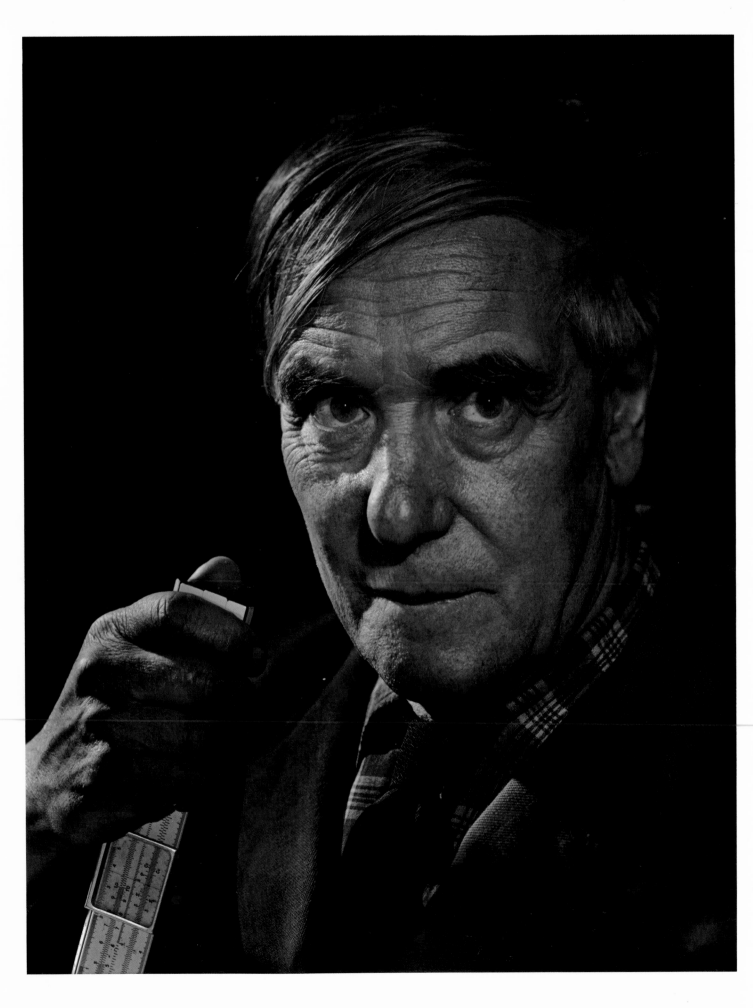

Peter Kapitsa
1963

In sharp contrast to the spirit of freedom of inquiry I had come to expect among scientists, my photographic meeting with the great Russian theoretical physicist Peter Kapitsa in Moscow was especially poignant. When we met, he had left Oxford University in England, where he and his family had emigrated, for a proposed short journey to Russia for a professional meeting. The visit had been made permanent by an insistent government. The Russians understood that his intellectual needs – problems to solve and a place to work at the Institute for Physics – would transcend all political boundaries.

When I photographed him the phrase "body language" was not yet in vogue but, in retrospect, his stance and tightness of shoulders and arms seem indicative of feelings of entrapment and suppression. Kapitsa's productivity as a problem solver continued, but I felt that within him there must have been spiritual sadness.

Helen Taussig
1975

Although Helen Taussig was the daughter of a famed Harvard economist, she could not attend Harvard Medical School because it did not then accept women. She went, instead, to Johns Hopkins University, where an early suffragette had willed funds for women medical students. She told us her career really started when an indifferent male professor threw an ox heart at her and said cavalierly, "See what you can make of this." She had indeed made much of this early challenge when years later, as Director of Johns Hopkins Pediatric Clinic, her compassion was aroused by the tragedy of the "blue babies." The infants' red blood cells were so starved of oxygen by a malfunctioning heart that the infants literally turned blue, and eventually died. The surgical process she proposed to Dr. Alfred Blalock gave these children a reprieve on life. As we walked through the cardiac clinic named for her, the children seemed to sense that someone tender and caring was near; some of them jumped up and down in their cribs to greet her. It was one of these children, who had just had the Blalock-Taussig operation, with whom I photographed the then seventy-seven-year-old pediatrician, still active and vital twelve years after her official retirement. The young patient's mother told me how moved she had been when her child returned from the operating room. The blanket fell open to reveal his little toes, formerly a cyanotic blue, now glowing a healthful pink.

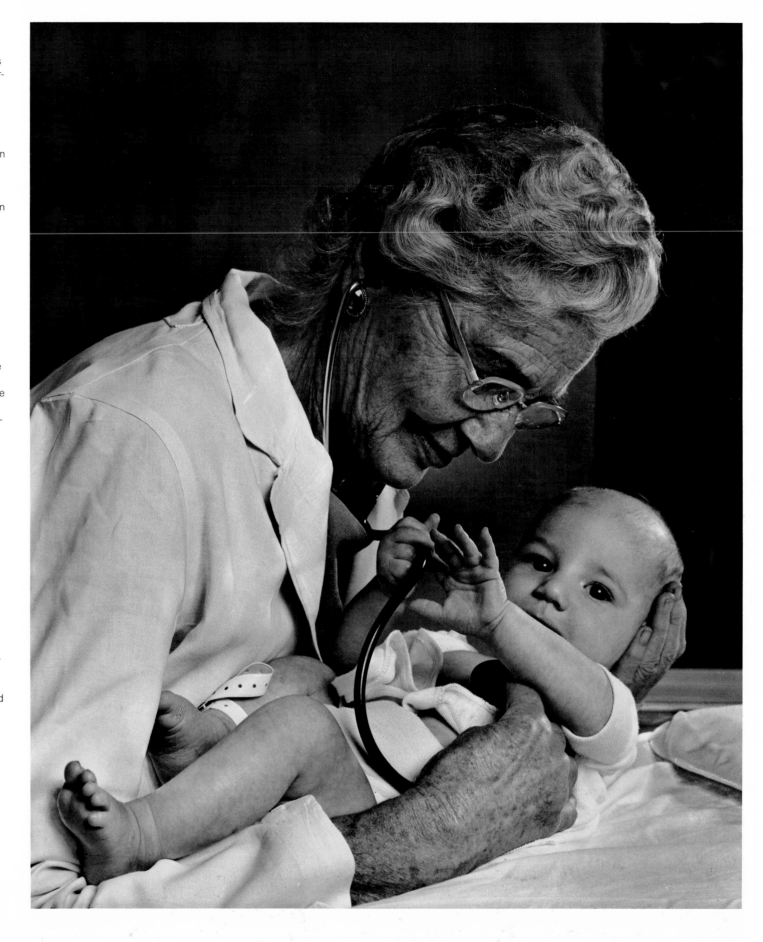

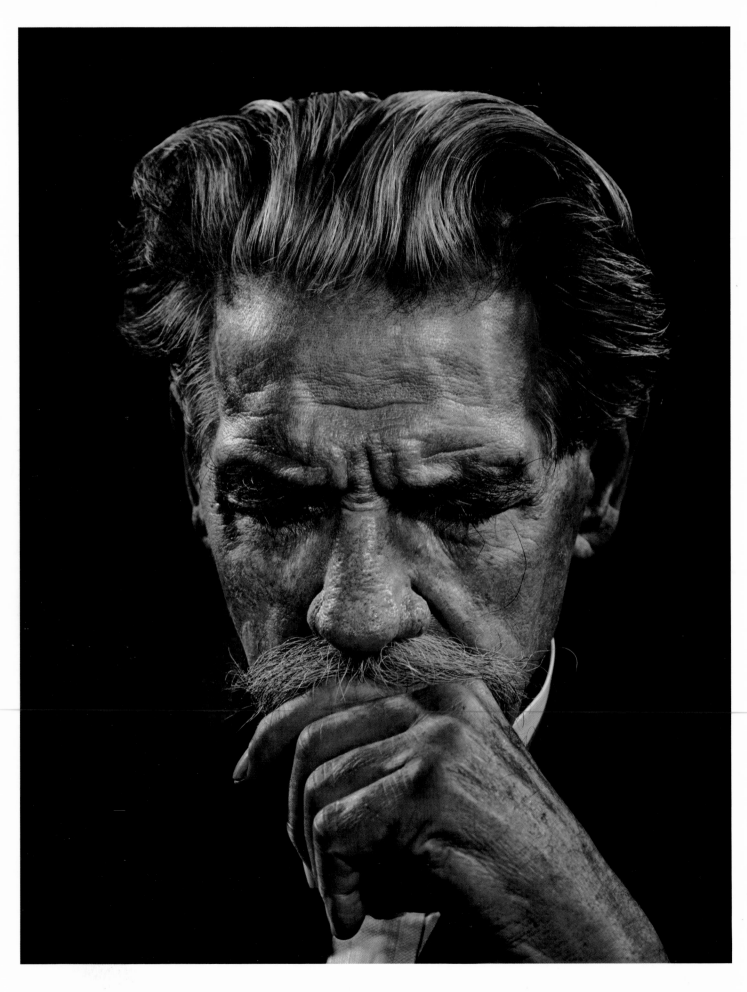

Albert Schweitzer
1954

"Which," I asked this humanitarian and Nobel Peace Prize winner, "is the greatest of the Ten Commandments?" "Christ gave only one commandment," replied Schweitzer, "and that was love."

Albert Einstein
1948

At Princeton's Institute for Advanced Study, I found Einstein a simple, kindly, almost childlike man, too great for any of the postures of eminence. One did not have to understand his science to feel the power of his mind or the force of his personality. He spoke sadly, yet serenely, as one who had looked into the universe far past mankind's small affairs.

I asked if there were any connection between music and mathematics. "In art," he said, "and in the higher ranges of science, there is a feeling of harmony which underlies all endeavor. There is no true greatness in art or science without the sense of harmony. He who lacks it can never be more than a great technician in either field."

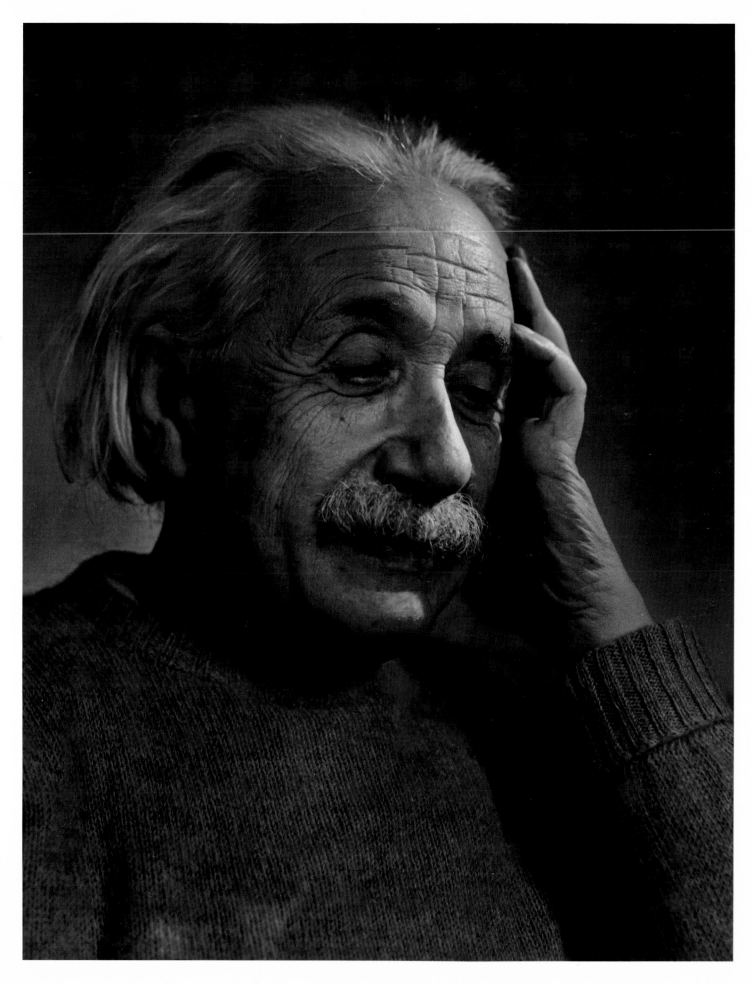

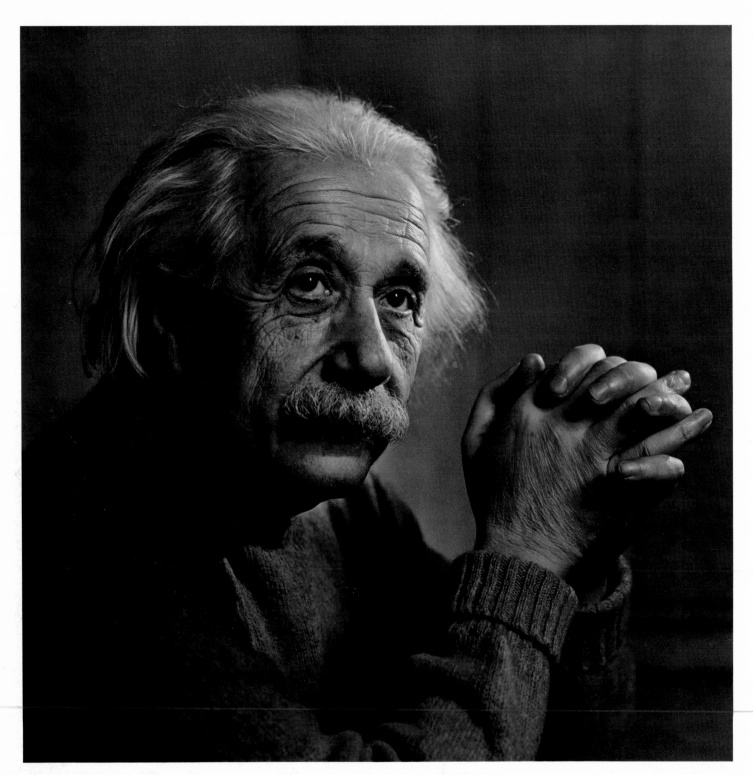

Albert Einstein
1948

"Curiosity has its own reason for existence…never lose a holy curiosity."

Carl Jung
1958

The Swiss psychiatrist, in his
library in Zurich, agreed with
the title of James Thurber's
book *Let Your Mind Alone*.
"But," he remarked, "unfor-
tunately your mind is not dis-
creet enough to leave *you*
alone." I said I would make
an unsatisfactory patient for
the psychiatrist, because
I gained my happiness
through my work. "Ah," he
answered, "the secret of
happiness…those who seek
happiness can never find it.
You should wait till it comes,
like the arrival of a guest later
in the evening."

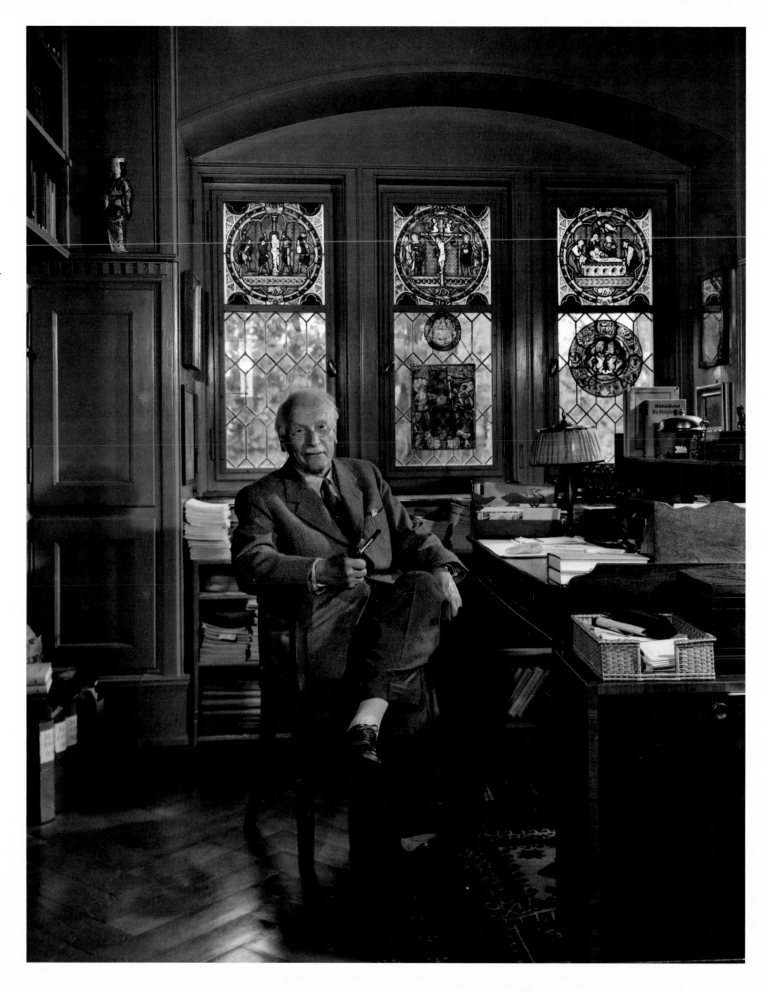

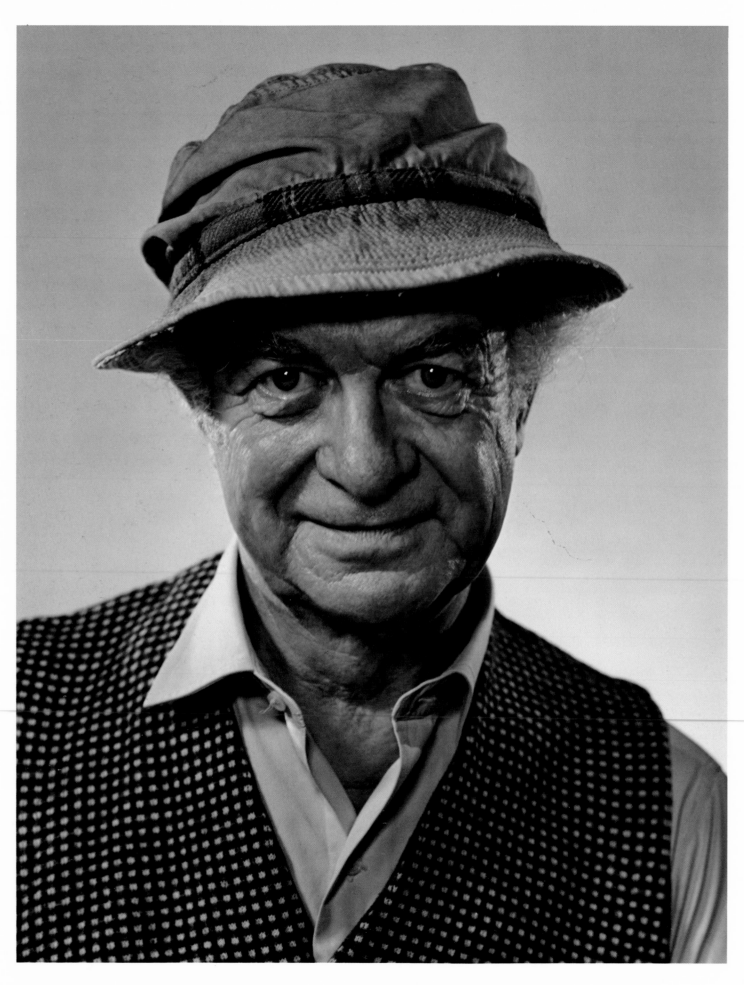

Linus Pauling
1970

On the day his first book on the benefits of vitamin C was published, I photographed the recipient of two Nobel prizes – the Nobel Prize in Chemistry and the Nobel Peace Prize. Like many men of genius he had an open simplicity and a fey, leprechaun quality, as if he were experiencing things for the first time with a childlike freshness of vision.

Philippe Cousteau
1972

The incentive for the famed oceanographer Jacques Cousteau to be photographed was my wish to include in the session his two beloved sons, the marine architect Jean-Michel, and the gifted underwater photographer and his father's collaborator, Philippe. We enjoyed the hospitality and friendship of Philippe and his wife Jean and were profoundly shocked at Philippe's untimely death in a freak accident during an expedition.

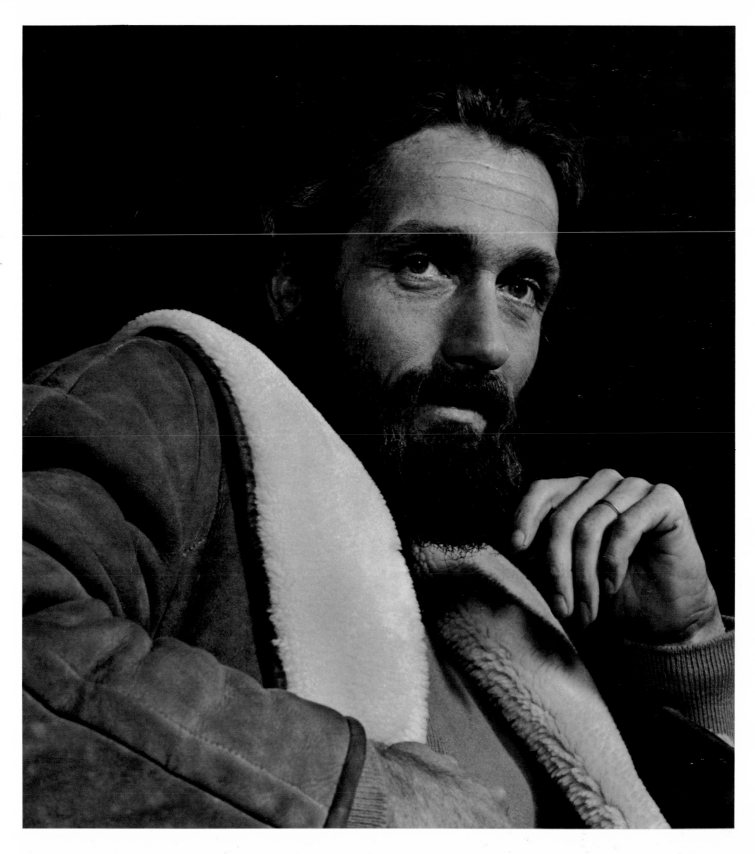

9　Musicians

Musicians are among my favorite subjects. As a group, they tend to be emotional, temperamental, and impatient – and, as a photographer, I thrive on all of these attributes. I can ignore, even enjoy, their idiosyncrasies for the sake of the divine music they create. If they are performers on an instrument, there is the element of surprise, of gesture, and the sense of the mood created by the music, even though the final photograph I have chosen for this book may not have been made in actual performance.

Some of the most profound photographic experiences I have had have occurred with musicians and composers. Two days spent with a musical titan, Sibelius, at his home in Finland, presented to him by his grateful homeland, and the meetings over the years, in Prades, in New York, and Marlboro, Vermont with the musician's musician, Pablo Casals, are among these special privileges.

Paul Robeson
1941

It came as a poignant irony to me, in reviewing the photographs for this book, that I photographed Paul Robeson the same year that I photographed Winston Churchill – 1941. One man had a sure sense of his homeland and its values, while the other had to leave it in a personal crisis of conscience, only to return broken in his later years. The doubts of Robeson's middle years brought an interruption to the bestowing of his brilliant gifts. This photograph was taken before Robeson left the United States. Here he is still the all-American athlete, the brilliant vocal artist and gifted actor who had already stamped O'Neill's *The Emperor Jones* as a personal triumph and was soon to do the same as Othello, the Moor of Venice.

I invited Paul Robeson to be photographed after hearing his concert in Ottawa. Before the building of the magnificent National Arts Centre, concerts were held in a 1920s gilded movie palace, the Capital Theatre, popularly known as "The Stable" to those who deplored its acoustics. With his magnificent voice, Paul Robeson turned the stable into a cathedral. When he came to my studio the next day to be photographed, he regaled me with Negro spirituals of such surpassing beauty that I wanted to share them with my wife. Robeson was introduced to her over the telephone, and Solange had a private concert of her own.

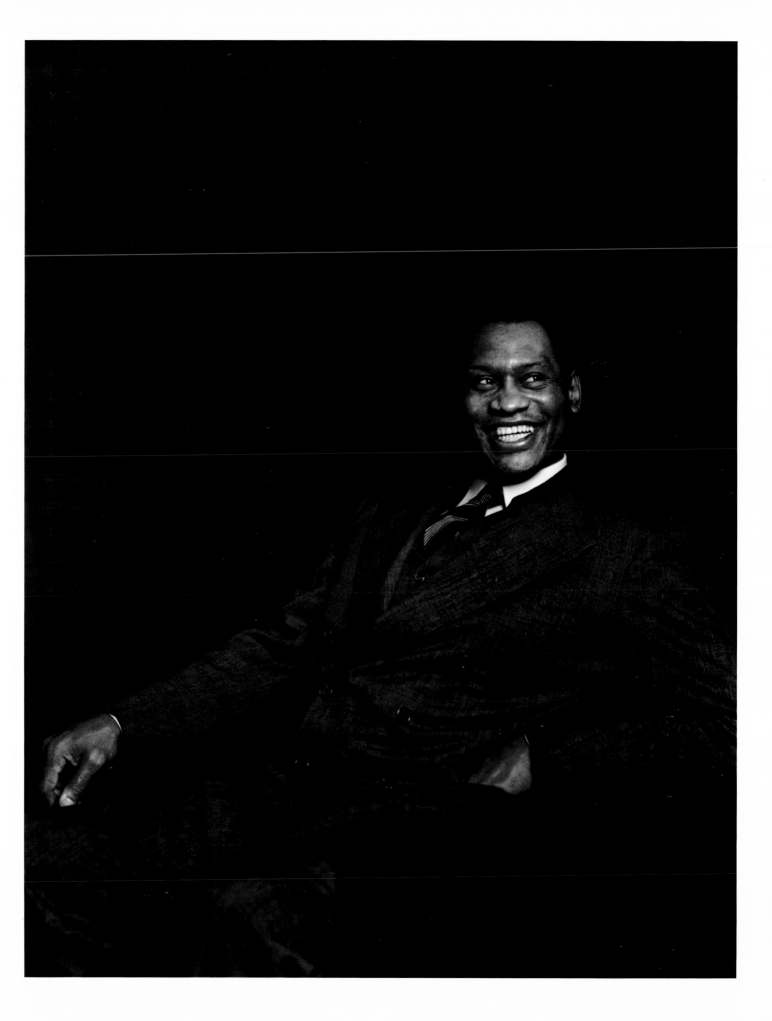

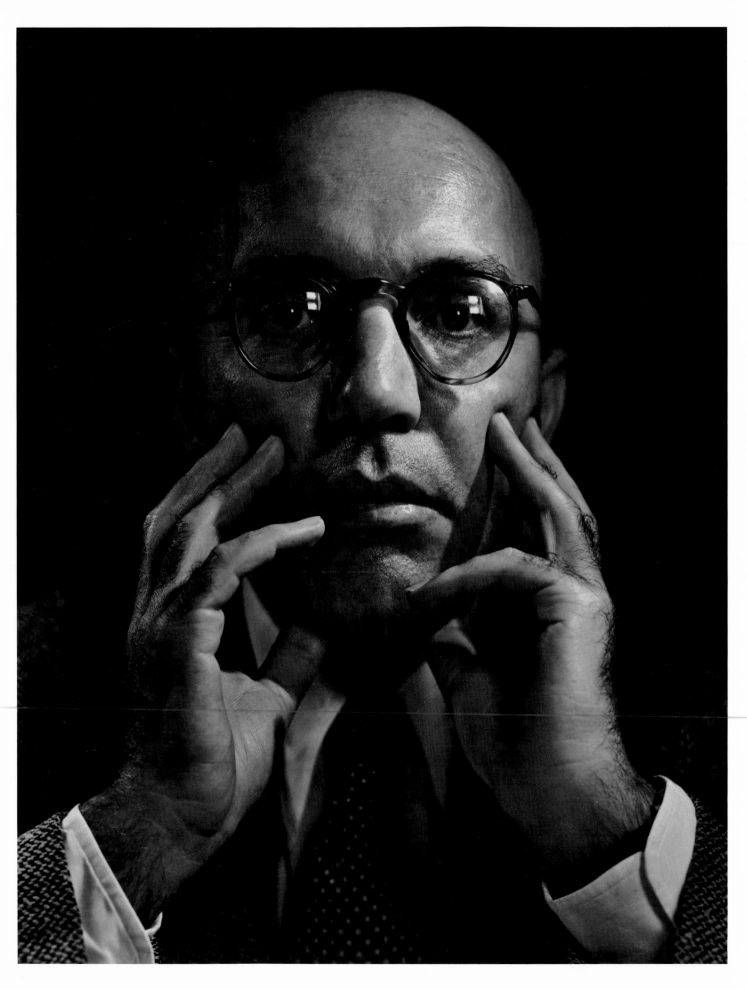

Kurt Weill
1946

The brilliant, iconoclastic German composer came to America with his wife, Lotte Lenya, in 1935 and his work soon became part of the American musical idiom. Classically trained, he carved out a new career in the United States writing innovative scores for some notable American musicals. His *Threepenny Opera, One Touch of Venus,* and *Lady in the Dark* were all certified triumphs when I photographed him at his country home in Rockland County outside New York, where, for the first time, he was enjoying financial success. "It is lots of fun to have a smash hit," he remarked happily.

The farmhouse was near a running trout stream which we both could hear and see as this photograph was being taken. The session was sometimes boisterously interrupted by his sheep dog, Woolly (pronounced with a V), a gift of his collaborator Moss Hart. His closest friend and neighbor, the playwright Maxwell Anderson, came by to run interference whenever "Voolly" tried to get in front of the camera.

Samuel Barber
1956

I photographed Samuel Barber on the same day that I photographed his companion and fellow composer Gian Carlo Menotti, in their home outside New York. When I commented on Barber's using an engineer's drafting table on which to compose music, he said that it was right and fitting, since the structure of music was akin to stress engineering, and one had to prepare the proper blueprints.

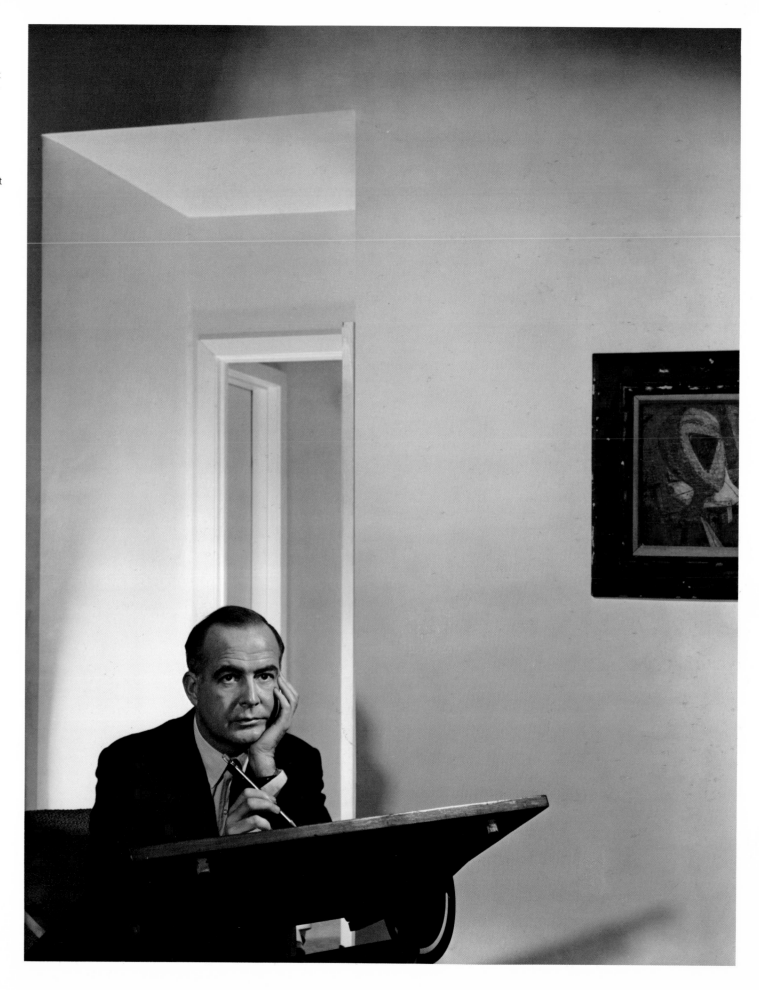

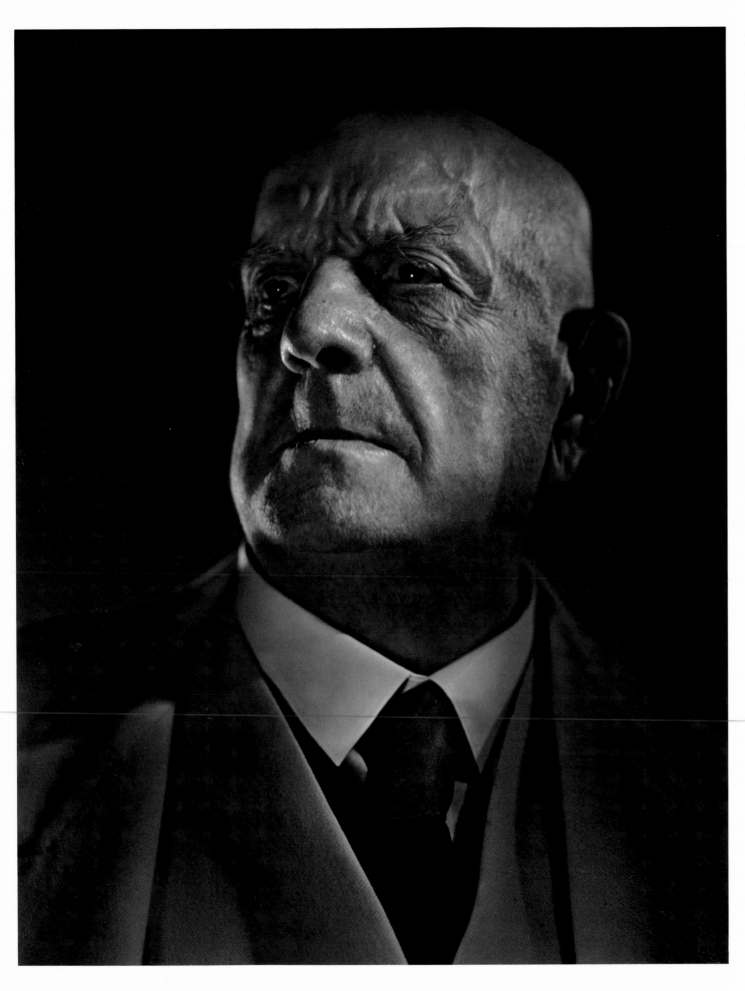

Jean Sibelius
1949

I arrived at Sibelius's home "Ainola," named for his wife Aino, laden with gifts from his admirers—an inscribed manuscript from Ralph Vaughan Williams, a warm letter from the celebrated critic of *The New York Times,* Olin Downes, a box of his favorite cigars and a bottle of old cognac from the Canadian High Commissioner in London. This last we shared with little Finnish cookies and coffee the two mornings I was with him. The strong, straight-backed patriarch of eighty-four years basked in the affection of his family, his daughter interpreting for us, although there was such a meeting of minds words became scarcely necessary.

The structure of his fine face reminded me of carved granite, yet with infinite warmth and humanity. His hands trembled, but the aura of genius was around him. This photograph was one of the last taken. He was visibly moved as I told him how the Finnish workers, in their northern Canadian logging camps, doubled their wartime output when his *Finlandia* was played for them.

Artur Rubinstein
1957

One of my earliest encounters with the challenge of temperament occurred when RCA asked Artur Rubinstein to telephone to me upon his arrival in Ottawa for a concert. The great virtuoso complied to the letter – but at two in the morning! "How long will this photograph take?" he demanded to an abruptly awakened photographer. Half asleep, I replied, "Until we are both exhausted." "I like that," he crowed, and we got along famously after that. A few days later, at the celebrated Round Table at New York's Algonquin Hotel, he gleefully shared his Canadian photographic experience with two of his musical colleagues, Leopold Mannis and Leopold Godowski, who also happened to invent the Kodachrome process. In a tone that conveyed that he had something singularly unique to impart, he conspiratorially lowered his voice and confided, "Way in the backwoods of Canada, in Ottawa, of all places, I have discovered a fine young photographer!" "Could it be Karsh?" queried Mannis. "Hush, Leopold," said Rubinstein, "you are spoiling my story."

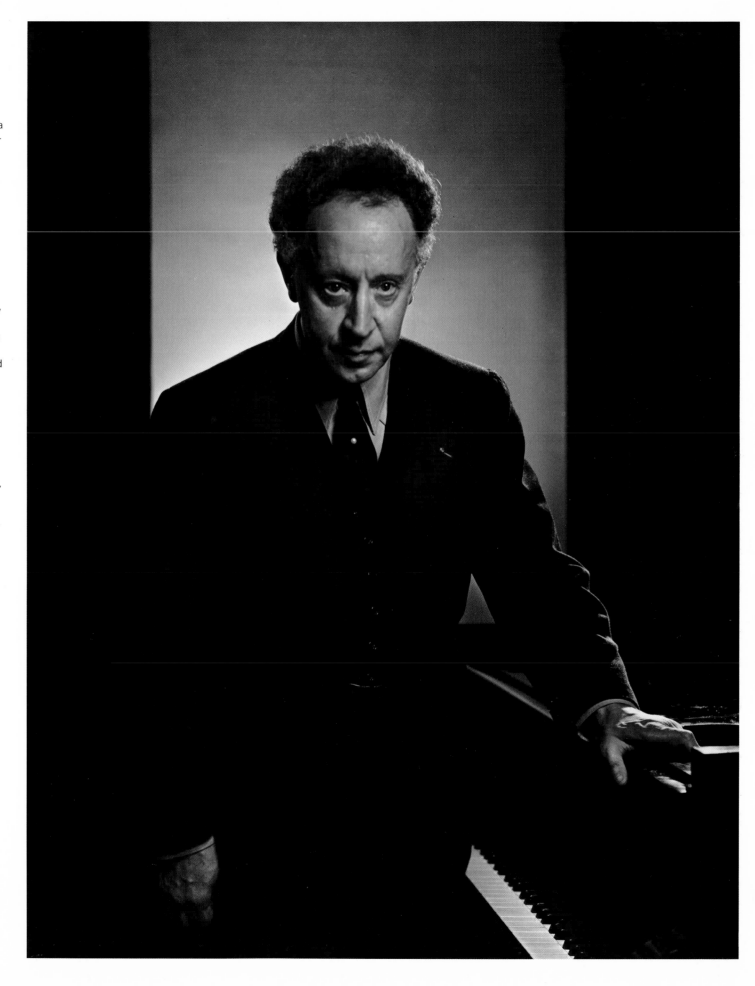

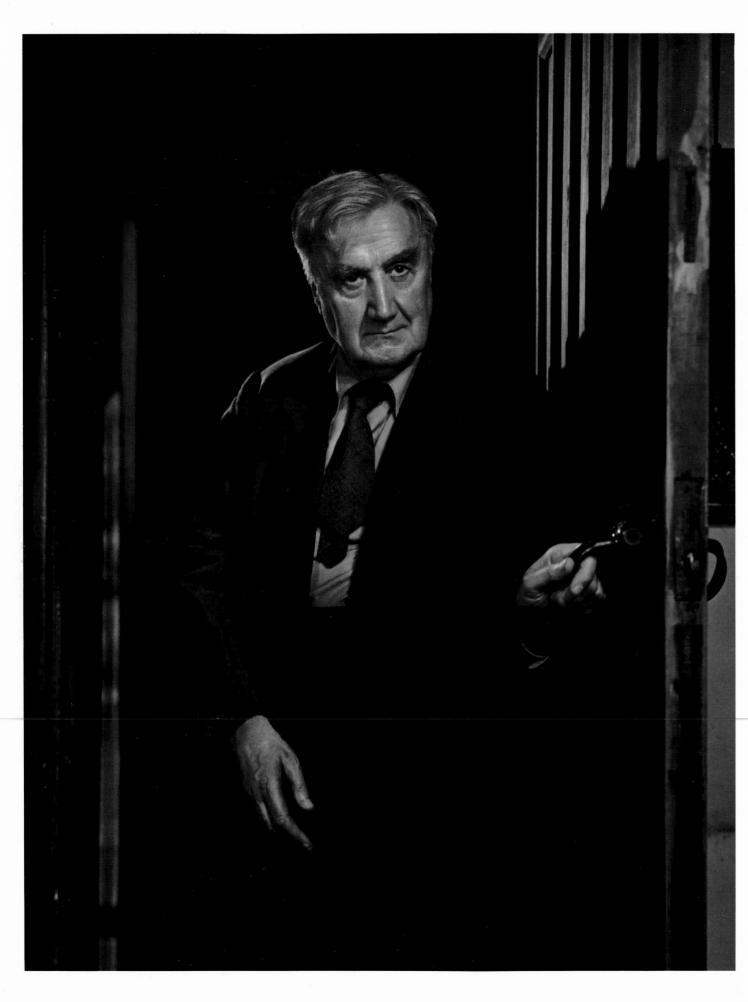

Ralph Vaughan Williams
1949

The big shaggy-haired English composer welcomed me to his home in Dorking, England. We were soon chatting about our mutual enthusiasms: Mozart, mathematics and music, and London versus New York as the more influential musical center. Vaughan Williams did not agree with some of his colleagues that composers should be consulted by conductors as to how their work should be played: "When people tell me how they interpret my music, I can only reply…it is there for people to interpret as they wish. Flowers produce different scents, which, when blended, produce a perfume that has its own independent existence."

Benjamin Britten
1954

His envious dachshund
would not allow me to take
more than a few photo-
graphs of Britten alone in his
house by the sea, in Suffolk,
England. The dog demanded
to become part of the pic-
ture. Britten swiveled on the
piano seat to make room for
his canine collaborator, who
leaped into the safety of his
arms, while yet casting a
wary eye at me.

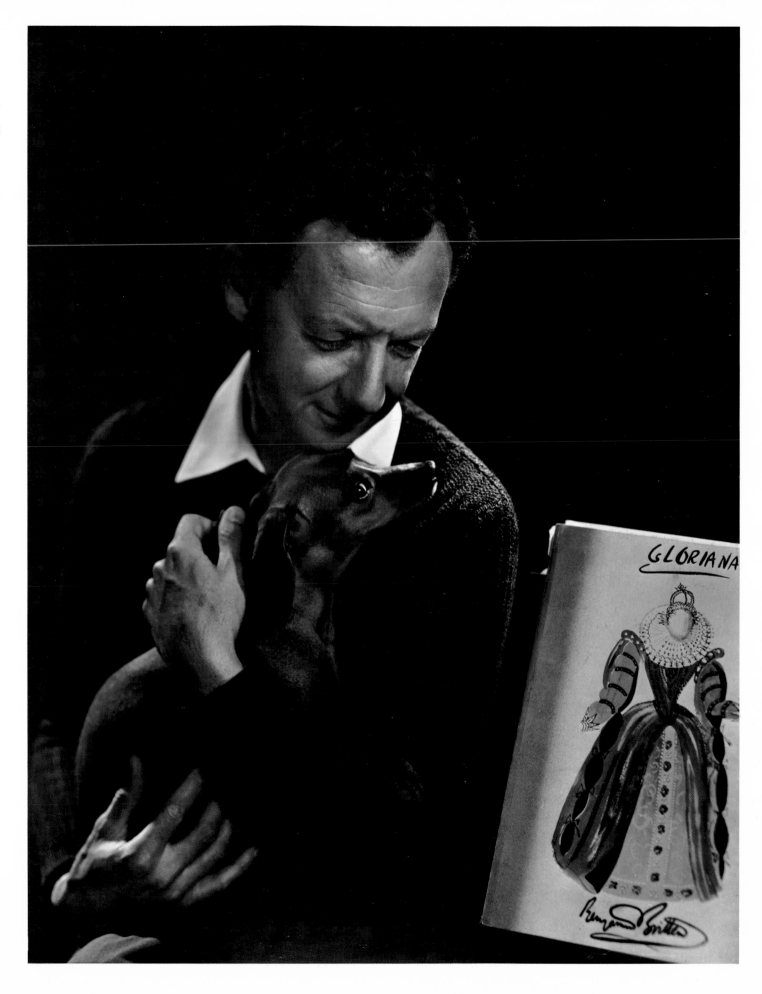

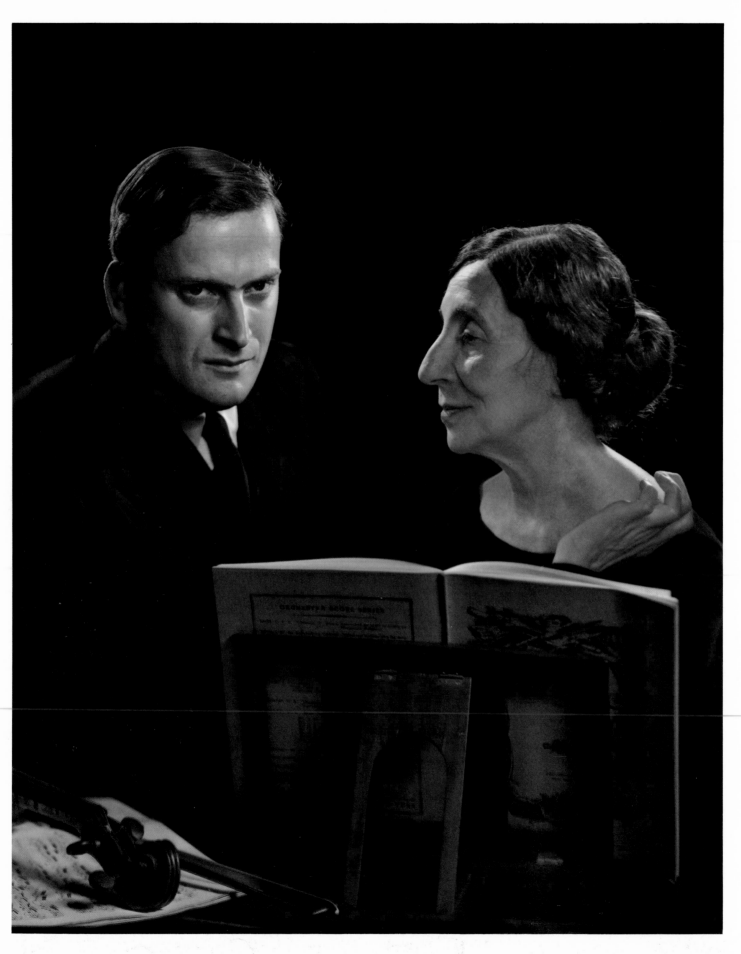

Yehudi Menuhin and Wanda Landowska
1945

The mature former child prodigy and the acknowledged mistress of the harpsichord made a striking contrast in personality, he affable and sincere, she imperious and demanding. While playing, she wore thick stockings instead of shoes. All the furor of preparation was forgotten when the two of them played together.

Fritz Kreisler
1955

On short notice, the only locale which could be provided for photography was the cluttered Dickensian library of his agent. The violinist-composer was in the twilight of his life and could no longer hear his own compositions or his playing. Nevertheless he retained the special charm and graciousness that the Viennese seem to possess.

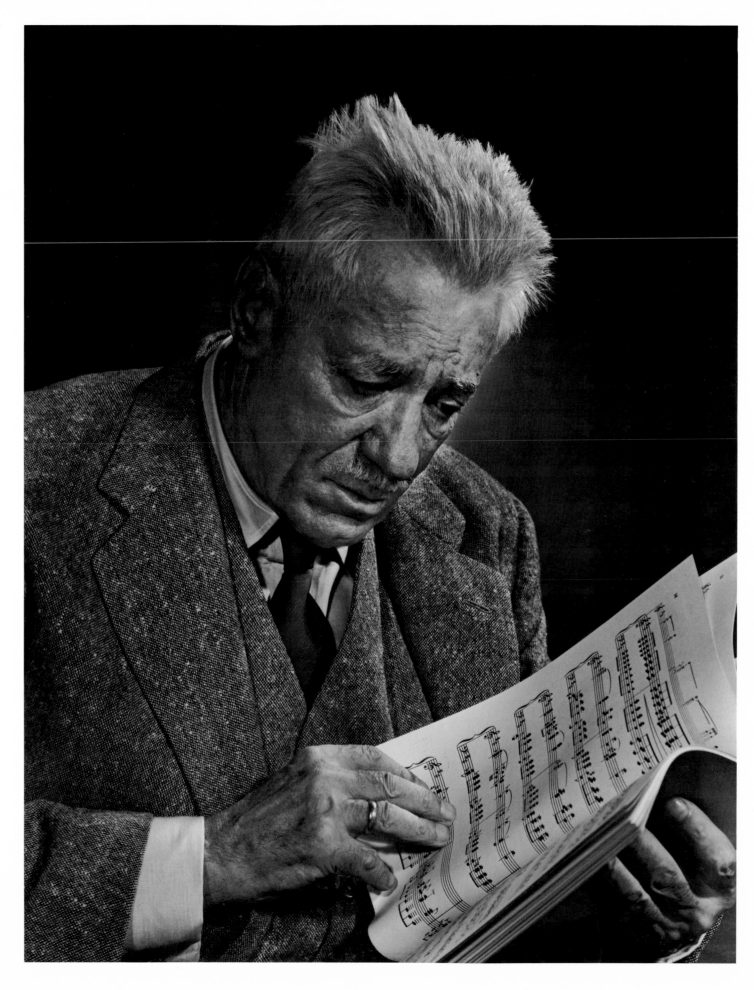

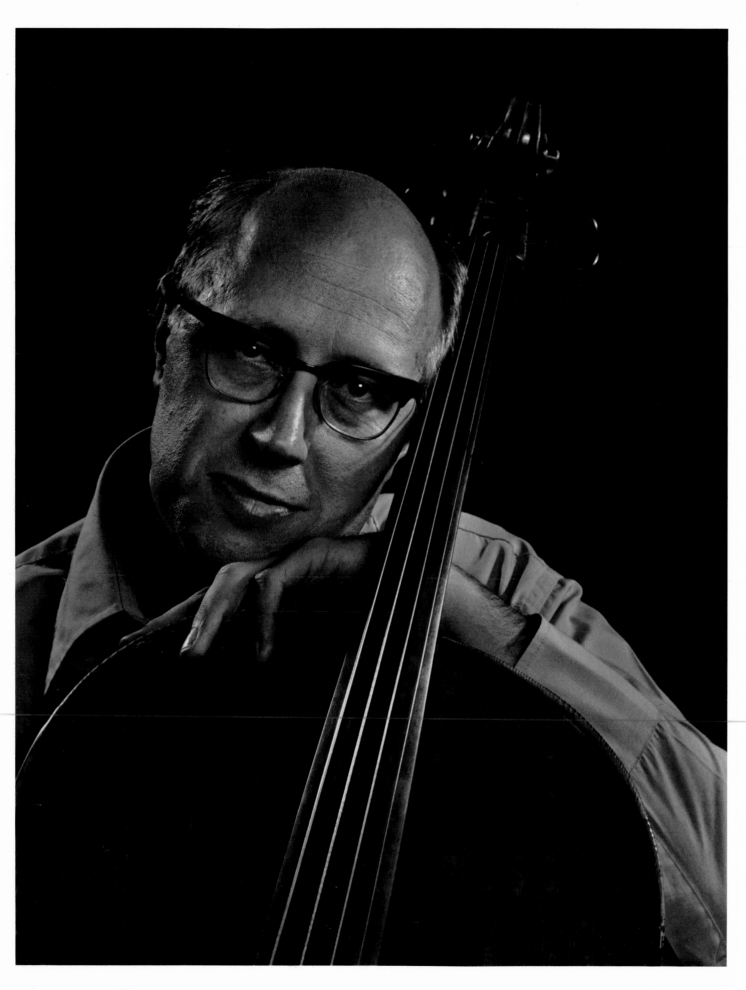

Mstislav Rostropovich
1974

I was not on a photographic mission at all. I was on holiday in the wildlife sanctuary of the Camargue, fulfilling a lifelong desire to see this extensive tract of land in southern France where the cowboy was said to have originated. To my surprise, Rostropovich was a fellow weekend guest of the distinguished French shipowner Monsieur Henri Fabré and his wife. After dinner, talk turned to the famed cellist's native Russia, and how lonely and dispossessed Rostropovich seemed to feel at the prospect of never being allowed to return.

Eugene Ormandy
1979

My friends the piano virtuoso Eugene Istomin and his wife, Martita Casals Istomin, introduced me to the conductor who had made his name synonymous with the Philadelphia Orchestra. Rich with honors, and already prematurely nostalgic for the years in which he was responsible for the Philadelphia Orchestra's maintaining its position as one of the world's best, he reluctantly planned to retire his baton the next year.

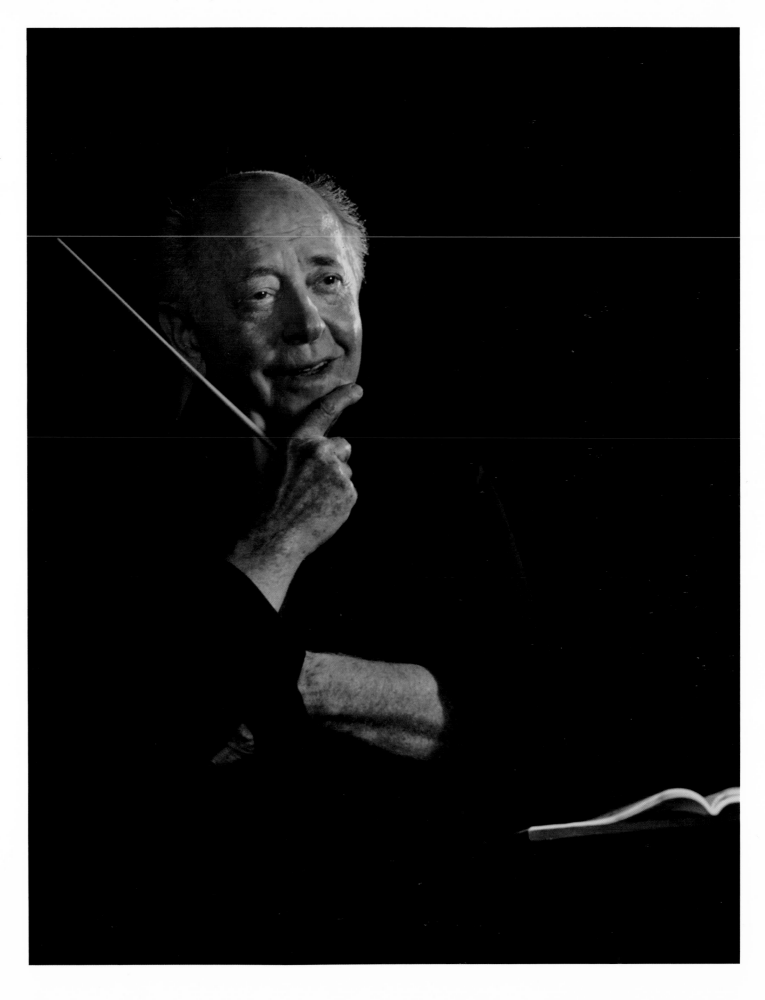

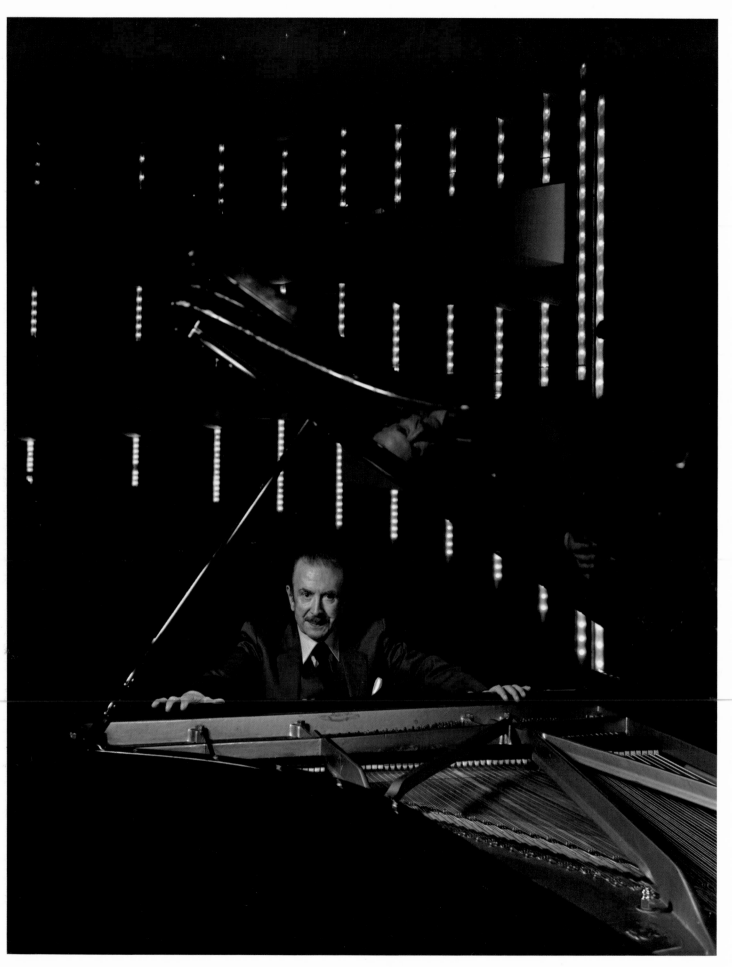

Claudio Arrau
1980

Against the backdrop
created by the pattern of
overhead lights at the
National Art Centre in
Ottawa, the Chilean-born
pianist, noted for his inter-
pretation of the nuances
of Debussy and Chopin,
pauses during rehearsal
of a concerto to hear the
conductor's comments.

Pablo Casals
1954

In the Abbey de Cuxa in Prades, I spent several glorious hours with the master of the cello, Pablo Casals. Our rapport was instantaneous; he trusted me to carry his cello into the Abbey. He told me of his uncompromising stance against the Spanish dictatorship of the Franco regime. I was so moved on listening to him play Bach I could not, for some moments, attend to photography. I have never photographed anyone, before or since, with his back to the camera – but it seemed to me just right. For me, the bare room conveys the loneliness of the artist, at the pinnacle of his art, and also the loneliness of the exile.

Years later when my portrait of Casals taken from the back was on exhibition at the Museum of Fine Arts in Boston, I was told that an elderly gentleman would come and stand for many minutes each day in front of it. When the curator, by this time full of curiosity at this daily ritual, ventured to tap the old man on the shoulder and gingerly inquired, "Sir, why do you come here day after day and stand in front of this portrait?" he was met with a withering glance and the admonition, "Hush, young man, hush – can't you see, I am listening to the music!"

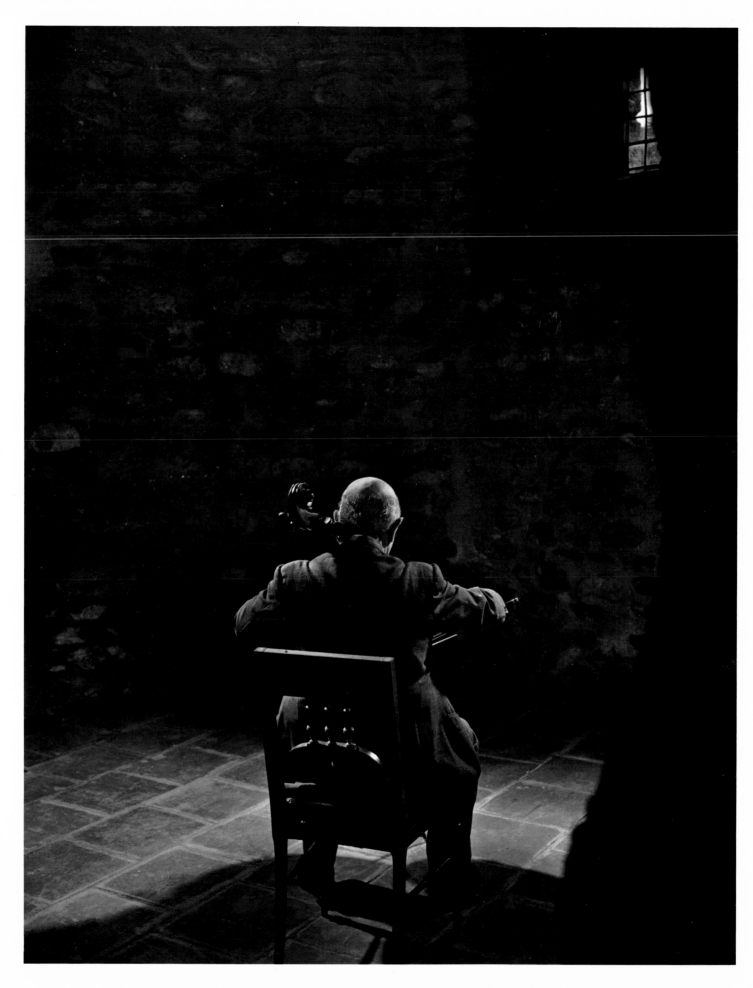

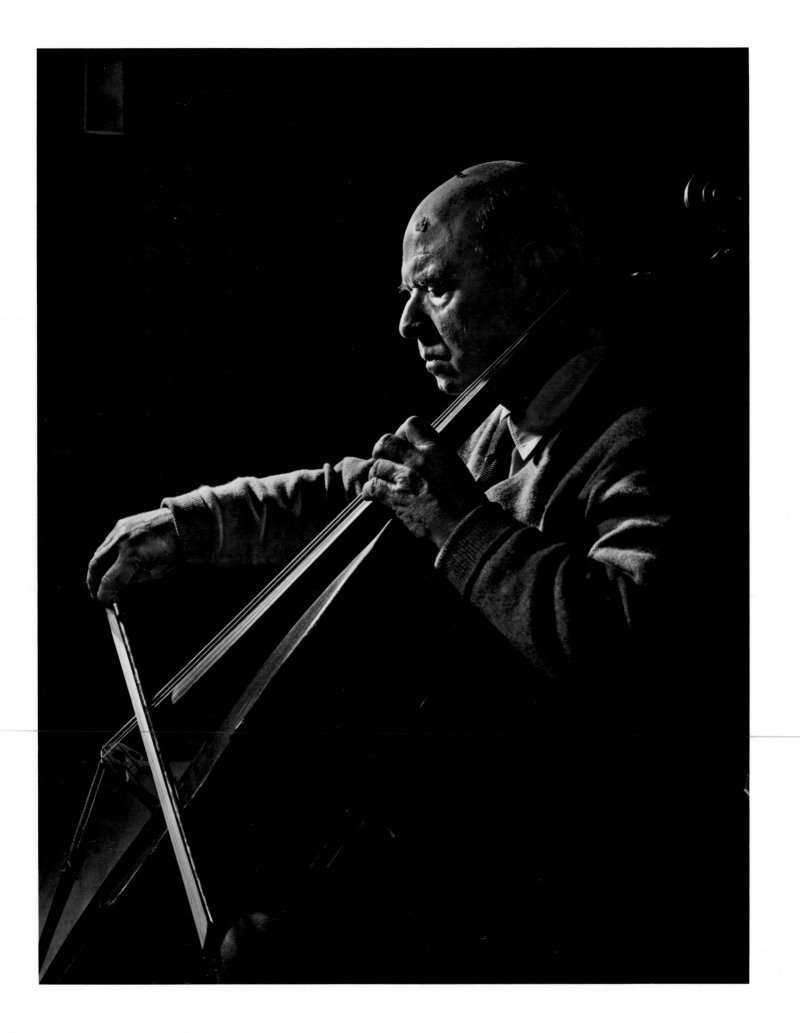

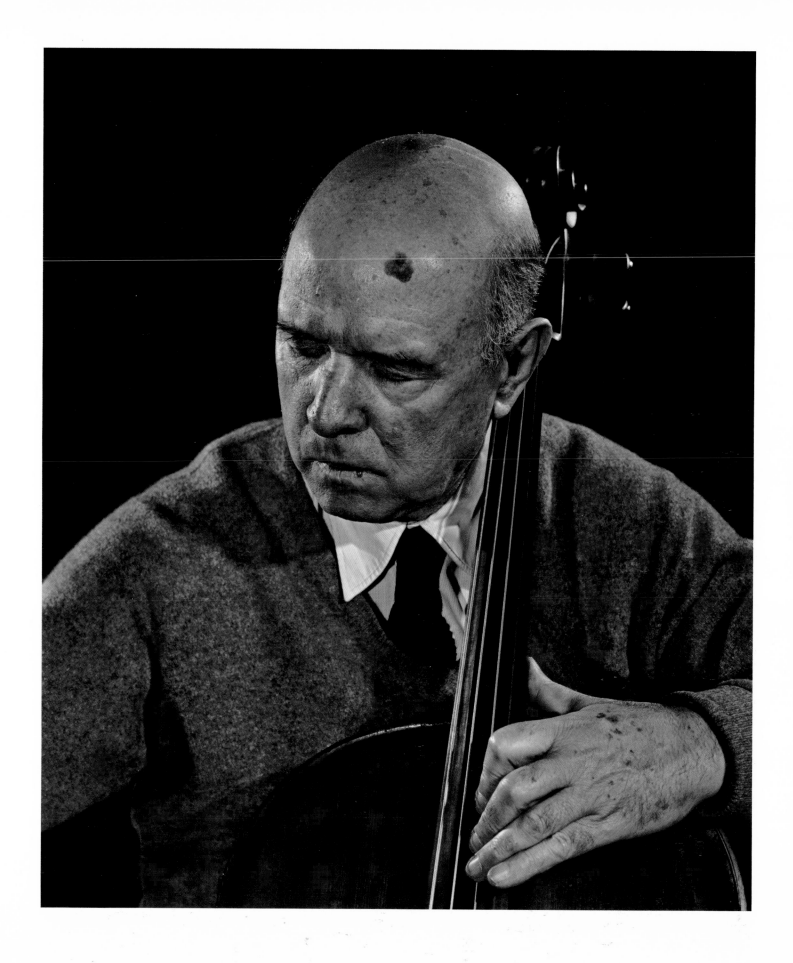

During my Boston apprenticeship, all of our work was done by available light from a specially constructed northern skylight. When I came to Ottawa and was introduced to the Ottawa Little Theatre, my eyes were opened to tungsten (artificial) light and its use in the theater to produce special effects and moods. This well complemented my training in the use of daylight. Even though the actors and actresses were amateurs and citizens of Ottawa, this was my first heady contact with the world of theater. I made it a point to sit through rehearsals, coached by my twenty-one-year-old teacher, Lord Duncannon, who taught me to listen to the dialogue and photograph the members of the cast in character at intermission time. "All you need do," he said, "is to repeat the lines the actors were saying at the time you saw a good picture and they will respond to the cue."

But when I came to photograph the famous movie stars of the 40s and 50s, I was less interested in photographing them in character than as individual personalities. With actors, however, it is sometimes difficult to separate the true personality from the favorite role. Especially in those years, actors and actresses tended to be intentionally typecast. Clark Gable and Tyrone Power were the rugged, handsome leading men; Bogart the troubled, macho hero; Peter Lorre and Sidney Greenstreet were archvillains. Ingrid Bergman was purity itself. The reason that the private lives of stars were then so closely guarded was perhaps that their studios wanted to promote the myth that their personal lives were extensions of their images on the screen. Today it is unthinkable that Ingrid Bergman would be subjected to so much controversy and prejudice, but the fans of those years felt betrayed when she failed to live up to her portrayal of Joan of Arc.

My attempts to make significant portraits on the studio lot were frustrated by the union demand for a full complement of cameramen, assistant cameramen, lighting men, makeup artists; all this activity, accompanied by recorded music playing throughout, was not conducive to intimate conversation. The movie stars welcomed the novel idea of being photographed at their homes, which I believe contributed to a degree of naturalness and informality.

As I looked over the photographs of the stars selected for this book, their professional longevity struck me. For the most part they remained prominent until their deaths. Those who are still with us, like Bette Davis and Gregory Peck, remain great stars. Because actors and actresses are a part of our fantasy life, to look now at these photographs, taken over three decades ago when the subjects were in their prime, is to relive our own youth, and, in our awareness of the turns their lives have taken since, we seem to be augurs of their future.

Margaret O'Brien
1946

She was the young darling of America, everybody's little girl, everybody's sometimes bratty, but always lovable, kid sister. She could cry on demand of the director, and contentedly ate chocolate ice cream cones, her face wreathed in smiles, after finishing her most tearful scenes.

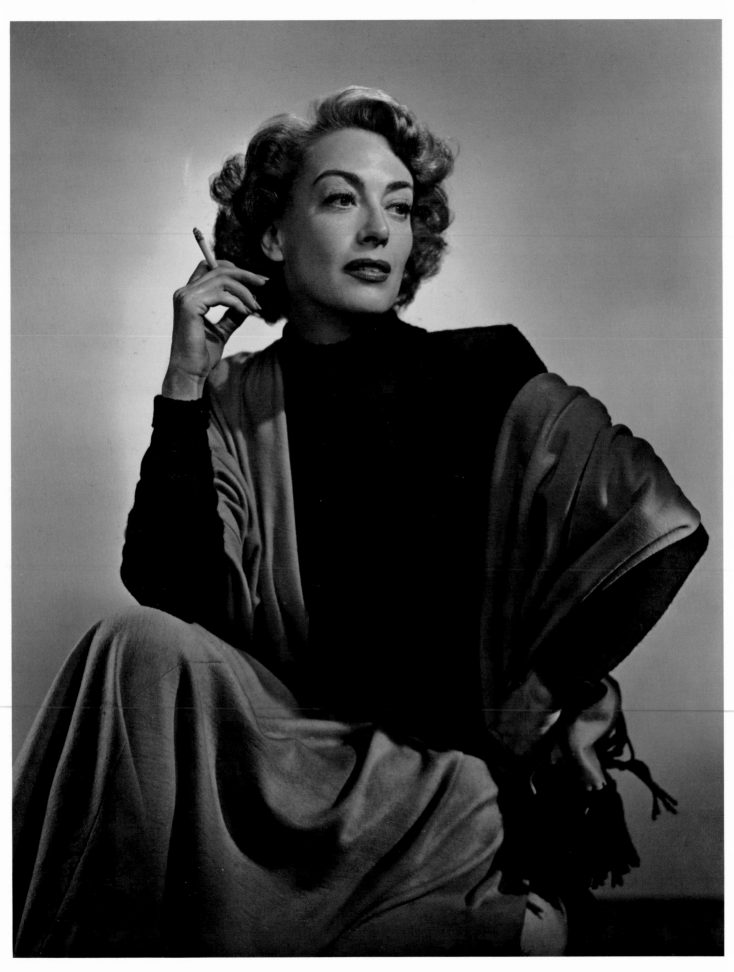

Joan Crawford
1948

The sitting with Joan Crawford was a prize won in a singles tennis game at the Beverly Hills Hotel. My partner challenged me with the tantalizing prospect of a kiss from "one of the most famous actresses in Hollywood" if I succeeded in winning the match. I had no other alternative but to beat him roundly! The "famous actress" we visited for cocktails and for the promised kiss – both cheerfully bestowed, I might add – was Joan Crawford. Thereafter she never failed to remember birthdays, holidays, and other important occasions with handwritten personal notes.

Ingrid Bergman
1946

The death of this courageous woman, a sensitive and compassionate actress, brought a flood of memories. How effervescent and full of life she was! Kurt Weill asked for this photograph when the Playwrights Company was considering her for Maxwell Anderson's *Joan of Lorraine*.

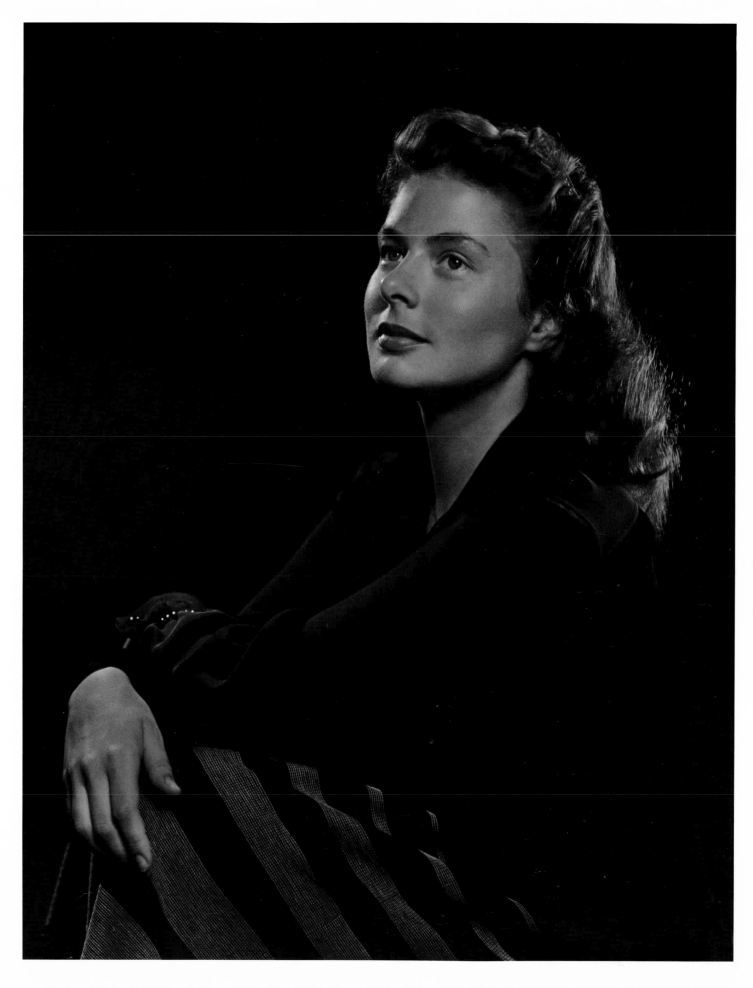

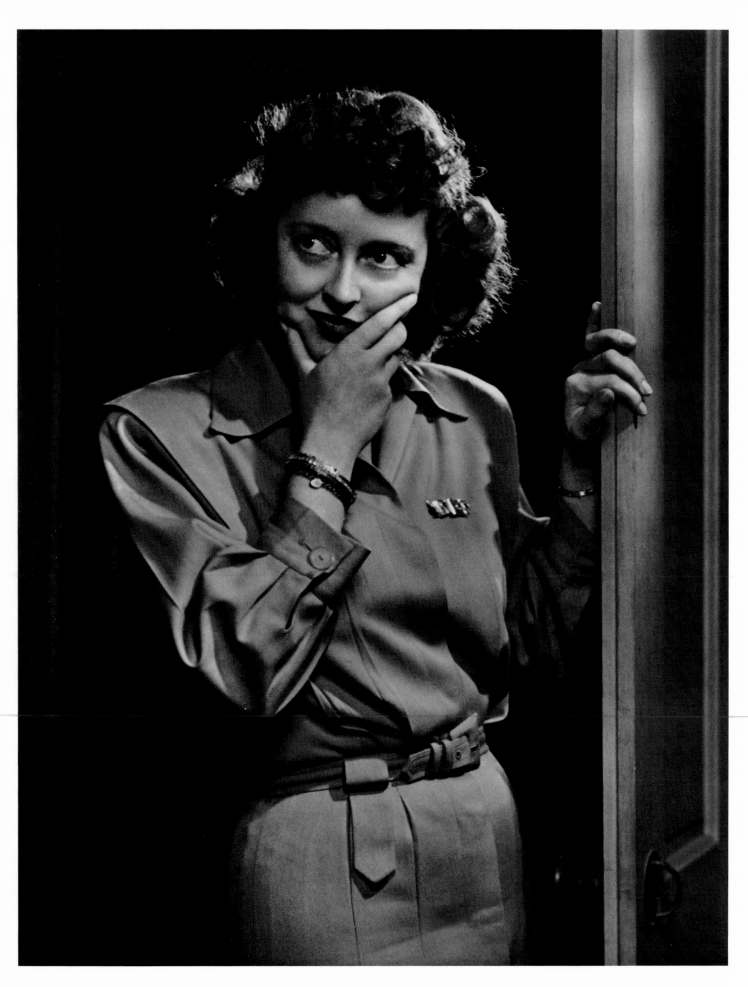

Bette Davis
1946

She remains today the great lady of the cinema, with the same healthy blend of skepticism and independence that was so much in evidence when I photographed her at her Laguna Beach cottage.

Gregory Peck
1946

A film historian remarked to me that the day of the "gentleman leading man," typified by Gregory Peck, was past. Now an "elder statesman" of the film capital, Peck retains the sincerity and friendly ease that impressed me during our photographic session.

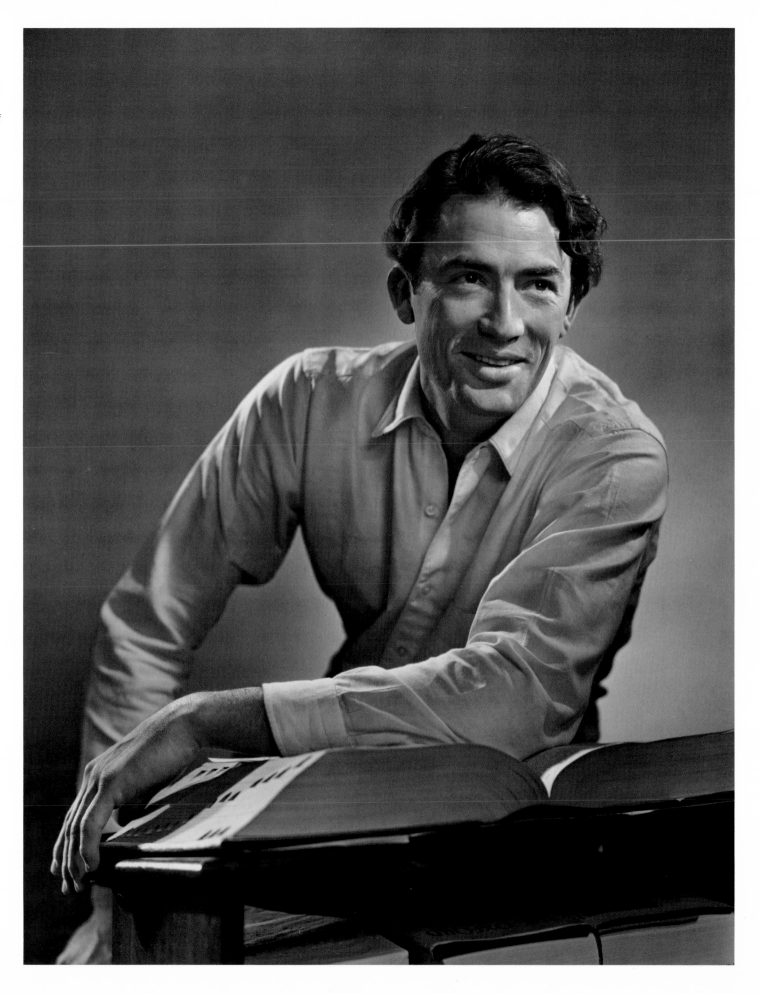

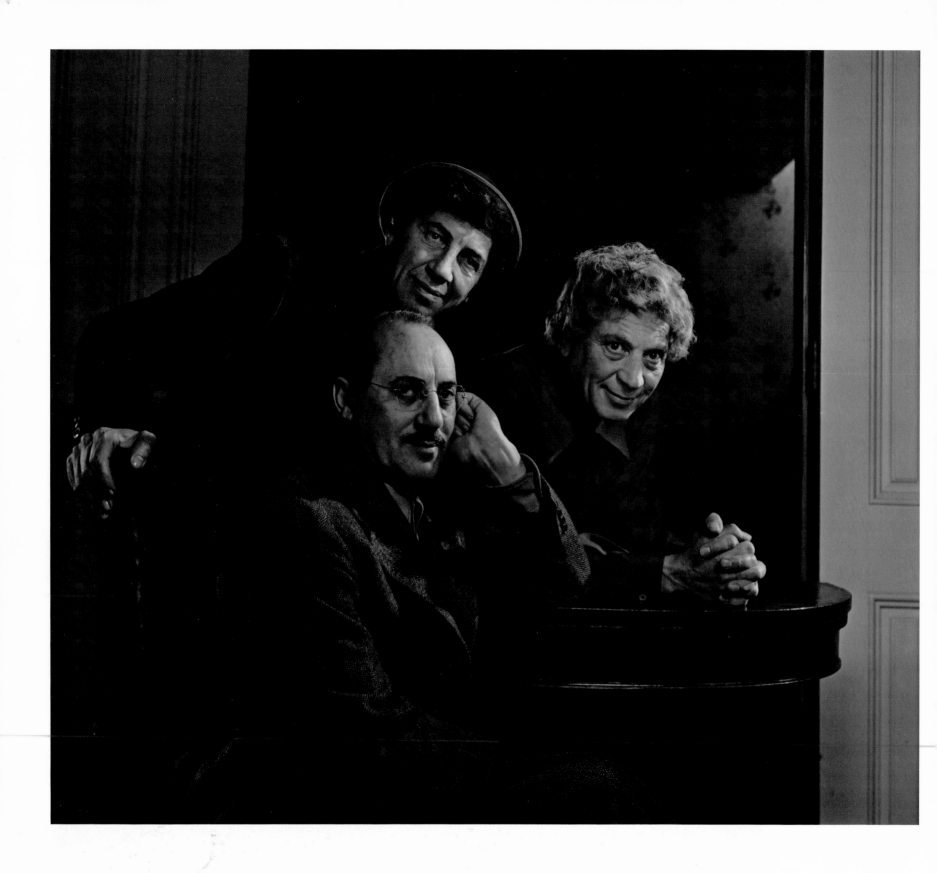

The Marx Brothers
1946

The antics of the brothers' zany film *A Night at the Opera* were repeated in "A Night at the Photographer's." It was a wonder that I could persuade the Brothers Marx to remain still long enough for me to click the shutter. Any camera, especially that of a somewhat harassed photographer, elicited hijinks and hysterically abandoned behavior. They ran around the room dropping hilarious vaudeville one-liners in their wake. Individually and collectively they enjoyed pushing me to the limits of sanity. My stern admonition to stay still for just one moment would end in my collapsing in side-splitting laughter, as yet another bit of Marx Brothers "business" was perpetrated.

Beatrice Lillie (Lady Peel)
1948

The English comedienne, herself the wife of an English lord, punctured the pretenses of the British upper classes with her devastatingly accurate wit.

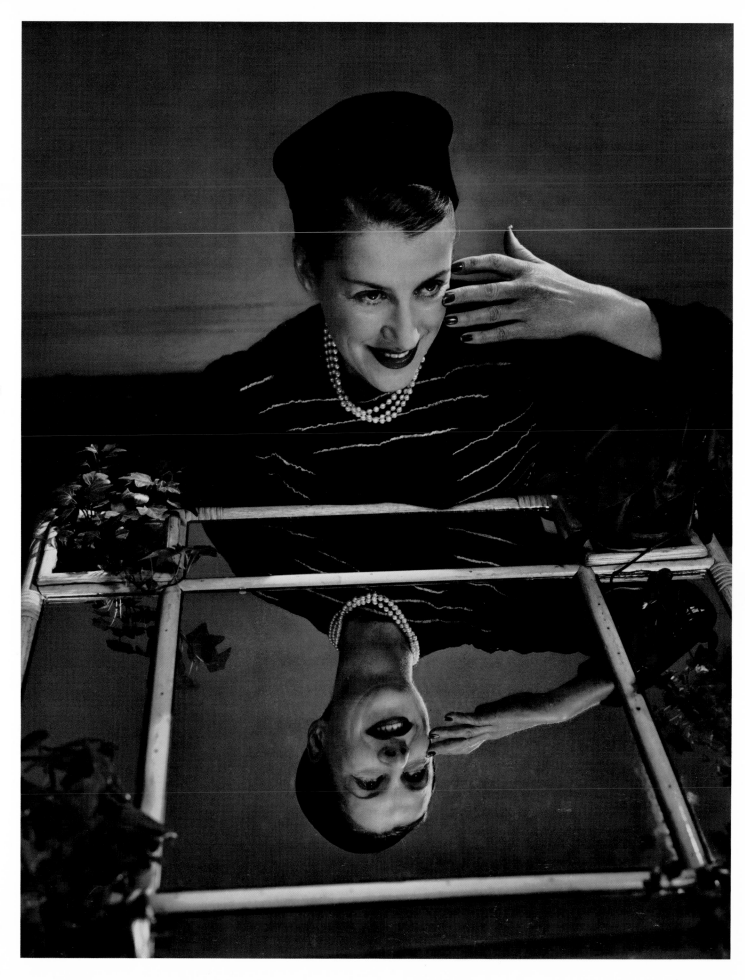

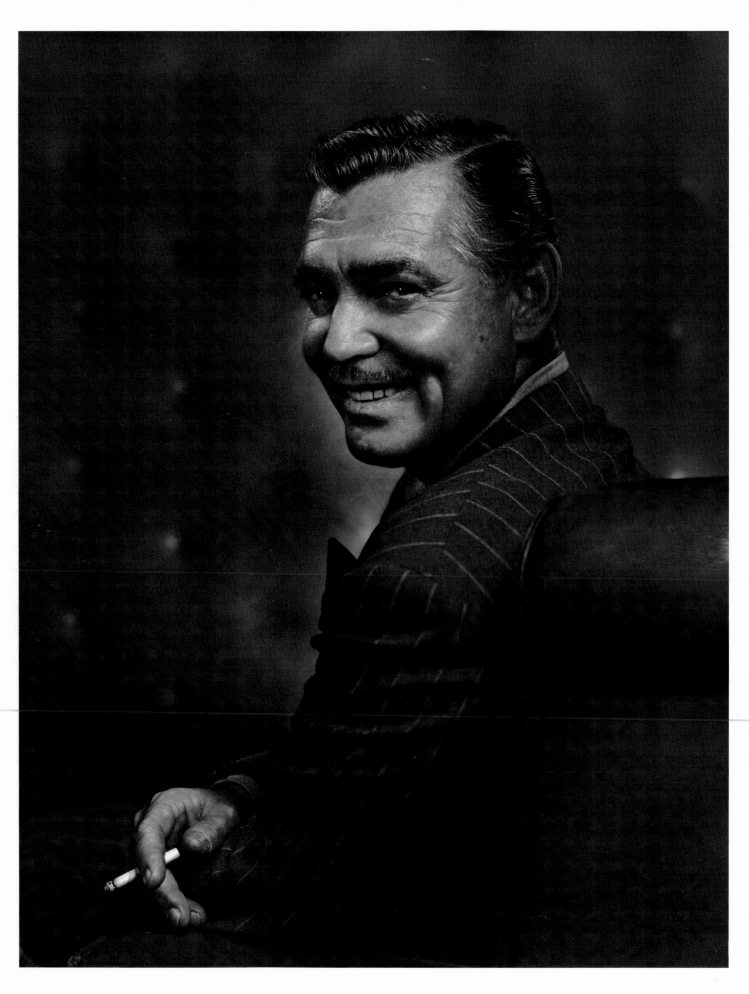

Clark Gable
1948

"The King" of the movies, unlike Rhett Butler in *Gone with the Wind,* emphatically *did* "give a damn" when he was late for the photographic appointment. He was stuck between floors in an elevator at a famous Wilshire Boulevard department store, causing a minor riot — and boundless delight to those adoring fans with whom he was confined for the better part of an hour.

Tyrone Power
1946

A gracious gentleman
and a member of a famous
theatrical family. I have often
wondered, had he been born
a decade later, entering mid-
dle age when open heart
surgery was a medical
commonplace, whether he
would have succumbed,
as had his father and his
brother, to a fatal heart attack
in his early forties.

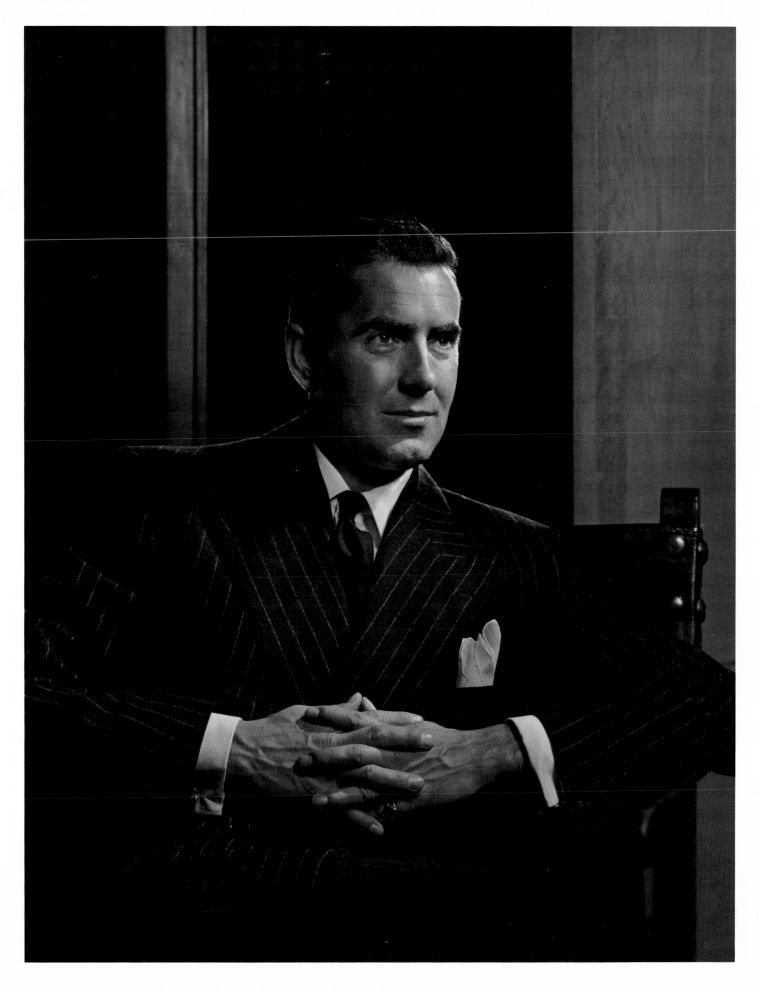

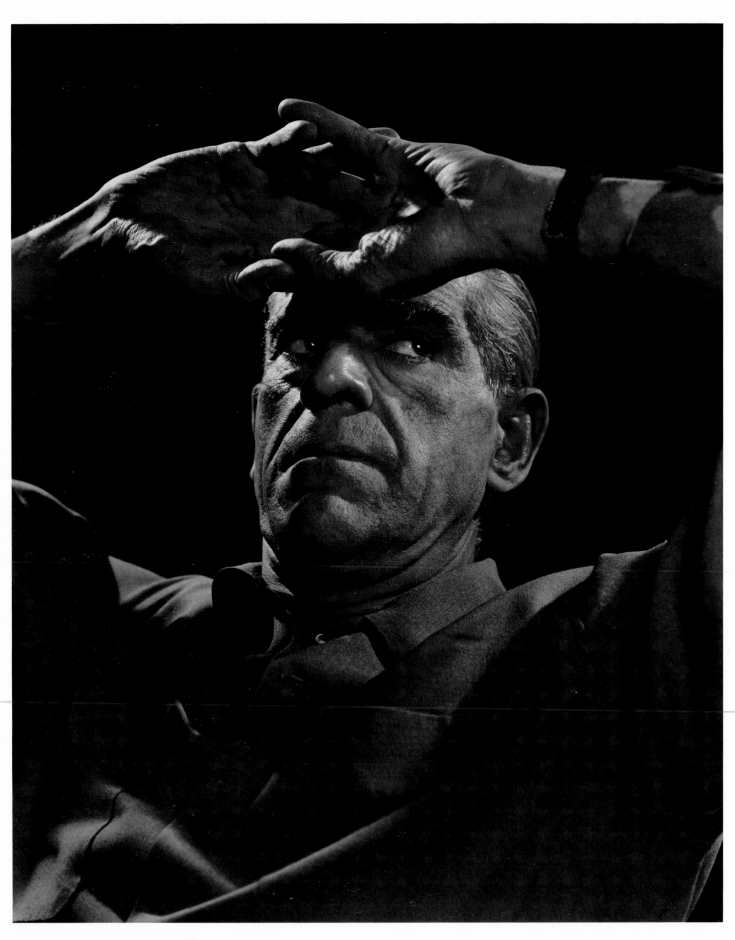

Boris Karloff
1946

The monster of Frankenstein lived a secluded existence in a modest room of the private club in which I photographed him. Gentle and scholarly, with an exquisitely modulated voice, he spoke of English gardens and growing roses.

Peter Lorre
1946

The large sign on the driveway outside of his home read "Beware of Ferocious Dogs." They turned out to be two frisky Pekingese. The movie legend of Peter Lorre was that of the timorous, sometimes menacing, sometimes bumbling sidekick of the archvillain. He turned out to be a gemütlich Viennese gentleman of wit and culture. This photograph was taken after our dinner together. When I observed the effect of the lamp on his face, it seemed to synthesize every character he played in American films.

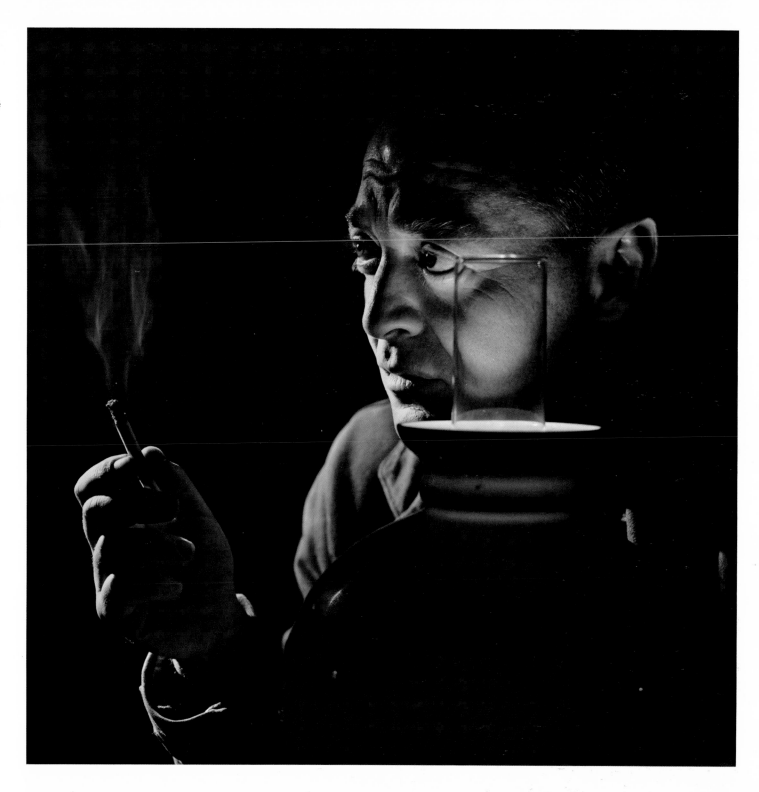

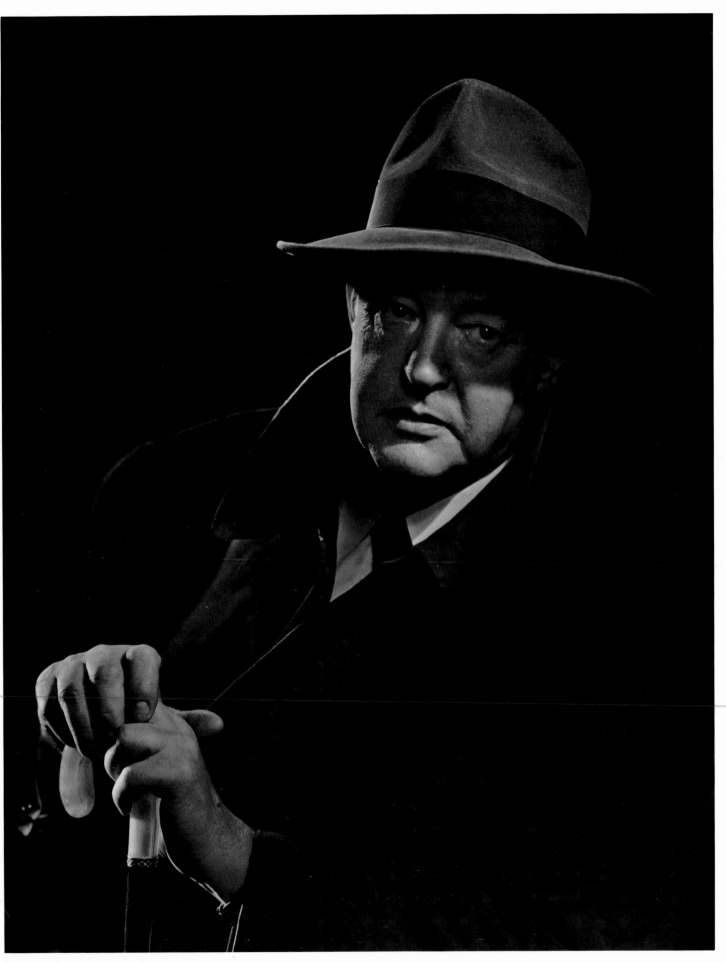

Sidney Greenstreet
1946

Before the movies delved into the psychological motivation of the ''bad guys,'' Sidney Greenstreet's artistry transformed the standard one-dimensional archvillain into a subtle and complex personality.

Humphrey Bogart
1946

The handsome son of a successful New York physician and his artist wife, Bogart's role-model in the theater was the aristocratic Leslie Howard. As a fledgling Broadway actor, it was he who first asked that famous question, ''Tennis, anyone?'' But by the time I photographed him, the image of the tender-tough hero was already wrought. Bogart and his English butler had planned a thoughtful surprise to welcome me to his home: an issue of the *Illustrated London News* opened to my portrait of King George VI.

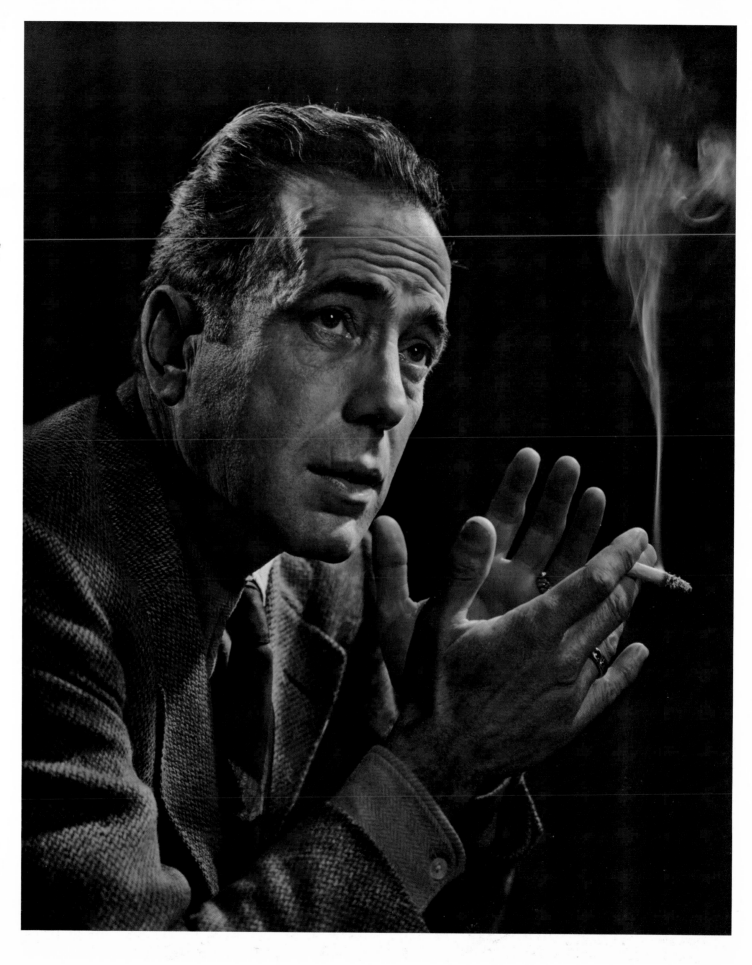

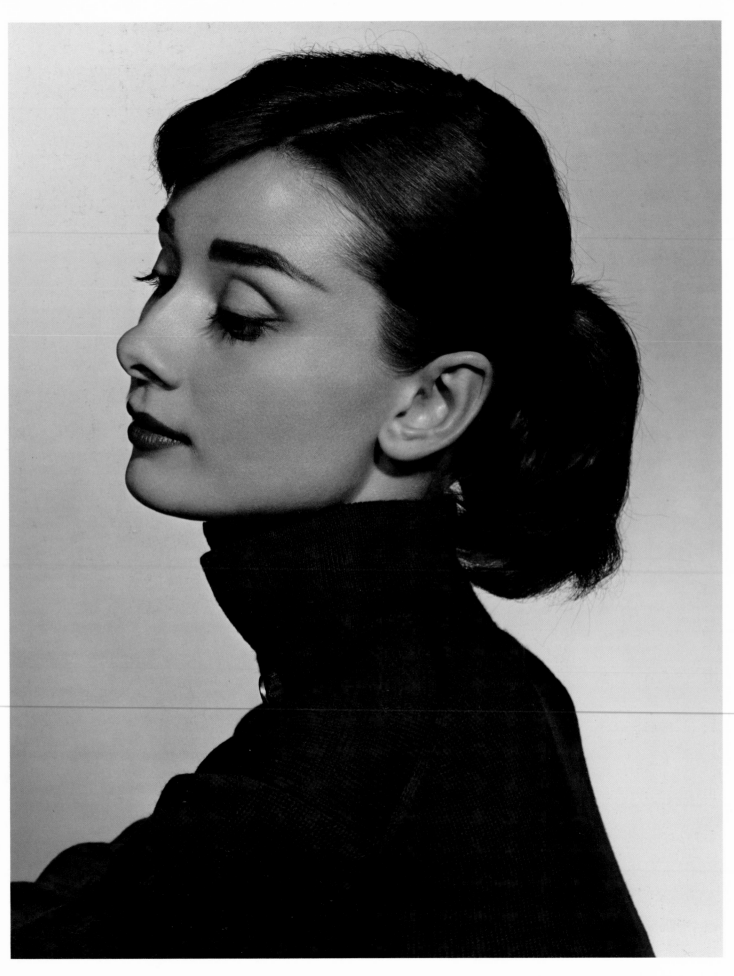

Audrey Hepburn
1956

The French novelist Colette picked her out of a ballet lineup to play *Gigi* on stage, and her career was launched. When I photographed her in Hollywood and commented on her quality of sophisticated vulnerability, she told me of her harrowing experiences during the Second World War. Years later, in the Kremlin, Chairman Brezhnev agreed to sit for me only if I made him "as beautiful as Audrey Hepburn."

Grace Kelly
1956

The future Princess of Monaco took me to her New York apartment before her fiancé, Prince Rainier, arrived so that we might select gowns for their photographs. The following day she was involved in whirlwind preparations for her forthcoming spectacular marriage to the Prince, but she remained fresh and serene throughout the sitting. It was evident, even then, that she was to bring both beauty and dignity to her role as the Princess of Monaco.

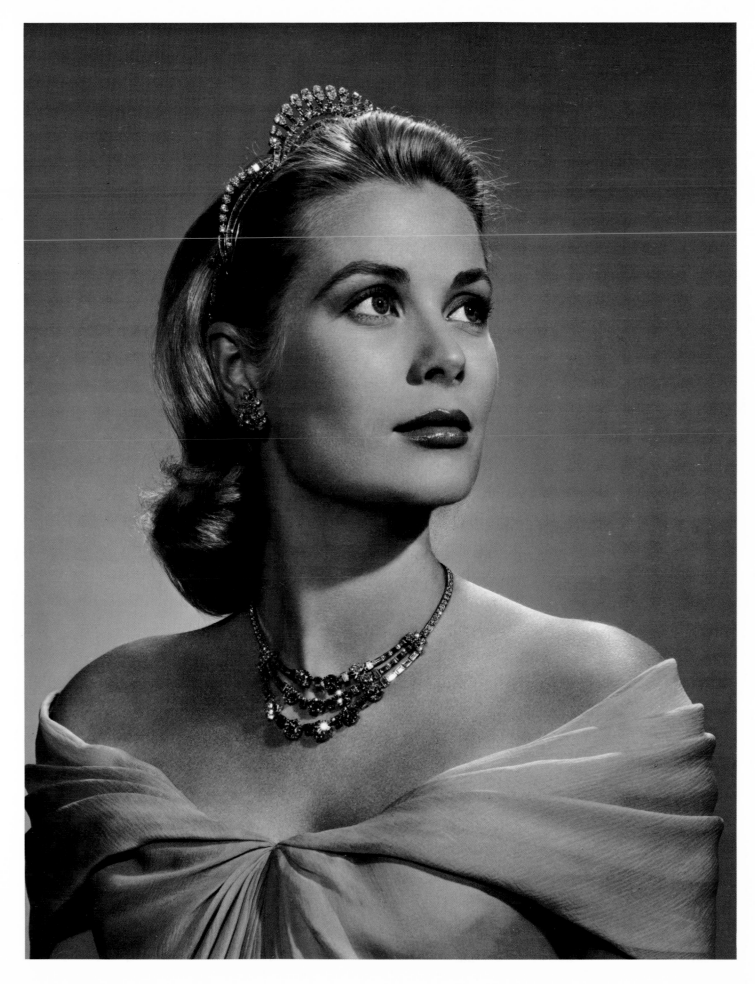

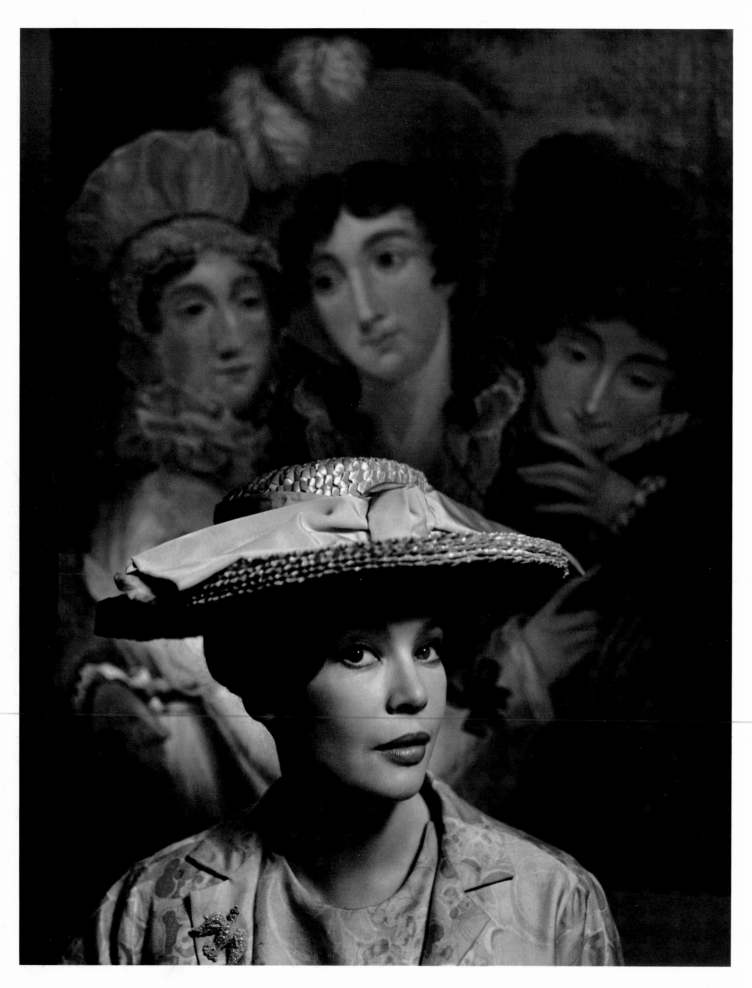

Leslie Caron
1963

The gamine-heroine – the Gigi of the movies – in a proper English garden-party hat whose purchase, she said, was inspired by the nineteenth-century painting behind her.

Elizabeth Taylor
1946

She was fourteen years old, a charming and unassuming child, who had captivated the world in *National Velvet*. She was totally engrossed with her pet chipmunk and cat, the newest additions to her extensive home menagerie. I named the cat Michael. The next day she called to me from an open car on the M.G.M. lot and held up her newest feline friend. "Look who I have with me," she cried triumphantly, "Michael Karsh Taylor!" This photograph is a sultry harbinger of the great beauty she was to become, and still is.

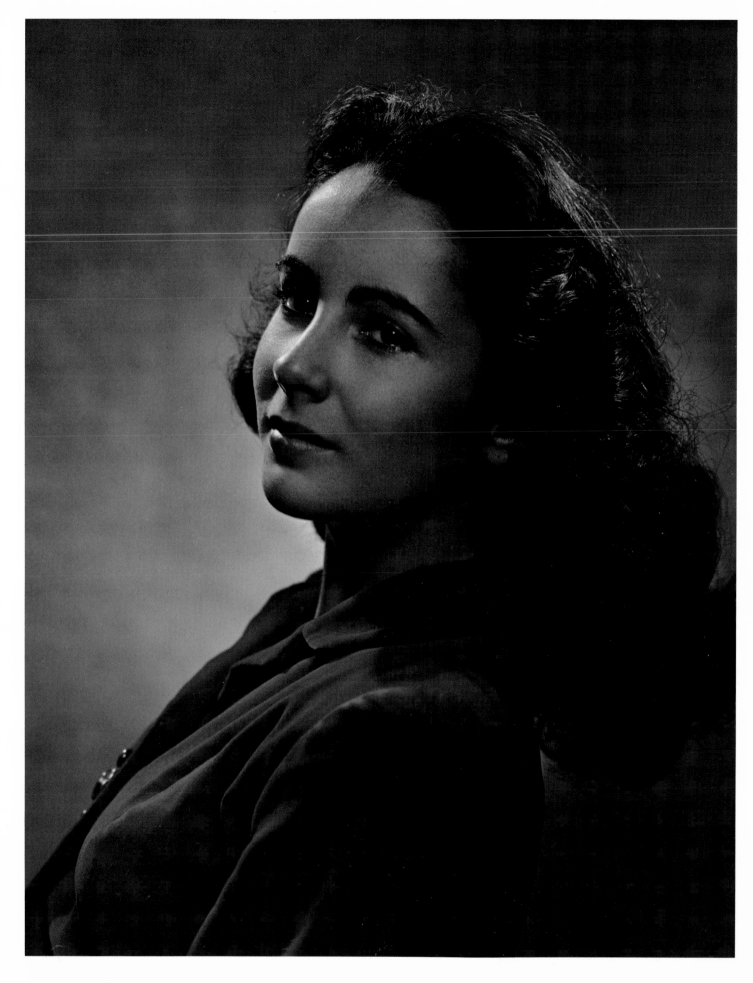

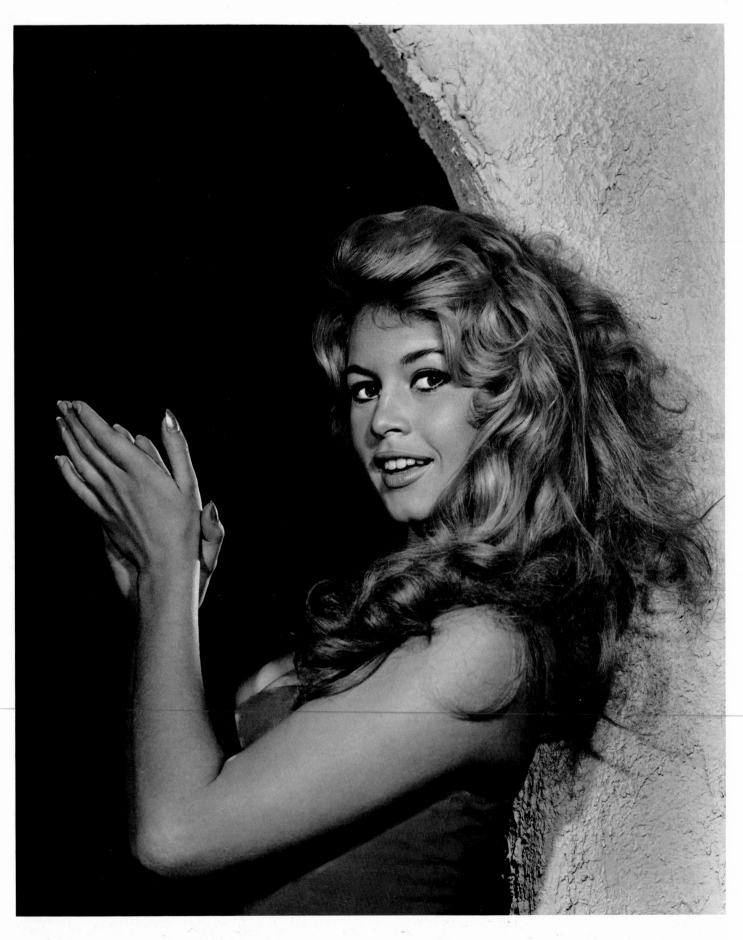

Brigitte Bardot
1958

I flew from photographing
Pope John XXIII in Rome to
another delightful experi-
ence in Paris, portraying
Brigitte Bardot, the French
sex kitten with the baby
pout. Her initials, B.B., were
already a worldwide symbol
of delicious irresponsibility.
When she heard where I had
previously been, she clapped
her hands and exclaimed,
"Ah, from the saints to the
sinners!"

Anita Ekberg
1956

The smorgasbord was already lavishly spread on the table of Anita Ekberg's California home when I arrived. Her natural behavior resembled the love goddesses she portrayed – uninhibited and seductive, and totally without guile. When changing from one gown to another, she ignored the screen her attendant had placed before her. She exuded sexuality; in the garden, as she exuberantly hugged a tree trunk, it became a gesture of utmost sensuality.

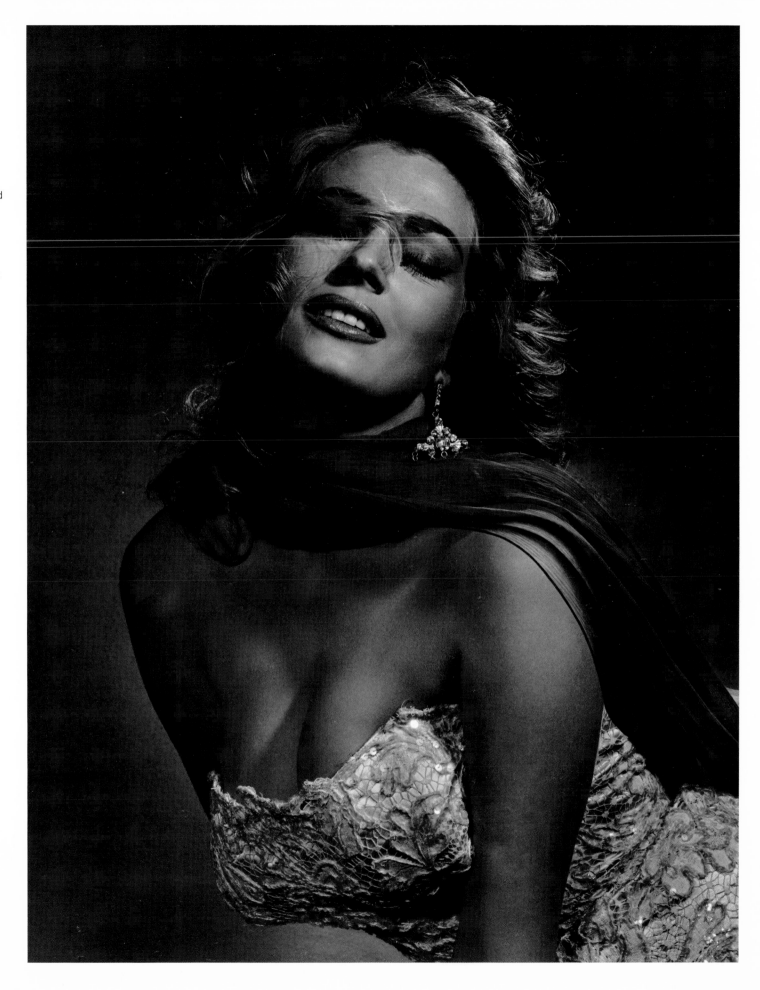

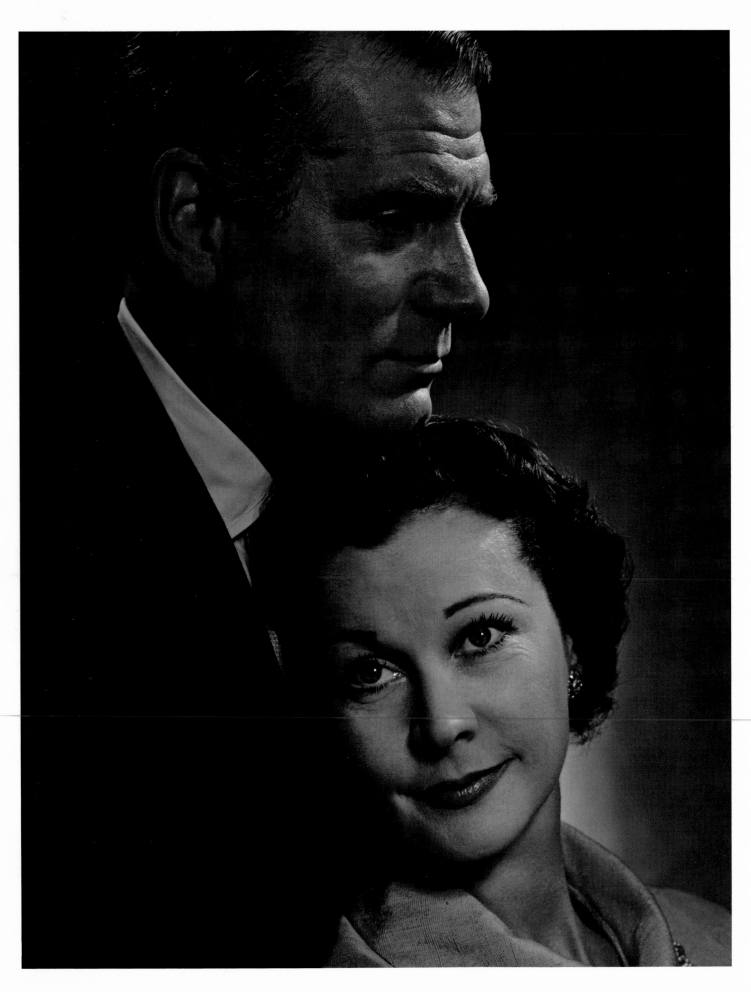

**Sir Laurence Olivier
and Vivien Leigh
1954**

He was, and still is, acclaimed
as the greatest actor in the
English-speaking world. She
had triumphed as Scarlett
O'Hara. The evening I photo-
graphed them, he spoke of
the importance of seemingly
minor details in establishing
a character. He was jubilant
that he had discovered an
authentic nineteenth-
century pince-nez to wear
when playing Dr. Astrov in
Chekhov's play *Uncle Vanya*.
"No one else might know it
is real," he explained, "but
the fact that it is adds
authority to my feeling
about the role."

Anna Magnani
1958

Why did she become an actress? The volatile Italian performer replied, ''Because of unhappiness, perhaps. I wanted to do so many things. I exploded with ideas, like firecrackers.'' At our photographic session I endeavored to explore behind her brooding, almost overwhelming, air of tragedy. Not until her only son, a polio victim, then in his teens, came into the room in his wheelchair, did I understand part of the reason for her melancholy.

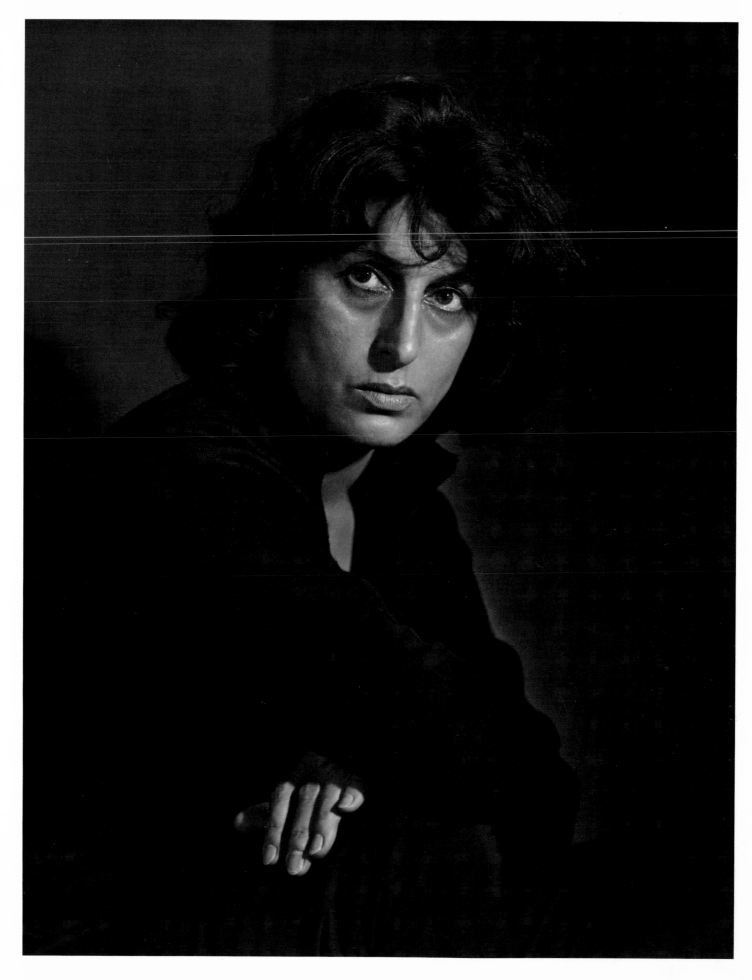

Melina Mercouri
1971

In my New York Studio, visiting with her producer-husband Jules Dassin, she flung her Saint Laurent cape around her like a triumphant spirit of victory. She spoke of her concern and love for her native Greece. It seemed fitting that, a dozen years later, she would be her country's Minister of Culture.

**Sophia Loren
with her son Eduardo
1981**

She impresses as much by
her lucid intelligence as by
her beauty. This photograph
was an unexpected dividend
of a rewarding photographic
session in her Paris apart-
ment. I was touched by the
love with which Sophia and
her son Eduardo greeted
each other when he returned
from school. After she saw
these photographs, she
called me to say I had truly
captured her heart and spirit
and "the next time we will
play at photography much
longer."

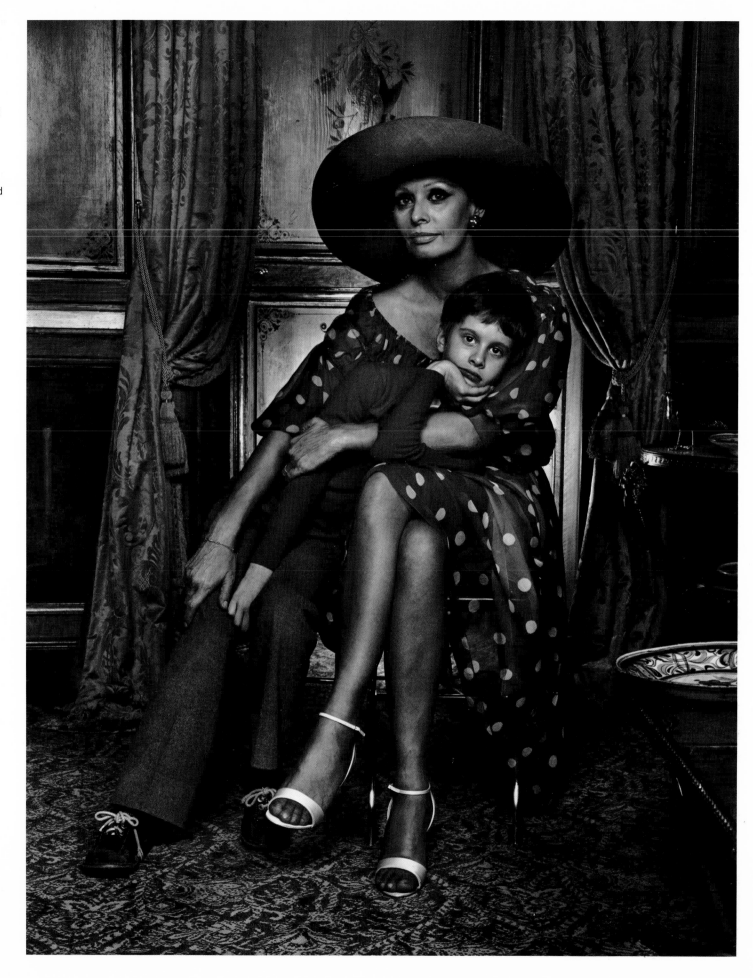

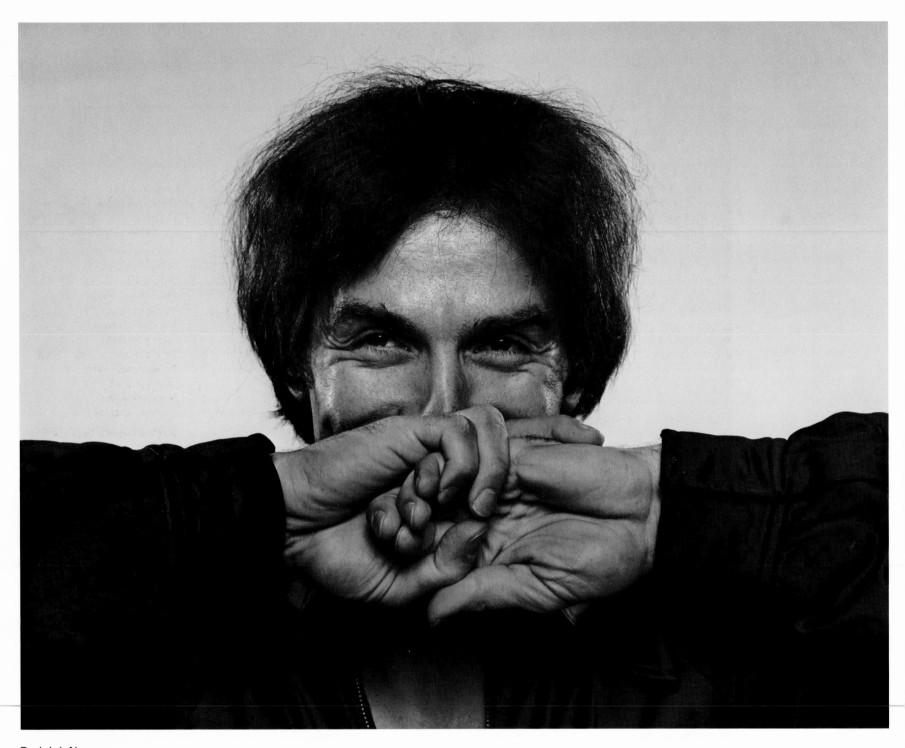

Rudolph Nureyev
1977

The celebrated dancer/ choreographer was guest artist with the National Ballet of Canada and would shortly venture into his first film role, that of the great screen lover Rudolph Valentino. During our photographic session we cajoled each other about great lovers. "Let me see those sensuous lips of yours," I playfuly suggested. Puckishly, mischievously, he covered his mouth, and smiled with his eyes.

Designed by Carl Zahn

Production coordination by Nan Jernigan

Composition in Univers Light by Typographic House

Printed by Imprimerie Jean Genoud, Lausanne, Switzerland